Materials List

Oil Paints in 37 ml Tubes

- Cadmium Yellow Light (hue)
- Cadmium Red Light (hue)
- Alizarin Crimson
- Ultramarine Blue
- Mars Black
- Titanium White
- Yellow Ochre
- Cerulean Blue (hue)

Other Necessary Supplies and Equipment

- Gamsol or Turpenoid, 16 oz. can
- Linseed oil
- Canvas panel or stretched canvas, sized for specific project
- Three small to medium glass jars with lids
- Rags and paper towels
- Palette knife (metal, not plastic)
- Palette (glass or disposable paper palette with tear-off sheets)
- Four to five bristle brushes, ¼ inch to ¾ inch
- Tackle box or container to carry all this stuff

Your Very Own Viewfinder

You can cut out the following viewfinder and use it when planning your painting projects. Just don't forget to also cut out the interior opening (or the viewfinder wouldn't offer much of a view). The circle represents the position for a hole punch.

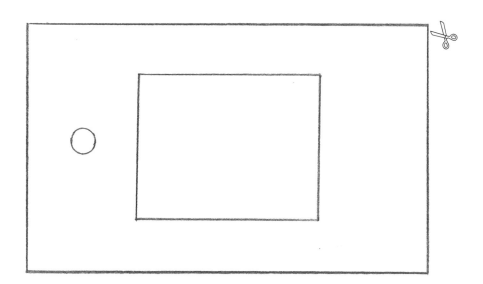

Oil Painting For Dummies®

Color Wheel

This color wheel includes pure hues, shades, tones, and tints.

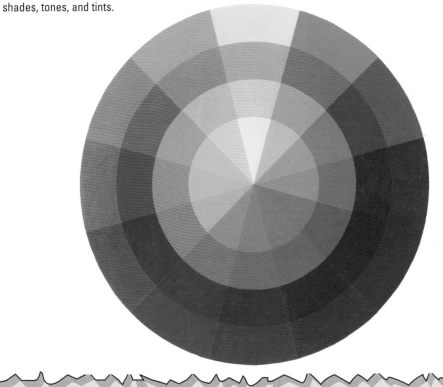

For Dummies: Bestselling Book Series for Beginners

Oil Painting

FOR

DUMMIES®

by Anita Giddings & Sherry Stone Clifton

Wiley Publishing, Inc.

Oil Painting For Dummies®

Published by
Wiley Publishing, Inc.
111 River St.
Hoboken, NJ 07030-5774
www.wiley.com

Copyright © 2008 by Wiley Publishing, Inc., Indianapolis, Indiana

Published by Wiley Publishing, Inc., Indianapolis, Indiana

Published simultaneously in Canada

For general information on our other products and services, please contact our Customer Care Department within the U.S. at 800-762-2974, outside the U.S. at 317-572-3993, or fax 317-572-4002.

For technical support, please visit www.wiley.com/techsupport.

Wiley also publishes its books in a variety of electronic formats. Some content that appears in print may not be available in electronic books.

Library of Congress Control Number: 2007942004

ISBN: 978-0-470-18230-7

Manufactured in the United States of America

10 9 8 7 6 5 4 3 2 1

About the Authors

Anita Giddings is an artist and educator living in Indianapolis, Indiana. She holds a Bachelor of Fine Arts degree from Herron School of Art and Design and a Master of Fine Arts degree from Indiana State University. Giddings' education and training is in painting but her work also includes sculpture, photography, and installation.

Giddings began formal education in fine art when her high school art teacher, the late Mrs. Elizabeth McCallister, *made* her go to art school. After graduating from Herron School of Art in Indianapolis, she went to graduate school and received her Master of Fine Arts degree in painting.

Giddings began teaching community education classes more than 20 years ago. She particularly enjoys teaching painting and introducing her students to a greater appreciation of art through art making. She is currently a faculty member of Herron School of Art and Design in Indianapolis and also runs a program of studio classes for non-art students on the campus of Indiana University-Purdue University Indianapolis.

Giddings met Sherry Stone Clifton when she returned to Herron to teach, and the two have been friends ever since. When the opportunity came to write this book, Giddings asked Stone Clifton to collaborate with her because of their shared philosophy of teaching.

Sherry Stone Clifton grew up in a family dotted with self-taught artists. Her great-grandfather made little paintings of animals and landscapes on scraps of cardboard cut from box lids. Her mother dressed up furniture and other odds and ends around the house with paintings. Her father retired from a career as a draftsman to work in stained glass.

A scholarship landed her the opportunity to attend art school at Herron School of Art and Design, where she studied printmaking and painting. She graduated with a Bachelor of Fine Arts degree. After graduation, she taught non-art majors courses in painting and drawing at Herron, beginning a teaching career that has spanned 20 years. She taught community outreach courses for all ages at Herron and the Indianapolis Museum of Art. For several years now, she has been a Lecturer in Foundation Studies at Herron, where she teaches drawing, color, 2-D design, and creative processes for first-year art students. She has earned awards for teaching at Herron and regularly speaks at conferences and publishes articles about teaching beginning art students.

She says that she is first and foremost an artist. She believes that her artwork enhances her teaching and that her teaching enhances her artwork. She has this to say about teaching art:

"This book reflects the ideas about teaching art that I use in my classroom every day: Learn to make art by making it. It's important to look at actual art by the masters — both old and contemporary. Read about art ideas and techniques. Drawing a little every day and studying design and color will give your painting a strong foundation. An open mind and healthy curiosity about the world is good. Beginning students are very special to me. They have wonderful hopes and dreams, and I love helping them make progress toward achieving them."

Dedication

To the two women who encouraged me always: my mother Phyllis Giddings and the late Mrs. Elizabeth McCallister. —AG

For my parents, who never once suggested that I study something "practical." —SSC

Authors' Acknowledgments

We would like to thank Tim Gallan, Mike Baker, and Sarah Faulkner at Wiley Publishing for help and patience in this project. Our thanks as well to the Graphics and Layout teams at Wiley who helped put this book together. We would also like to thank Vance Farrow, our colleague and technical editor.

We also thank Sara Hook, Lisa Londe, and our colleagues in the faculty and staff at Herron School of Art and Design, Indiana University-Purdue University Indianapolis.

Thanks to Lisa Kleindorfer, Heather Shebeck, and Michael Schulbaum for the loan of their paintings. To Carla Knopp, Richard Emery Nickolson, Andrew Winship, Marc Jacobson, and Mary Ann Davis for allowing us to photograph their studios. Thanks to Erin Harper Vernon for help with documenting artwork.

We would also like to thank William Potter, Valerie Eickmeier, and Eric Nordgulen at Herron School of Art and Design for giving us the time and space to complete this book.

Thanks to our own teachers over the years who guided us, to our families, friends, and students for putting up with us during this project, and to our friends at Herron School of Art and Design, who acted as our sounding board and gave us advice over the past few months.

Publisher's Acknowledgments

We're proud of this book; please send us your comments through our Dummies online registration form located at www.dummies.com/register/.

Some of the people who helped bring this book to market include the following:

Acquisitions, Editorial, and Media Development

Senior Project Editor: Tim Gallan

Acquisitions Editor: Mike Baker

Senior Copy Editor: Sarah Faulkner

Editorial Program Coordinator: Erin Calligan Mooney

Technical Editor: Vance Farrow

Editorial Manager: Michelle Hacker

Editorial Assistants: Leeann Harney, David Lutton, Joe Niesen

Front Cover Photo: Jerry Driedl/Getty Images

Cartoons: Rich Tennant (www.the5thwave.com)

Composition Services

Project Coordinator: Lynsey Osborn

Layout and Graphics: Stacie Brooks, Carl Byers, Laura Campbell, Alissa D. Ellet, Brooke Graczyk, Jennifer Mayberry, Brent Savage, Erin Zeltner

Proofreaders: Laura Albert, Melissa D. Buddendeck, Caitie Kelly

Indexer: Rebecca R. Plunkett

Publishing and Editorial for Consumer Dummies

 Diane Graves Steele, Vice President and Publisher, Consumer Dummies

 Joyce Pepple, Acquisitions Director, Consumer Dummies

 Kristin A. Cocks, Product Development Director, Consumer Dummies

 Michael Spring, Vice President and Publisher, Travel

 Kelly Regan, Editorial Director, Travel

Publishing for Technology Dummies

 Andy Cummings, Vice President and Publisher, Dummies Technology/General User

Composition Services

 Gerry Fahey, Vice President of Production Services

 Debbie Stailey, Director of Composition Services

Contents at a Glance

Table of Contents

Introduction

*O*il painting. The words themselves bring to mind centuries of art. From the masterpieces of the Renaissance to the charming landscapes that you see in a shop on vacation, the rich, glowing colors are fascinating. Oil painting makes it all look like magic. As an artist's material, it both attracts and intimidates with its possibilities. In this book we set out to introduce you to this enduring medium. We want to give you as much information as we can to make oil painting a part of your life.

Whether you're trying oils for the very first time or you're an experienced painter, this book walks you through the ins and outs of oil painting. We cover the basics, and we offer some information for those of you who have pursued this wonderful endeavor for some time.

We include as much information as we can — both in technical matters as well as how to see the world as an artist, as a painter. We know that there are many books on oil painting. What sets this book apart are the step-by-step projects that lead you to the fluent use of color in your paintings. We show you how to depict three-dimensional forms and create dramatic and powerful images. We also include a section that covers design in painting to guide you in the creation of innovative and original artwork. Design is a part of every painting, but we teach you how to hone your natural design instincts for more effective and creative compositions.

Oil paint is the queen of materials for artists. Painting is what you go to see at the museum; it's what you think of when you hear the word "artist." But oil painting, with its 500-year history, can be intimidating. We give you as much information as possible to get you off to a great start.

Writing this book follows very closely our philosophy as artists and teachers. We firmly believe that the best way to gain an appreciation for fine art is to share in the experience of art making. Learning to paint gives you firsthand experience into what it means to be an artist. You learn not only to paint but also to see the world as artists do. A whole world of painting will open up to you.

About This Book

It's not uncommon for people to teach themselves how to draw. You pick up a pencil and paper and go. But painting often seems like a mystery. Mixing colors, the oils and solvents, so many brushes — where do you start? You see programs on television, but the paintings all seem to come out looking the same. We designed this book with you in mind. Through the lessons in this book we teach you to paint the way YOU paint. We cover the basics of

honing your skills and lead you to develop new ones as you learn color, composition, and how to use oil paint.

Our book has an easy-to-follow format. After some basic lessons based on working from direct observation, you have a chance to create your own designs and approaches to making an oil painting. We try to include everything that you need to learn to paint and to continue to explore painting for years to come.

Our advice to you: Be patient with yourself, and give yourself room and time to experiment. And have fun. Our philosophy is simple. We believe that anyone can learn to paint. If you want it enough, if you can devote a bit of time (two to three hours a week) to this endeavor, and if you're motivated enough to buy the materials and set up an area to work, you can learn to paint.

Now, we'll be honest with you. You have to tolerate being a rookie for a while. You may have some lovely paintings right from the start, but expect to make some awkward, funny-looking paintings until you get the hang of it. But the rewards are great. When you're first learning to paint, every painting shows your increased knowledge.

Conventions Used in This Book

To help you navigate this book we set up a few conventions:

- We use *italics* for emphasis and to highlight new ideas and terms that we define within the reading.

- We use **boldface** text to indicate a set of numbered steps (you follow these steps for many of the projects). We also use boldface to highlight keywords or phrases in bulleted lists.

- The main painting projects in the book have their own project headings so that you can easily identify them as you flip through the chapters. Ancillary projects are flagged with the Try It icon.

- Every project tells you what you need, when you need it. Before you start any project, read all the way through the steps to make sure that you have the supplies you need.

What You're Not To Read

We wrote this book so that you can find information easily. We put absolutely everything that we could think of into this book and we believe that it's all essential information to help you learn to paint with oil. But you can skip over some material. Some info is more technical or describes a particular approach that may not apply to every situation. Feel free not to read the following:

✔ **Text in sidebars:** Sidebars (those gray-shaded text boxes) allow us to include every possible thing associated with oil painting. Although they include useful information, they aren't entirely necessary reading.

✔ **Anything with the Technical Stuff icon attached:** This information is interesting but not critical to your understanding of the topic at hand.

In addition, we know that you probably won't read this book in exact sequential order. In fact, for most of you, skipping over Part I completely and going to Part II first is the best way to proceed. This method gets you started painting right away. You can use Part I as a reference for any questions that you have about supplies, tools, your work area setup, and so on.

We want to believe that you'll soak up every word we wrote. But we know that much of it may be too arcane to absorb in the initial reading. We hope that you keep this info in mind as your skills develop and use our book as a resource in the future.

Foolish Assumptions

In writing this book, we made some assumptions about you, our dear reader:

✔ You have the desire to pursue fine art painting, creating your own images, and attempting to make the type of paintings that you see in a museum or in art history books, as opposed to using oil paint for craft applications.

✔ You've had experience with drawing, either self-taught or from lessons you received at some point in your life. We assume that you can look at something and draw a recognizable image of it.

✔ You may know little about art history, but you have an interest and an appreciation for what you have encountered.

✔ You know nothing about painting or you may have tried to figure out oil painting on your own and not made much progress. We assume that you may have tried to paint with oils on your own but are looking for direction.

This book is basic enough to help the rookie painter painlessly figure out the ins and outs of painting with oils. If you're nervous about your drawing skills, it's possible to learn to paint while you develop your drawing skills.

If, on the other hand, you know a bit about this topic already, you'll still find something challenging to pursue. We also include projects and approaches for the individual with more art experience. Check out the chapter headings to look for specific topics or painting projects to hone your skills. And if you have painted before, don't be surprised if you find some info in the basic lessons that fill in any gaps in your knowledge.

How This Book Is Organized

This book is set up intentionally to be user-friendly. We try to cover topics from buying supplies to step-by-step painting projects to developing paintings with creativity and originality. Each part focuses on a different piece of the painting process.

Part I: Getting Your Feet Wet in Oil Paint

In this section you find an overview of everything you need to get started, from buying the materials to setting up a place to work. We also cover the painting process and setting goals for learning to paint. We cover some of these things in more detail later in the book, but start here to get the big picture.

Part I isn't intended to be a step-by-step lesson; instead, it's more of a reference to get you started with your supplies, paintings, and all the physical things that you need to get in order to paint. If you want to start painting right away, you can start with Part II, but be sure to flip to Part I when you need to look up details.

Part II: Break Out the Brushes and Start Painting!

You really get down to painting in this part. If you're an absolute rookie, you'll find our step-by-step projects clear and straightforward. If you have some background in painting, you'll still find the information valuable. We include many things about oil painting that we've discovered in our years of painting, most of which weren't covered in our first painting classes.

We fill the chapters in this part with painting projects that we call *studies*. These quick, informal paintings focus on the use of a particular set of colors used in specific ways. They help you to build your knowledge and use of color, leading you to a greater degree of fluency in the use of color in your work.

Part III: People, Places, and Things

In this part we lead you through the main subjects of painting — the still life, the landscape, and the portrait. You learn to paint a variety of objects in the still life projects in Chapter 9; you discover several ways to tackle the most popular topic in painting, the landscape, in Chapter 10 when we cover trees, water, buildings, and depicting objects in the distance. It's a comprehensive chapter.

We also walk you though how to paint a portrait in Chapters 11 and 12. Within several projects, we show you how to proportion a face, the best angle for a portrait, how to mix accurate flesh tones, and more.

Part IV: Color and Design

Painting is all about self-expression and communicating ideas in a visual way. In Part IV, we help you begin to express your own ideas in painting by talking about how to plan your painting and get your ideas down on paper, and looking at ways you can use photographs as resources. We talk about good design and show you ways to avoid the mistakes beginners make. We show you how you can enhance your expressiveness by looking at ways that you can tie the way you compose your painting to your ideas. Finally, we give you all the tools you need to be an expert at using color in your painting.

Part V: The Part of Tens

This part covers what to do and where to go with your new interest. Check out these chapters if you want to build on your new skills and get some inspiration from other artists.

Icons Used in This Book

In the margins of almost every page of this book, you find icons. They serve the purpose of directing you to some particular types of information.

This icon saves you time and energy by letting you know an easier method for doing something, or telling you where to look to find more information on the topic we're discussing.

Important information is present whenever you see this icon. It serves to remind you that you need to remember this informative item for later.

Although the info in this book is user-friendly, sometimes we just have to supply some very important details about oil painting. This icon indicates some specialized information and may not be entirely necessary for the project at hand, so feel free to skip over these sections.

This icon tells you what not to do and why, and when to expect those bumps in the road. Its purpose is to save you time and energy — you have to learn some lessons yourself, but when you can, learn from the mistakes of generations of painters!

We use this icon to point out and define technical terms and other jargon that you may hear when you're immersed in the art world. Some of the terminology behind these icons even helps you to become literate in the language of art known in some circles as artspeak.

We use this icon to point out fun and informative exercises in the book. Try these exercises to really embrace the lessons and become a better painter.

Where to Go From Here

You don't have to go through this book in sequence. Part I is an overview of lots of practical information, and you can use it as a reference. If you're just starting out, we strongly encourage you to go through the projects in Part II, step by step. If you've been painting for a while, check out Part II for a refresher or to make sure that you know the basics. When you're ready for more of a challenge, head to Part III.

Part I

Getting Your Feet Wet in Oil Paint

In this part . . .

*W*e cover everything you need to know about how to get started painting, from buying the materials to putting your signature at the bottom. We also give you some projects to put your skills to use along the way. This section gives you a good overview of what it's like to paint. When you finish reading it, you'll feel much more confident about starting to paint.

We, your humble authors, believe in you. Our goal, more than anything, is to teach you how to paint and give you all the information and support that you need as you progress. Whether you're starting a pleasant pastime, picking up where you left off years ago, or beginning a serious pursuit of painting, this is the place to begin.

Chapter 1

So You Want to Paint

There you are, standing in front of a painting in a museum or gallery or art fair, and you have the desire to create a work of art. You may have had this feeling for quite some time but you don't know where to start. Or maybe you've had lessons or a class in the past and it just didn't work out. We know that for many people, learning how to paint is a lifelong goal. And we firmly believe in your ability to reach that goal.

To make a painting or other work of art is to become a part of the cultural expression of your society. It is to create something personal, something of beauty or significance that is your vision alone. We also know that for many people, learning to make art is the best way to gain a true appreciation for the arts. During this process you learn not only to paint but also to see the world around you with an acute sense of perception. You grow to understand the working process of painting and are able to see its evidence right on the surface of a canvas.

If you've decided to learn to paint and you don't know where to begin, we can help. In this initial chapter, we give you an overview of this book and walk you through the process of learning to paint, step by step. We try to make the process understandable, painless, and fun. Collectively, we have more years of experience than we care to admit, and we know that with patience, we can open up this world to you. We're unabashed promoters for learning to make art and we're very excited to have this opportunity to work with you in this process. Take a few minutes to look over this chapter before you go running off to the art supply store. And get ready for an enjoyable experience.

What It's Like to Paint with Oils

Oil paint is made up of *pigment,* the stuff that gives the paint its color, and *oil,* which allows it to flow off the brush well and to dry in a slow and measured way. The oil in the paint is usually linseed oil, which dries slowly, but it does

dry (unlike mineral oils, which never thoroughly dry). Oil paint dries through chemical action, as opposed to the process of evaporation in water-based liquids. You need to understand this process in order to utilize all the properties of the oil paint to their best advantage.

The great thing about oil paint is that it's creamy and dries slowly so that you have time to paint an image. You can experiment with brushstrokes, blending new colors, and expressing yourself with a wonderful art medium.

Please be aware that oil paint does have an odor. The smell of oil paint isn't acrid; it's more of a nutty scent. After you've been painting for a while and you set up your own studio, the smell of linseed oil when you open the door to your studio in the morning can be very welcoming, but some people can have an allergic reaction or otherwise find it undesirable.

If you suspect that you may have a negative reaction, purchase a tube of inexpensive color and test it. Find an inexpensive color, such as yellow ochre, and take it home. Open the tube, squeeze a dime-sized pool of paint onto a paper plate, and leave it nearby while you watch TV or do another quiet activity. If your eyes become irritated and you wear contacts, try not wearing them while you try the oil paint and be sure to have ventilation in your work area. Some people have a reaction on their skin from the paint; if this is the case, you can use latex gloves.

Also be sure to test the solvent used with oil paint. Purchase a bottle of Gamsol and put it to the same test. If the smell of the solvent is the problem, you can try water-mixable paints such as Max oil paints made by Grumbacker (there are other brands as well). If the oil paint itself bothers you, you may want to try a water-based acrylic paint instead.

Gathering Your Materials

You need to know a few things about oil paints before you buy your paints and supplies, so be sure to familiarize yourself with their general characteristics before firing up your charge card. In this book, we get you started with standard oil paints, but as you shop, you run into odd versions of oil paints, such as the fast-drying alkyd paints or water-mixable oil paints. When you have more experience, experiment with these kinds of oils, but for now, stick with the more-traditional materials.

Some major brands are Daler-Rowney Georgian, Gamblin's Sketching Oils, Winsor Newton's Winton series, Grumbacker's Academy colors, and Shiva. These brands are all student grade or inexpensive colors and are perfect for the projects in this book. The paints we use in this book are a mix of these manufacturers. Purchase tubes based on price, available colors, and the sizes of the tubes available. The exact list of colors that you need is in Chapter 3.

In addition to the paints themselves, you need other equipment and supplies. Here's a quick overview:

✔ Solvent (use Turpenoid or Gamsol)

✔ Brushes

✔ A palette and palette knife

✔ Canvases to paint on

✔ An easel or something to support your painting while you work

Other useful items include a paint box for storing and carrying your supplies, jars for your solvent, and special easels for outdoor painting. A complete starter list of colors and all supplies is discussed in detail in Chapter 3.

Finding a Space to Paint

An important factor that you need to consider is where exactly you're going to get your painting done. Here's what we advise:

✔ You need a space that's approximately 8 x 8 feet. This minimal space does well for the small painting projects that we lead you through in this book.

✔ Be sure to have good lighting, cleanable floor surfaces, and tabletops (in case of spills).

If you're working in a room with carpet, a plastic mat designed for home offices works very well. Many artists get started by creating a studio in a garage, a screened-in porch, or a utility room. A table, chair, and some inexpensive clamp lights or lamps can nicely transform a basement room into your own studio.

Safety issues

The first thing we want to stress is that oil paint is an art material for adults, *not children.*

Oil paints are quite safe to use, but you must be able to take safety seriously in order to have an enjoyable experience and protect your health. You need to be aware of two areas of concern: air quality and exposure to the skin.

Some oil paints contain toxic elements that your skin can absorb, so you must handle them with safety in mind. Wearing disposable latex gloves is always a good idea. If you're allergic to latex, try some of the similar alternatives or barrier cream. You can obtain appropriate gloves at any hardware store.

Ventilation is the first thing to consider for the area that you're going to work in. If you have windows that open and a fan to move the air out of your studio area and living space, you can work comfortably. Paying attention to good ventilation means that you aren't exposing yourself and your family to annoying and potentially harmful odors from solvent vapors. You can also limit your exposure if you habitually work with low-odor solvents like Turpenoid and Gamsol.

To avoid fire hazards and protect the environment, properly handle and dispose of solvents and solvent-soaked rags. You have many options for the safe use and disposal of your discarded art materials. Call your local fire department for specific instructions for your area to find out how to safely dispose of solvents and other hazardous wastes. For more tips and ways you can recycle your materials, refer to Chapter 3.

Also remember to maintain good studio habits. Cleaning up as you go, keeping the paint off your skin, refraining from eating while you paint, and painting with your brushes — not your fingers — makes oil painting a safe pursuit for you.

Painting in shared spaces

If you have children in the area where you paint, take precautions to make sure that the materials are safely used and put away when you're not there.

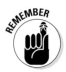

We can't stress enough that good ventilation is critical — especially if children are around. Be sure that you're using low-odor solvents and keep the air moving *out* of the room. Solvent vapors are heavier than the air in a room, so they fall toward the floor. Children playing on the floor are therefore exposed to the vapors more than you are.

Children love to paint too, so avoid tempting them by storing your paints and supplies in locked cabinets above their reach, just as you would your kitchen and bathroom cleaners. Store wet canvases well above their reach as well. If they're old enough, distract them with a supply of age-appropriate art materials of their own.

Oil paints can also be a danger to pets. Set up a system to put your materials and your wet paintings out of reach.

If good ventilation isn't possible, you don't have to give up on the idea of oil painting. You can find several lines of high-quality water-mixable oils that have nearly all the qualities of standard oil paints. Many artists who can't tolerate working with standard oils and solvents use them with great results. You can follow all the lessons in this book with water-mixable oils.

Keep all oil paint materials out of the way of anyone or anything that may be harmed by touching, tasting, or smelling them. Be sure to handle and dispose of solvents and used rags safely to avoid fire hazards and to protect the environment. Oil painting is safe as long as you're aware of how to properly handle and care for your materials and paintings.

Starting Your Painting Adventure

To get started, you need to find an art materials supplier. If you live in a city, paints and other materials are likely available from many suppliers in your area, and you may be lucky enough to have a couple of well-stocked art supply stores that cater to the specific needs of artists. Not every town is big

enough to support an art supply store, though, but hobby shops, craft and fabric stores, and even "big box" discount stores often carry a selection of oil painting materials.

You can find good sources for materials online as well, and sometimes the discounts are very good. Many of these suppliers had well-known, mail-order businesses before going online and carry a vast selection of art materials. Checking out these suppliers is worth your while, even if you don't like to buy online, because they often provide information to help you make your selection of materials.

Of course, in terms of helpful guidance, nothing beats a local art supply store that's owned or staffed by artists. A face-to-face discussion with a live human being can be well worth the slightly higher price.

Shop around. Online prices can be very seductive, so be sure to factor in the shipping charges as you compare online prices with those of your local sources.

We encourage you to explore different options for suppliers, but we advise you to stick to the materials list in Chapter 3 to make sure that you get the right supplies. We price out the basic set of materials that you need to get started at $90 to $100. This initial investment sets you up with the materials that you need for a long time. For the first few months, canvas should be the only material that you use up. You may have to purchase another tube of paint from time to time, but for the most part, the materials should last quite some time.

Chapter 3 outlines how to save money on your supplies, but you want to be sure to get good-quality materials to make your artistic work enjoyable. Poor-quality paints and brushes cause frustration and disappointing results.

Getting yourself organized to paint

Consider how much time, space, and funds you need to get started and what you're willing to commit to this endeavor. You can skimp on space and money, but to improve, you need to make a consistent investment of time.

We suggest that you set aside two to three hours a week for a period of eight to ten weeks in order to get a good start. That allows you to move smoothly though the painting projects in this book, have enough time to enjoy the work that you do, and develop some solid skills.

You need space to paint as well; we outline that info earlier in this chapter so that you can consider your options. Also read over the section in Chapter 6 on setting up your workspace to paint.

The initial cash investment can be expensive. The budget that we suggest for a solid supply list can give you a lot of flexibility, but don't let lack of money discourage you from painting. Remember that you can build your set of paints in stages by buying only what you need for each set of assignments. There's no harm in spending a few months making black and white paintings. You can call it your Gray Period!

Another important organizational skill is to take good care of your equipment and supplies. Put the lids back on your tubes, clean your brushes and other tools, and tidy your area to save time and money for your hobby.

Understanding the painting process

Before you begin painting, spend a bit of time looking over the basics of the painting process. You'll be working in a manner that artists refer to as *general to specific.* This means that you lay out the basic shapes and colors of the overall image before diving into the details. Painting in layers is one of the main attributes of oil painting. The how-to section that covers applying paint to canvas is good to read as well (see Chapter 6). And finally, proper cleanup and storage of your equipment means that you can get started again quickly and your materials will last a long time.

Developing the discipline to enhance your skills

Many people believe that artistic ability is based solely on talent — an inherent quality that you're born with. This isn't the case. Some people do have a keen interest in art that leads them to naturally devote time to developing their skills even when they're quite young. But at any point in your life you can discover and choose to develop your artistic skill. Art is a discipline and requires practice in order to increase skills and develop understanding and the ability to express yourself artistically.

Some important parts of this process are having goals for what you want to achieve with your painting and working toward those goals in stages. Don't be discouraged by those lovely 30-minute paintings that you see on TV. That kind of painting is primarily about learning clever techniques — which you can also learn — but bringing out the true painter in you takes patience.

Tolerate being a rookie for a while. You'll enjoy the process and create some nice pieces if you can relax and take it step by step. Learning to paint is like learning a new language, sport, or how to cook; you have to start with the basics and then work up to the special techniques. In painting, simple subjects allow you to get used to the materials and build your skills so that you can go on to more-complex subjects. At any point in the learning process you can stop and repeat a project, using different colors or objects to work from. Practice is important for any artistic pursuit, and honing your skills allows you to successfully go on to more-demanding subjects, such as landscapes and people.

Setting aside time to paint

As with any discipline, setting aside time to develop your skills is important. Decide how much time you can devote to your painting, and then make a schedule and stick to it. A two-hour session once or twice a week is good. This is your time — don't allow anything to interfere with your work. If you can't actually work on a painting, go to the library and check out some books on art or go to a gallery or museum.

Set realistic goals for your work. Your first painting may look a little simple, but remember to be patient. This book starts with simple paintings and works through to more-complex subjects. At every point, we outline how to evaluate each project or painting and how to gauge your progress. You must tolerate being a rookie. Pay attention to the basic goals for each project and you'll be rewarded.

Developing Painting Skills

One common question is whether you need to learn to draw first. Drawing skills are useful for painting, but you don't have to have training in drawing before you start to paint. If you're self-taught in drawing and you think you can make a reasonable image of something, you can start painting. If you can draw something that you see from real life (as opposed to working from photos or other artwork) and other people can recognize what it is, you're fine. Throughout this book, we give you tips to help you with the drawing process while you're leaning to paint.

The process of beginning a painting is to sketch in the various parts in a wash first, and then apply paint to block in the major light and dark areas. The next step is to make refinements to the colors and shapes. You can see this process in the painting in Figure 1-1, which is a great example of an oil painting done in layers. You start with a thin layer and gradually use more paint, letting colors in the lower layers peek through.

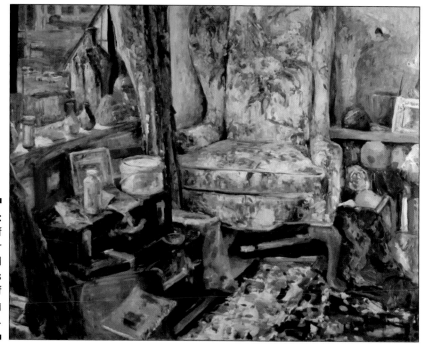

Figure 1-1:
A painting of an interior showing all the various stages of the painting process.

The following steps outline the basic process of painting with oils:

1. **Start with a simple sketch.**

 Your initial marks on a canvas make up the drawing in a *wash,* a thin, fast-drying mixture of paint and solvent that's easy to correct. During this stage of the painting, you can make changes to your drawing of the individual objects very easily. Each change in your sketch goes over the last until you have the proper sizes and placement of all elements on your canvas. Don't ever try to erase or to clean marks off with solvent; it only makes a mess. Just wait until it dries a bit and paint over the area.

2. **Plan your design.**

 After you sketch the image on the canvas with your wash, you can see the overall effect and predict how the painting will turn out. This all happens in the first 20 to 30 minutes of the painting. Our painting projects lead you through the assessment of your efforts and guide you on how to tell whether you have a good, solid design for your painting. At this early stage you can still make changes in the layout of the image and improve the overall design of the elements.

3. **Apply the major colors.**

 After you have a good drawing and a solid design, you can start to block in the major colors. Apply the appropriate color to each form on your painting while making adjustments to the forms as you go. As you apply the color to each form on your canvas, it takes on a more fleshed out and substantial appearance. You also apply these colors in a thin mixture of paint and solvent.

4. **Work in layers.**

 At this point you have the basic colors — the lights and darks — blocked in. Start to apply a heavier layer of paint to each of the forms. This layer may be exactly the same color as the first layer, or you may make subtle adjustments to the color, allowing the differences to peek through and add complexity to your painting. The painting process is fun and relaxing as you develop your painting layer by layer. We walk you though this process in detail in the first painting projects. In later projects, we introduce ways to make these layers work for you to create beautiful effects.

Chapter 2

Getting to Know Your Oils

*W*hen you arrive at the art supply store or when you shop online, you encounter a vast collection of paints, solvents, varnishes, and the like. You see displays with paint sets, individual tubes, and jars of goodness-knows-what. This chapter covers the basic characteristics of oils and related materials, including solvents, mediums, and other additives, and how to work with them. Knowing what your paint is made of and how to use it allows you to work with oil like a pro.

For the most part, the information we present here is for the beginner. But, we know that you encounter a number of mystifying materials at the art supply store; therefore, we also include some other, more-complex, materials. Becoming familiar with all the different types of materials is important, whether you're a beginner or an advanced painter. When you know a material's purpose, you know whether it will be of any real use to you.

The Basics about Oils

Oil paint developed in the early 15th century in northern Europe. Up until that time, artists primarily used *tempera,* an egg-yolk-based paint, for their paintings. Artists who were using egg tempera added linseed oil to it to make the colors transparent. And thus discovered oil paint.

This discovery was a great leap forward for artists. The linseed oil allowed for a buildup of transparent layers of paint to create subtle and glowing colors. Oil paint has been the epitome of painting ever since.

The main ingredients: Pigments and binder

The paint that you purchase in the store is a blend of *pigment* — the material that gives paint its color — and *binder,* which "glues" the pigment to the support. In the case of oil paint, the binder is linseed oil. When you buy a tube of

paint, the proportion of pigment to binder, the quality of the pigments used, and the way these two substances are mixed together determine the quality of the paint.

You have the benefit of centuries of experimentation at your disposal. You have so many grades, colors, and types of paint to pick from, and almost all are top-quality paints. In years past, artists were subject to unstable paints that changed color over time, as well as some very toxic pigments! The popularity of oil painting and the good work of the American Society for Testing and Materials (ASTM) have provided you with the assurance that your paints are tested and safe.

Some toxic colors are still available. They have unique qualities that can't be perfectly substituted with safer materials. Artists who use materials such as lead white or Naples yellow must be aware of the dangers of the materials and take precautions. You have no reason to expose yourself to toxic materials to pursue oil painting. Oil paint is safe and easy to work with if you always look for the seal of the ASTM on the tubes of paint that you purchase and if you handle the paint in the appropriate manner. The ASTM D 4236 seal assures you that the product is properly labeled for health hazards. You can also take precautions as you work. No matter what you see Van Gogh do in a movie, don't eat your paint.

Here are some precautions to take as you work with oil paints:

✔ Don't eat anything while you're painting.

✔ Don't drink anything while you're painting.

✔ Don't smoke while you're painting.

✔ Use adequate ventilation.

✔ Never sand an oil painting; the dust particles from the pigments are particularly dangerous.

✔ Don't paint with your fingers.

The first three activities in this list may seem harmless to you, but they all increase the chances of paint accidentally getting into your mouth.

The difference between the cheap and the expensive stuff

One of the types of paint that you see when you make your first purchase is student-grade paints. Student-grade paints have a higher proportion of oil to pigment than professional- or artist-grade paints. The cost is lower, which allows you to do some serious experimentation without worrying that your tube of paint costs as much as a dinner at a nice restaurant!

Some manufacturers may add fillers to the paints, especially student-grade paints. These fillers shouldn't affect the way the paint behaves as you use it. Fillers aren't necessarily a bad thing. They're also used for pigments that

have tremendous tinting strength to make the paint more workable for the artist. Fillers primarily affect the brilliance of the paint, but you generally don't notice it until you have more experience with color or until you compare swatches of the student and professional grades side by side.

Another way that the manufacturer can make inexpensive student-grade paints is to use substitute pigments. These colors have the word "hue" in the pigment name. Some examples of hue colors are cadmium red light hue and cerulean hue. These colors are identical to the originals in hue, but they may not be quite as bright or opaque. Until you work with the original and the substitute, you may not notice the difference.

You may also see colors such as Naples yellow hue and lead white hue, which manufacturers made because the original versions are highly toxic. Again, the hues behave in much the same way as the originals with regard to tinting strength, opacity (hiding power), and so forth. Their color is almost impossible to detect as a substitute unless you're an expert.

Occasionally when you first open a new tube of paint, a lot of oil comes out of the tube, separated from the pigment. This is just linseed oil that has settled out of the paint. Put the lid back on and knead the tube just a little to mix the paint and oil back together again. If a lot of oil comes out of the tube, it's up to you whether to use it or take it back to the store.

Student-grade is great when you're just starting out. You can go through as much of the cheap stuff as you like and switch to the better pigments and grades after you hone your skills.

How oil paints behave

Oil paint has a creamy, smooth consistency right out of the tube. Sometimes the paint is denser in consistency — titanium white is one example — but you can use most paints right out of the tube. For ease of use and creating thin layers, use a combination of solvent and medium to modify the paint. The solvent dilutes the paint, and the medium adds oil back into the paint to achieve a creamy consistency and bind the pigment particles.

You're likely to notice how slowly your paint is drying. The drying time for a color varies depending on how thick the paint is, how much solvent you used, and how much medium you added. You can also adjust the drying time by using substances specially made to decrease the drying time of your paints.

The slow drying time of oil takes some getting used to. Keep in mind that the slow drying time ensures that your painting is curing properly. Oil paint doesn't dry the way that most people think of things drying, by evaporation of liquid. Oil paint dries through the chemical process of curing. The paint develops a skin of dry surface initially, but the paint itself takes quite some time — maybe months — to dry completely. The process of curing also creates a hard film of dried linseed oil on the surface of the painting. This protects the painting and ensures that it will last for many, many years.

Taking care of your paint

Here are some tips on caring for your tubes of paint:

- ✔ If a tube springs a leak along its side, you can save it by wrapping it in heavy-duty aluminum foil. When you're making such a mess with it that you want to pitch the whole thing, go get a new tube.

- ✔ If you have lost or broken caps, you can again use foil to keep the paint from setting up in the tube. In the end, you may have to throw it away. Whenever you discard a tube of paint, keep the cap for these types of problems.

- ✔ Keep the openings of the tubes clean. Wipe them off with a paper towel to keep hard, dried paint from gumming up the threads of the screw top. Clean out the lid in the same way so that it fits back on tightly. Keep a set of pliers in your paint box for paint tubes that are difficult to open. That should keep you from twisting the tube so much that the tube breaks from the stress.

- ✔ One last thing, and maybe it goes without saying: Never use your teeth to open a tube of paint!

The Characteristics of Pigments

Some manufacturers give you a lot of information on the tube. You may be able to see what the pigment is, what type of oil is used to prepare the paint, and whether the color is transparent or opaque — all very useful! But what does all this information mean to you? Read on for a rundown of the topics that you may see listed on the tube, on a display at the store, or in the suppliers' brochures.

The first thing you see is the name of the paint. Some names are classics, such as cadmium or ultramarine, while others are specific to a brand or are odd mixtures of several other colors. It can get confusing. Monostral blue is also known as phthalo blue, thalo blue, or phthalocyanine blue. (Oh, and they're pronounced the way they're spelled.) Sometimes colors vary from one manufacturer to the other. Cadmium red light is one example; it can look very orange in some brands and bright red in others.

You can also see other qualities of the paint. These include the texture of the paint when you're working with it, whether it's coarse and gritty or very fine. You see some qualities, such as the gloss of transparent colors and the dull look of opaque colors, as the paint dries. Some of these qualities are an asset to the finished painting. Some may need to be adjusted by applying the paint differently or by adding different types of substances to paint.

Is it opaque or transparent?

One of the first qualities that you notice when you start working with your paints is that some of them seem to need lots of coats in order to cover the canvas, and others have a lot of hiding power. In this case, you're seeing the

quality of transparency versus opacity. To find out which is which for a particular paint, read the labels or check out the chart in Figure 2-1 or at the store. Or you can just test it yourself.

The degree of transparency or opacity is important because one of the chief features of oil paint is the ability to work in transparent layers. Of the many transparent pigments, you can find opaque and transparent versions of just about any color that you want. Working transparently means that you can create depth and complexity to the colors that you put in your painting. Table 2-1 is a transparency chart that shows most of the paint that you'll encounter.

Table 2-1	Transparency Chart for Oil Paints
Opaque	*Semi-Opaque*
Titanium White	Lamp Black
Yellow Ochre	Burnt Umber
Cerulean Blue	Raw Umber
Cobalt Green, Blue, Violet	Hansa Yellow
Cadmium Yellow, Orange, Red	Zinc White
Raw Sienna	
Permanent Green Light	
Mars Black	
Venetian Red	
Semi-Transparent	*Transparent*
Ivory Black	Phthalocynine Blue and Green
Prussian Blue	Rose Madder
Ultramarine Blue	Manganese Blue
Viridian	Dioxazine Purple
Aureolin Yellow	Golden Ochre
Burnt Sienna	Alizarin Crimson

Just about all sources agree on whether a color is transparent or opaque. But it *can* be a judgment call as to whether a pigment is only partially transparent. You can find conflicting information depending on the manufacturer or the book you consult. In the end you have to decide how the paint works for you. Here's a project to examine this quality.

Figure 2-1:
Painting in two layers of color as opposed to using a mixture of two colors.

Project: Painting in layers

The nature of painting dictates that two colors mixed together don't look the same as they do when they're applied in two separate overlapping layers. This project demonstrates how colors look when they're applied in layers as opposed to mixtures of two colors. See Figure 2-1 for an illustration of this project, and follow these steps:

1. **Use a #4 and/or a #6 flat or bright paintbrush to mix a quarter-sized pool of cadmium yellow with solvent until it's the consistency of Kool-aid; apply it to one side of your canvas paper or paper primed with gesso.**

 Don't cover more than half the canvas.

2. **Clean your brushes, and then wait a day or two until the yellow is completely dry.**

 The paint dries this quickly because of the amount of solvent and because you applied it in a thin layer. See Chapter 3 for details on brush cleaning.

3. **Use the same techniques you use in Step 1 to mix a quarter-sized pool of cadmium red light with solvent.**

4. **Apply the red mixture over the yellow.**

5. **If the red covers the yellow too completely and just looks *red,* wipe some of the red away with dry paper towel.**

 You can see the yellow under the red. Looks like a sunset, eh?

6. **For the second half of the experiment, make a mixture of the cadmium yellow light and the cadmium red light; apply this mixture to the other half of the canvas.**

 Try to have as much yellow in the color as red. You can try different proportions of red or yellow, thick or thin, but it just won't look like your first experiment of layered colors. On the first side you can see both the

yellow and the red at the same time. The color is orange but you can see the layers. On the second side the colors look solid orange without the layers. We expand on this idea in Chapter 8 when we talk about all the different ways to apply paint to canvas.

Tinting strengths

Most of the paint displays and brochures show the colors of the paint so that you can select the color that you need. The swatch of color shows the paint as it comes from the tube as well as a lighter version of the color. The lighter version is the color mixed with white, usually on a one-to-one ratio — this is the paint's *tinting strength.*

If you have a color with a high tinting strength, test it before you use it in quantity. Some colors have such a tremendous tinting strength that they get in your way and hamper your work. When working with these strong colors, start gradually, adding a small amount at a time to another color.

Phthalocyanine green is notorious for its tremendous tinting strength. Coauthor Anita Giddings used it on a painting while in college. Everything on the canvas turned the color of blue-green Tupperware: green buildings, green streets, green sky. The professor took the tube away and forbade her to ever use it again.

Project: Studying your paint

Painters and printmakers use a process to study their paints and inks. You can easily use the same process. You do these studies on index cards, so you need at least one for every tube of paint you have.

1. **Set out your paints, palette, palette knife, solvent, and paper towels.**

2. **Set a plain index card vertically, and write the name of a color at the top.**

 Leave room below the name for the three color samples you will apply to the card.

3. **Squeeze a small dot of that color to one side near the top of the card under the written name.**

4. **Use your palette knife like a squeegee to scrape the paint as thinly as you can down the length of the card.**

 This is called a *draw down.*

5. **Beside the draw down at the top, paint a spot of color straight from the tube.**

6. **Mix equal parts of your color and white and paint a spot of the color next to the spot of tube color.**

7. **Look closely at the color of the draw down to determine whether the color is transparent, opaque, or semi-transparent; write the result on the card.**

If you see a lot of white paper showing through the paint, the color is transparent. If you don't, it's opaque. It could also be in between, or semi-transparent. Write what you see on the card anywhere.

8. **Compare the color of the draw down to the painted color from the tube to determine its undertone; write "no undertone," "undertone is warmer," or "undertone is cooler" on the card as appropriate.**

 Some — but not all — colors have *undertones.* The thinned color of the draw down will look warmer or cooler than the painted color. For example, alizarin crimson has a warm undertone. The color of the draw down looks more orange than the color of the *body* or *mass* of the paint. If the color of the draw down and painted color match, the color has no undertone.

9. **Determine the tinting strength of your color by comparing the color of the tube with the spot of color you mixed with white; write this info on your card.**

 If the spot of color you mixed with white is only slightly lighter than the color from the tube, your pigment is very strong and has a *high tinting strength*. If the white changed it significantly, your color has a *low tinting strength*.

Repeat this with each of your colors. Just doing this exercise will help you learn the properties of each color. You can continue this experiment with any new color you purchase as well.

The drying speeds of pigments

Oil paints by their nature are slow drying. This attribute is an asset to the artist because it allows you to make subtle changes in your work, gradually modifying the color or texture or apparent brushstrokes. Of course, it can also make for some frustrating messes while you get used to it.

Different colors also vary as to the time that it takes to dry. Table 2-2 is a list of paints and their relative drying speeds.

Table 2-2	Drying Speed Chart for Oil Paints and Oil Media
Rapid Dryers	*Average Dryers*
Flake White	Raw Sienna
Raw Umber	Mars Colors
Burnt Umber	Chromium Oxide
Cobalt Green, Blue, Violet	Zinc Yellow
Manganese Blue	Phthalocynine Blue and Green
Prussian Blue	Strontium Yellow
Naples Yellow	Viridian Green

Rapid Dryers	*Average Dryers*
Aureolion (Cobalt) Yellow	Quinacridone Red and Violet
Venetian Red	Ultramarine Violet
Indian Red	
Slower Dryers	*Slowest Dryers*
Earth Colors	Ivory
Cadmium Colors	Lamp
Cerulean Blue	Van Dyke Brown
Vermilion	Emerald
Ultramarine Blue	
Hansa Yellow	
Zinc White	
Titanium	
Ochre	
Permanent Green	
Alizarin Crimson	

Try to be patient while you get used to the drying time of oil paints. If this quality is really making you nuts, you can use drying mediums (we describe them in the upcoming section "Mediums: Standard, glazing, drying, impasto, and alkyd"). These mediums decrease the drying time for your oil paint to days rather than weeks.

Remember that the slow drying time of oil paints is a normal characteristic and is a part of the chemical curing action of the oils. If you work with your paints in a normal way, they should dry to the touch in a few days.

Be careful about rushing the drying time of oil paint. Don't try to speed the drying by using heat or directing forced air on the painting. Not only is it bad for the painting, but you may also burn your house down.

Adding Other Materials to Your Oil Paint

You can use oil paints right out of the tube, but the consistency is stiff. Paint can have so much body that it feels like you're painting with ice-cold butter. Adding other materials to the paint — either to dilute the paint or to thin the body of the paint by adding more oil — increases the variety of ways that you can work with it.

So, aside from the actual paint that you work with, you also use a liquid to help mix the paint, thin it, and improve the overall flow of the paint from the brush onto the canvas. Read on to find out what to add when.

Working fat over lean

Because of the way oil paint dries, you have to apply it in layers that don't interfere with the curing action of the paints. You can paint in a manner called *alla prima,* a fancy Italian term meaning a painting that's done all in one sitting. If you intend to work on the painting for a longer period of time, however, you must use the *fat-over-lean* method.

Working *fat over lean* means that you start the painting with a lean mixture of paint and solvent. You use only solvent as a wetting solution. Then, for the next layer of paint, you change to a mixture that uses a combination of solvent and linseed oil. For the last layers, you use the fattiest mixture, using more of the linseed oil to paint with.

What happens if you put a lean mixture of mostly solvent over a fatty layer of paint mixed with a lot of linseed oil? It doesn't work well. You may achieve a nice effect initially, but later, when you look at the painting, you see a whitish haze on the surface. This is called *blooming,* and it can't be removed.

Another problem that can happen if you ignore the fat-over-lean rule is cracking and crazing (also called alligatoring). A painting that cures unevenly will crack and age prematurely.

Solvents

Turpentine is the traditional liquid that artists use to dilute oil paint, mix painting mediums, and clean brushes. It has been the standard for centuries. Unfortunately, most of the noxious smell associated with oil paint comes from this liquid.

In place of traditional turpentine, we recommend that you use one of two brands of odorless mineral spirits as a solvent: Gamsol or Turpenoid. These two products are inexpensive and available in a convenient size (16 ounces is good). They're available just about everywhere:

- **Turpenoid mineral spirits** has been around for many years and may be more widely available than Gamsol. It's practically odorless, and you can use it to make washes, mix with oils, or clean brushes. Be sure to buy regular Turpenoid, not Turpenoid Natural, which has a stronger smell.

- **Gamsol mineral spirits** is made by Gamblin and has the least smell. You can use it, too, to make a wash and to mix with oils and resins to make a painting medium. It also cleans your brushes at the end of the day.

We strongly advise you ***not*** to use regular turpentine or mineral spirits that are available at a hardware store. These are stinky, stinky substances and they aren't appropriate for oil painting on canvas.

Getting the solvent can open

Opening a can of Turpenoid or Gamsol can make you a little crazy. The manufacturer puts a metal lid inside the screw top to keep the cans from leaking in the transit. The problem is getting it out. One way is to pry up the edge of the

metal plug and use needle-nosed pliers to pull it out. You may need an old butter knife or painting knife to pry up the edge. You can also try to punch a hole in the lid and then use your needle-nosed pliers to pull it out.

If you use an awl to punch two holes through the interior lid insert, you can avoid removing the insert. Punch one hole for pouring, and punch the other above it to allow air into the can so that the solvent can flow. You can pour only small streams, but you shouldn't need more than that.

Be patient, don't get in a hurry, and have paper towels on hand for spills.

Working with solvents as you paint

Keep your solvent in two jars as you paint. Use one jar of solvent as a wetting solution to dilute the paint in the early stages of the painting. Use the other for cleaning your brushes as you work and at the end of the day before you clean them with soap and water. Using two separate jars prevents the unintentional mixing of colors.

Never leave your brushes standing in a jar of solvent. The bristles warp and the glue holding the bristles in the brush deteriorates. You have no need to keep your brushes in solvent — the paint on your brushes stays wet for hours. Letting your brushes sit in solvent ruins your brushes very quickly. Keep your brushes out of that jar of solvent!

Oil paint that you dilute with solvent dries very quickly, depending on how much paint you use and the pigments (drying times vary with each color). This quick-dry tendency allows you to create a quick oil sketch that you can correct or use as an underpainting for the final painting. Sometimes you're happy with this quick sketch — it looks something like a watercolor painting. The effect may be pleasing, but the painting isn't stable. The solvent dissolves the binder, the linseed oil in the paints, to such a degree that the pigments don't stay on the canvas. You can brush them off like dust. So you have to add another layer of paint with oil in it for the painting to be complete.

Be sure that your canvas is properly prepared and primed. Painting with a wash of odorless mineral spirits on a faulty canvas causes the oil paint to soak through the canvas. Oil on raw canvas eventually rots.

Being safe with your solvents

Never use any solvent to clean your skin. Use soap and water only. If you have a lot of paint on your skin, use baby oil to clean it. All solvent, whether turpentine or odorless mineral spirits, works as a degreaser to your skin. It removes the natural oils of your skin; those oils function as a barrier to the harmful elements in paint and solvent. The solvents are also very toxic themselves. They can be absorbed through the skin and cause serious health problems.

You can apply a number of effective barrier creams to your hands before painting. Not only do they prevent the absorption of toxic substances, but they also make your hands easy to clean.

Putting your old solvent to good use

After your solvent is completely dirty, you may wonder how to dispose of it. This method is the most environmentally friendly: Don't dispose of it at all.

If it gets too dirty to use, put a lid on the jar and set it aside in your painting area. After a few weeks, the paint solids settle out of the solvent. Then you can decant the clear solvent into another jar to use for painting. Some artists actually like this substance. It contains a bit of the dissolved linseed oil from the paints and has a creamier consistency than straight solvent. If you don't want to paint with it, you can use it to clean your brushes in your cleaning solvent jar. Put the lid back on the jar that originally held the solvent, and then you can dispose of the sludge as you would dispose of old house paint. Contact your local Household Hazardous Waste disposal service for more information.

Mediums: Standard, glazing, drying, impasto, and alkyd

A painting medium is an oily liquid that you use to adjust the body of the oil paint. It can thin the paint, make it dry faster or slower, or make the paint transparent or matte in appearance. It can even thicken the paint to the consistency of cake icing! The most common type of medium for oil paint is what the paint already has in it — linseed oil. The following premade mediums are commonly available:

- **Standard:** A *standard medium* is a mixture of materials, usually turpentine, linseed or other oils, and a resin. Each of these materials adds a characteristic to the medium, whether it's to aid in the drying, to provide a durable finish, or to keep the painting flexible on the canvas. You can find various types of mediums in stores from the same suppliers that make your paints.

- **Drying:** Some mediums speed drying of the painting; sometimes the painting will dry overnight. These mediums have the addition of *driers* that are tested for stability of the finished painting. Use care when you use these mediums. If a painting dries too rapidly, it may crack or develop fine hairline cracks over time.

- **Glazing:** You can use a *glazing medium* to create transparent layers of color. The mixture is also fast drying to allow repeated buildup of layers of glaze. You can apply a glaze to a painting in several ways. We describe them in Chapter 8.

- **Impasto:** *Impasto* is a way of painting in thick layers. You can apply the paint itself in a thick manner or you can use an impasto medium or gel. Add the impasto medium to the paint on your palette to create a thick, buttery mixture. Impasto mediums use either natural or synthetic oils and resins to give the paint a thick body.

- **Alkyds:** Several companies make painting mediums with synthetic resins known as *alkyds*. These mediums are very fast drying. Mediums made with alkyd synthetic resins were invented in the last 50 years and now come in a variety of consistencies from thin to thick impasto mixtures.

Special oils

The standard oil that's used as a binder or to mix oil paints is linseed oil. It's the best choice because of cost, stability, and ease of use. But it does have its drawbacks. Linseed oil yellows and darkens with age and dries too quickly with some fast-drying pigments. In this case, the pigments are mixed with saf-flower or poppy seed oil by the manufacturer. Take a look at the label of your titanium white; it may use one of these two oils.

You can use safflower or poppy seed for any work that you want to remain wet. Here's a list of other oils and their characteristics:

✔ **Stand oil:** A polymerized linseed oil that yellows less than untreated lin-seed oil; slow drying

✔ **Walnut:** Yellows less but must be used fresh; will turn rancid; slow drying

✔ **Sun-thickened linseed oil:** Linseed oil that's been exposed to air; a fast-drying oil that's preferable to refined linseed oil

✔ **Refined linseed oil:** Dries slowly and yellows over time

Varnishes and resins

You also sometimes see varnishes and resins available. These materials are used to ensure the formation of a tough, durable skin on the paintings. You can use them to make painting mediums or to make a final varnish. These materials are a bit more-complex in their use and nature. If you really want to know more about how to use them, we suggest that you enroll in classes.

What Not to Buy When You're Starting Out

Some paints and materials aren't necessary when you're first starting out. Either they're too complex in the way that they must be used, or they're too costly. Either way, they interfere with the learning process. In the store, you see an absolutely bewildering array of special paints, varnishes, resins, oils, driers, mediums, thinners — most in expensive 2-ounce bottles! We cover some of the items here and encourage you to think before you buy:

✔ **Very cheap paints:** Be careful buying very inexpensive paints, especially if the brand is unknown. Generally, student-grade is great for starting out, but you don't want to invest a lot of money and time on paints that are faulty. If you're in a regular art supply store, you can ask whether the store is familiar with the brand, how it differs from other brands, and whether the line of paints has any drawbacks.

✔ **Varnishes:** You have no reason to varnish a painting unless you plan to hang it in a smoky kitchen or bar. And in any case, varnishing a painting too soon after it's painted seals in the curing action and interferes with the process. See Chapter 5 for more information on the care of paintings.

✔ **Soft body paints:** This product is just paint with more oil in it. The most common type of paint you see is a soft body white. White is usually thicker and heavier than other tube paints. If you want a paint that flows more or has a smoother consistency, you don't need to purchase these soft body paints. Just add some linseed oil to the regular paint on your palette.

✔ **Really big or small tubes:** Sometimes getting a large tube of white paint is a good idea, because you use so much of it. But oil paint lasts forever (coauthor Anita Giddings has some tubes that are 30 years old). If you get the large tubes, the repeated opening of the tubes stresses the metal, causing it to break open. And then you have 100 ml of paint in your box. Yuck! We recommend that you get the regular 37 ml tubes. And don't buy the little tubes unless they're on sale; they aren't worth the bother.

✔ **Toxic pigments:** Always look for the ASTM D 4236 seal on every tube of paint that you buy. Don't buy lead white, Naples yellow, or cobalt violet. Plenty of other colors have a similar appearance and are also safe substitutes to these colors. Look for hue in the name and read the label for warnings.

Chapter 3

Assembling Your Materials

In This Chapter

▷ An overview of buying your art supplies

▷ Describing the tools and equipment you'll use

▷ Examining the various types of canvas you can buy

▷ Choosing basic safety equipment and other miscellaneous tools

Afta you have a bit of information about your materials, it's time to go shopping. But even if you feel well informed, going to the art supply store can be intimidating. You have to face all those brands, colors, sizes, and various types of materials. Where to start? This chapter gives you an overview of the material you need and guidance on how to equip yourself for this grand endeavor.

Buying Your Materials

You can find art supplies in many places today. You can go to a specialized art supply store, but you can also find painting supplies and equipment at the following locations:

- Craft shops
- Fabric stores
- Big box discount stores
- Online art suppliers
- Educational supply stores

Start with the phone book to see what's available in your area. Specialized art supply stores offer a wide array of supplies, and you can usually find a knowledgeable staff to help you make your selection. But specialty shops can be more expensive, and they aren't in every town.

On the other hand, craft shops and discount stores have great prices, but they may offer very little information. Either way, your best bet is to do a little research in advance and go equipped with a list.

Making a supply list

Start with the supply list from the Cheat Sheet in the front of this book. In this chapter, we give you more info about the materials in that list so that you can make a decision depending on what you find in your area and your budget. The supplies that we discuss in this section are the ones we recommend and use when we teach painting. You can see an array of the these items in Figure 3-1. These supplies are the bare essentials that you need to get started.

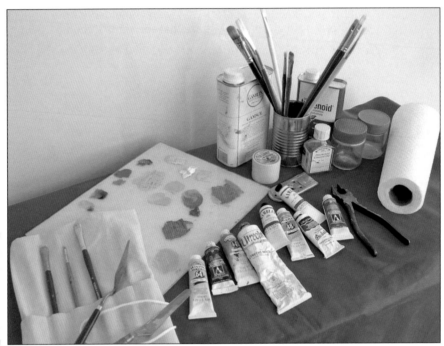

Figure 3-1: The supplies and equipment you use in painting.

Deciding on a budget

You have a choice about how you pursue painting. You can choose among the many grades of paint and supplies, and you can decide individually what your budget is. We want to be honest with you — painting can be an expensive hobby. We have some tricks, however, to make it less expensive and still end up with lovely results. We priced out the supply list at art supply stores and online retailers and came up with a cost of between $70 and $90 in 2007. You may be able to find other ways to cut costs as well.

We don't want you to spend a fortune, but being economical with your supplies isn't always a good idea. Low-quality art supplies make the learning experience more difficult. The paint doesn't behave properly, the brushes lose their hairs, and your palette knife may break. At the same time, we don't encourage you to be too extravagant with your budget. Being too careful with your expensive equipment and paints may inhibit your learning as well. You also run the risk of ruining some high-priced supplies that you don't know how to use quite yet.

Here are some options to save money:

✔ **Do some research in your area for the best prices.** Your area may not have enough supply stores to create competition, so shopping online or by telephone is also an option. Some well-known retailers are Michaels, Dick Blick, Pearl Paints, ASW, and Daniel Smith. You can also find smaller, locally-owned retailers in most medium-sized cities.

✔ **Look for paint kits that have almost all the colors from our list.** Be sure to get regular-sized tubes (37 ml). Shop for a set that has most of the colors from our list and then buy extra tubes of the missing colors. You want to get exactly the colors that we recommend for our projects in Chapter 7. And always make sure that the set is a good bargain.

✔ **Paint on canvas paper instead of stretched canvas.** Fredrix and other brands make canvas paper pads.

To be more generous with your hobby:

✔ Invest in good-quality brushes.

✔ Obtain a nice paint box to carry and store your supplies.

✔ Use stretched canvases — your paintings will look so authentic!

✔ Invest in an easel; choose from either a full-sized or French easel (to take outside) — both are good options.

✔ Buy frames for your completed work.

Start simple and then buy higher-quality equipment after you're more familiar with the process.

Choosing your colors wisely

This list includes the colors that are the most useful and the most economical for what you need. Some well-known name brands are Windsor Newton Winton line, Grumbacher Academy colors, and Gamblin. Always buy the 37 ml tubes; the little guys (about the size of your little finger) just aren't worth the bother — unless you see them on sale for $1 each.

✔ **Cadmium yellow light (hue):** A brilliant light yellow. Buy the exact color (not just plain old cadmium yellow; it must be "light"). If you can find a hue version, all the better. *Hue* indicates that the manufacturer has used substitute pigments. The substitutes are great for beginners because the result looks just the same as real cadmium. The hue allows you to indulge in some brilliant color without worrying about the cost.

✔ **Cadmium red light (hue):** A brilliant, opaque, bright red. Again, don't buy cadmium red hue unless it's "light." The regular versions are too dark, and you can't be as flexible in how you use them.

✔ **Alizarin crimson:** A transparent wine-colored red that's used to make violets and reds.

- **Ultramarine blue:** A deep transparent blue. You may see it as French ultramarine, which is the same color, but it's made with substitute pigments (and it sounds fancy). You can buy either one; the cost and appearance are almost the same.
- **Titanium white:** A dense, opaque, and inexpensive white
- **Mars black:** An opaque black

Here are some optional colors you may also want to consider:

- **Cerulean blue hue:** This color is a lighter, more opaque blue than the ultramarine; you may want it for a beautiful sky-blue or for water. Always start out with the "hue" version so that you feel free to use as much as you like.
- **Yellow ochre:** This mustard color of yellow makes the browns, natural yellows, and oranges that you see in nature.
- **Dioxazine purple:** A deep, transparent blue-purple. This color is great for mixing a wide range of violets, and it works well as a complementary color for dulling oranges.

Choosing brushes

The brushes we recommend for the beginner are china bristle brushes. They're tough and durable, and they make a strong mark on the canvas. They're tough enough to stand up to the oil paint and still clean up nicely. China bristle brushes are made from natural hair from pigs, and the fibers are a pale beige color.

You can also find synthetic bristle brushes that work very well, but make sure that they're made for oil paints. Technology has greatly improved the quality and affordability of brushes in the past several years. You can now find a wide variety of synthetic bristle brushes that work for oil paints and provide years of service at a good price.

Don't let low cost rule the choices that you make. You can find inexpensive brushes, but don't get the bargain multi-pack brushes that you may find in stores. The hairs will warp in all directions or fall out and become a permanent part of your painting. They're no bargain.

Aside from china bristle brushes, you'll also see sable brushes. They're softer and more delicate and *very expensive.* The brushes are made with animal hair or synthetic versions of those fibers. Sables are great for blending, glazing, and making soft, less-defined marks. They take more care than the china bristle brushes. After cleaning them, you have to reshape the bristles to prevent the hairs from becoming permanently warped.

The two characteristics you notice in any brush are shape and size. The different shapes allow to you load paint onto the brush and apply the paint in specific ways. Choose the size of the brush according to the size of your painting.

Selecting brush shapes

Here's a list of the brush shapes that will be most useful to you:

- ✔ **Flat:** This brush has a clean, straight edge for applying color evenly to an area.

- ✔ **Bright:** A bright is similar to a flat, but it has shorter bristles and makes a distinct calligraphic mark.

- ✔ **Round:** You generally use this brush for drawing and any type of line.

- ✔ **Filbert:** Filberts are interesting almond-shaped brushes that make an ovalish mark; they look like the round and the flat got together and had a baby.

You can also find other types of brushes that are used for specific purposes. For example, fan brushes are used for blending and textures, and long liner brushes are used for lettering. You can experiment with the brushes and find the size and shape that suit your working methods.

Brushes are sized by numbers based on the width of the brush at the *ferrule,* the metal sleeve that holds the hairs in place. For the projects in this book, your best choices are a #2 round and two or three others brushes — either filberts, flats, or brights in sizes #4 through #8.

Choosing the right brush size

The size of the brush has a relationship to the size of your painting surface, so you need a brush that makes a mark in proportion to the overall size of the format. That means that a brush that's 2 inches wide is designed for a canvas that's at least 2 or 3 feet in either direction. For a 14-x-18-inch canvas, sizes #3 to #6 are best. For a 6-x-9-inch canvas, you need smaller brushes, and for a large canvas of 3 x 4 feet or more, you need very large brushes.

The way you apply paint, your preferred size of brush, and the shape of the brush are very much individual choices. We suggest that you start with the four brushes we describe in "Selecting brush shapes." These brushes will get you started, and after three or four paintings, you'll find that you prefer a particular shape. Then go out and get more! You'll still need a variety of shapes. Rounds are great for drawing lines, but not for filing in large areas of color. A large flat fills in areas very well, but you have little control over the types of marks it makes.

Choosing palettes

A *palette* is a portable surface that you use to hold your paint while you're working. You use the palette to create a blend of tube colors, to test colors, and to create your selection of colors to use for a painting. The surface must be smooth and impermeable to keep the paint from soaking into the surface. The color of the palette must be neutral (white is best) so that you can see and accurately judge the color that you're making.

The classic palette is a kidney-shaped wooden panel with a hole for your thumb. This panel would be seasoned by applying oil to make the surface smooth and impermeable. But today, most artists use a glass palette. The glass palette has smooth, rounded edges and an enameled backing of white paint. For the sake of convenience, many beginners use a disposable palette. You can buy a glass palette or a disposable palette from art suppliers.

Disposable palette pads are made up of tear-off sheets for easy cleanup. They come in various sizes — 11 x 14 inches is good — and are very convenient. They do generate a lot of trash, and you have to keep purchasing more.

Finding the right palette knife

A palette knife is a necessary tool for every painter. We urge you to get a metal palette knife, not a painting knife (which is very different) in either of the two shapes you see in Figure 3-2. Both types work very well. The spatula-shaped knife is more readily available. Its angled shape makes it easy to mix the paint on the palette. The spade-shaped knife costs a bit more, but it allows you to have more control while you mix the paint. After you use one for a while, you can get different shapes and sizes, but artists commonly use only one for years.

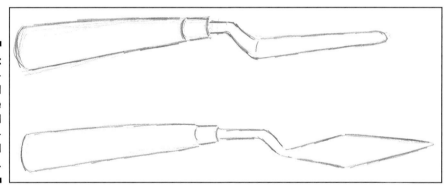

Figure 3-2: A spatula-shaped palette knife and a spade-shaped knife.

Don't get a plastic palette knife — it's worse than useless. It's impossible to clean, and it will break on you when you need it the most.

Choosing Surfaces to Paint On

Whether you're using canvas, paper, cardboard, or whatever, the term for what you put your image on is called a *support*. In this section, we give you a description of various types of supports and discuss the pros and cons of each.

Traditional supports include canvas, paper, cardboard, or a rigid panel, such as Masonite. Stretched canvas is the most common. Any support must be

primed before you apply any oil paint, but luckily, pre-made canvases, canvas papers, and canvas pads come already primed and ready to go.

Pre-made supports are the easiest for beginners to use. Canvas panels, stretched canvas (note the wooden stretcher bars visible on the back), and canvas paper that comes in pads are great for their quality and convenience.

Canvas panels and stretched canvas are rigid and easy to use on a tabletop or just propped up on a work table. Canvas paper isn't rigid after you take it off the pad, so you need something to tape or clip it to while you work. If you use canvas paper, we suggest that you get a canvas panel (such as the type made by Fredrix) one size bigger than your canvas paper, and either tape the paper to the back of the panel or clip it with butterfly clips. You can also work on the canvas paper while it's still on the pad, but it's messy to handle when you want to take it off the pad.

Other Painting Equipment You Need

There's more to painting than just paint, brushes, and canvas. This section covers other tools and supplies that you need or may find useful depending on your working style.

An easel

You need an *easel.* Get the heaviest one you can find so that it doesn't walk away from you as you paint. Some other options are floor easels or Julian (or French) easels for outdoor painting. Prices for this piece of equipment are $20 for a tabletop and over $100 for a full-sized easel. If you're resourceful, you can rig up something that works for you.

Positioning your painting surface at the correct angle for working is absolutely necessary. When you look at your canvas, the surface should be parallel to your face (see Chapter 5 for details). So, an easel, or something you rig up yourself that does the same thing, is essential. Here are some options for easels:

✔ To begin with, try propping your canvas against a heavy box on your work table. If your work surface is slick and the painting is sliding, try making a stop by duct-taping a piece of wood to the table.

✔ Look for paint boxes with easels built into them.

✔ A floor easel is great, but it can be expensive and it takes up a lot of room if you don't have a separate area for your work. If you find an inexpensive model made of three sticks that are 1 to 2 inches in thickness, don't bother wasting your money. This model skitters around the floor as you work and collapses unexpectedly. Go to an art supply store and try out the floor easels to see which works best for you.

Painting tools

The following tools are useful for storage and cleanup:

- **Jars:** Use glass jars with lids to hold your solvents and painting mediums. You need at least two: one for clean solvent that you use as a wetting solution, and one for dirty solvent that you use to dissolve paint from your brushes. You can use old recycled pickle jars (sized to hold about ½ to 1 cup), or get fancy with specially made jars with a wire spiral inside them. You can find them at most art suppliers. The wire helps you clean the paint solids from your brush. The jar must be glass — solvent eats through some plastics, so use glass to be safe.

- **Pliers:** Use this tool for hard-to-open tubes of paint.

- **Paint box:** Use this box to store and transport your tools and paints. Some come with their own easel on the lid, which is handy to work from and to transport the painting. A plastic bin with a handle works nicely, too. Toolboxes sold at hardware stores are often more economical than a paint box sold at art supply stores. They just don't have all the fancy compartments.

- **Soap:** You can use a bar of soap in a plastic container (as for traveling) to clean your brushes and hands. You can buy special soap for cleaning brushes that does a terrific job as well.

- **Aluminum foil:** Use this everyday item when you can't clean your brushes right away. Wrap the brushes until you can clean them (always clean within an hour or so).

Health and safety

We talk more about health and safety in Chapters 2 and 4, but here are some things that provide you some protection:

- **Gloves:** We recommend either latex or synthetic rubber gloves to keep paint completely off your hands.

- **Barrier cream:** This hand cream creates a barrier to outside elements. Avon's silicone glove is one example. Barrier cream isn't as good as gloves are, but it aids in your body's natural defense to outside elements.

- **Apron, old shirt, or something similar:** You want something to keep the paint off your clothes. An apron or old shirt will save your clothes from paint, cleaner, or solvent accidents. Just let the paint dry on the fabric.

Sighting tools

The two main sighting tools are the viewfinder, to help you establish your format, and a stick or paintbrush handle to help you find relative sizes and proportions. We provide you with the viewfinder (check out the Cheat Sheet at the front of this book), and you have the paintbrush handle in your regular equipment.

Viewfinder

A viewfinder allows you to set the format of your image — just like a viewfinder on a camera. You can use the one from this book or you can make one. Here are two options if you're making your own:

- ✔ **A bracketed viewfinder.** This viewfinder is made of two mat board "L" shapes (corners) that you clip together with paperclips, butterfly clips, or tape. See the directions in Chapter 14 on how to make this type of viewfinder.

- ✔ **An index card or similar piece of cardboard with a rectangular window cut into it.** You can enhance this viewfinder with threads that are taped in place to create cross hairs to aid in specific sighting (see Figure 3-3 for an example).

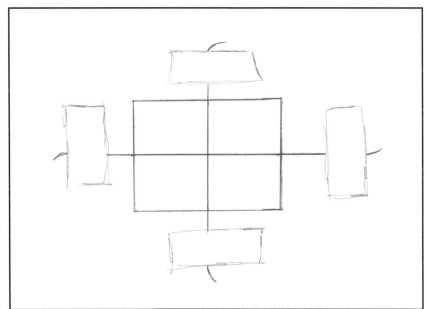

Figure 3-3:
Viewfinder with threads attached.

The shape of the viewfinder's opening must correspond to the shape of your canvas. You have two ways to check this:

- ✔ Stand back from your canvas and look through the viewfinder. Make sure that the edges of your canvas visually touch the edges of the window in your viewfinder.

- ✔ Lay the viewfinder on the corner of your canvas. Lay a ruler or other straight edge diagonally across the canvas so that the corners are connected. If the straight edge passes exactly through the corner of your viewfinder, it will work.

Skewer or other stick

You can use the handle of your paintbrush as a sighting tool. (See Chapter 6 for an explanation of how it works.) You can also use a pencil, a chopstick, a kabob skewer, or anything that's about 8 inches long, thin, and straight.

Miscellaneous supplies

You can find lots of toys in the art stores, some useful to you and others not. Here are a few:

- **Wet canvas carrier:** If you want to go somewhere to paint, whether it's a class or outside, these carriers are useful. You can carry your canvas home without smudging your work.

- **Fabric sleeve for brushes:** These sleeves keep the bristles of your brushes from becoming bent in your paint box. The sleeve is essentially a piece of canvas with pockets sewn into it. You place your brushes in the pockets, roll up the canvas, and store it. You can purchase one premade or easily make your own.

- **Adjustable plastic viewfinder:** A little expensive for what it is, this viewfinder looks a lot like a photo slide mount. It's fairly handy but smallish, which limits its use to distance work. It's great for landscape work, but limited for still life close-ups.

- **Wooden mannequins/models:** These tools are tabletop, humanlike figures made of geometric forms, and they're usually wooden. You can use them for still life objects if you want to, but they're no substitute for drawing from a real person. Get friends and family to model for you and save your money.

- **Specialty palettes:** You can find any number of beautiful white palettes made from ceramic or plastic. Nearly all are for watercolor painting and aren't appropriate for oil painting. Use your money for a good oil palette, or use the disposable paper palette until you can get one.

- **Specialty sketchbooks:** Almost nothing is as tantalizing as a beautiful sketchbook! Go for it!

- **Canvas pliers:** If you decide that you want to stretch your own canvases on a regular basis, go out — no, *run* out — to get yourself a pair of canvas pliers. You may find them only at art supply stores or online, but do the work to find them. They're relatively inexpensive — in the $15 range — but they save you a lot of raw knuckles, and nothing gets your canvas more taut. They're specially designed to grip the canvas and pull it to the backside of the stretcher so that you can staple it. (P.S. That hornlike shape on the business end of the pliers acts as a fulcrum for pulling the canvas.)

Chapter 4

Preparing to Paint

In This Chapter
▷ Finding a place to work
▷ Organizing your workspace
▷ Setting personal goals for you artwork

Shopping for materials and tools is fun, but you need to consider other things as you prepare to paint. You must set up your workspace so that it serves your needs. Look for ways to minimize the impact painting has on anyone sharing your living space. Establish a self-directed state of mind for your endeavor by making a plan for studying painting. Each of these items on your to-do list is just as important as obtaining your equipment.

In this chapter, we help you find a place to work. When you find this space, you want to organize it to make it comfortable and inviting for you, while making sure that it's safe for everyone in your house. We help you establish some personal goals for your work as you prepare yourself mentally for this creative endeavor. As we say in Chapter 3, how much you want to invest in this artistic pursuit is an individual decision. This chapter helps guide you through some of the decisions that you make along the way.

Setting Up Your Space to Paint

Whether you get your impressions of an artist's studio from old movies about Van Gogh or the set designs for *La Boheme,* you're probably starting with a romanticized idea of the space you need to paint — most people do. A ramshackle room with an easel, a bare window, drapery and other props in the corner, and broken furniture — and everything spattered with paint — is many people's fantasy of a "real" artist's studio.

If you do have a spare room with some natural light, that's lovely, but you don't need an ideal space to get started. Any space where you have adequate light and ventilation, and are warm or cool enough to work, will do. What follows is a basic set of points to consider when selecting a place to work. We also give you some practical suggestions.

When you start to work, you begin to discover your own priorities for your studio. Some things to consider are:

✔ Ventilation

✔ Size of the space

✔ Attractiveness

✔ Type of light

✔ Noise level

✔ Privacy

✔ Permanence of working area (whether you have to put things away every time)

✔ Cost of rent or cost of remodeling (if applicable)

✔ Ease of use (whether getting to or setting up for your work is difficult)

We discuss several of these factors in the following sections.

Make a list of characteristics that you want to see in a studio. Try to keep it down to only what's necessary. Prioritize the list for your own preferences and make adjustments. You may find that after you paint for one or two weeks, your priorities change. Maybe setting up in the family room wasn't such a good idea. Some options around your house are spare rooms, the basement (be sure you have ventilation!), a three-season porch, a little-used dining room (cover the table with a vinyl tablecloth or sheet laminate), or a laundry room, utility room, or mudroom. You can also have a transient or less-permanent space.

Deciding how much space you need

Initially, you have some practical size considerations for your space. You need enough space to set up your tools, paint, and canvas, as well as enough space to work. You also must be comfortable and safe while you work and have enough space to back away from your painting to assess your progress. A space that's 6 x 6 feet, plus some extra room to back up from your work, is a minimum. Figure 4-1 shows that you really don't need a whole lot of space to get your work done.

Safety, lighting, and overall size are major concerns, but you may want to consider how friendly your space is. If you feel isolated, claustrophobic, or otherwise uncomfortable, you're less likely to use the space and pursue your goals successfully. If the space is small, consider a mirror or mirror tiles to give the illusion of space, especially if you can place them across from a window. A plant, an art poster, and music to mask the other noises can make a space more habitable.

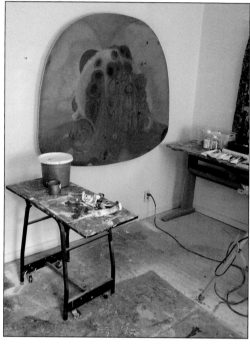

Figure 4-1:
One corner of a room can be enough for a workspace.

Photo courtesy of Carla Knopp.

Deciding where to set up

Whether you need privacy or don't mind an audience is an individual preference. Painting is an interesting pursuit (just look at Saturday afternoon public television for an example), and you may find that you're an irresistible force when you're working. People who live with you (both children and significant others) may want to talk to you while you work, and you may find concentrating difficult. Pets are interested in you, too. You may have to consider whether you're going to have a cat in the middle of your palette, or someone swatting your brushes or pawing your arm for attention. You may have a space that you can use at a time when everyone else in the house is occupied, or you can establish house rules that the basement, spare room, or garage is off limits during your work time. Lockable doors or baby gates help cut down on traffic, too.

Permanent or transient space?

Permanence is great if you value leaving your work, tools, and painting in place until you return. After all, you can devote less time to putting things away and taking them back out again. When you want to work, your equipment is there, waiting for you. A studio can be an attractive space and a valuable addition to your home, as well. A work area with a painting in progress and interesting paraphernalia can become an attractive part of the design of your home, as you can see in Figure 4-2.

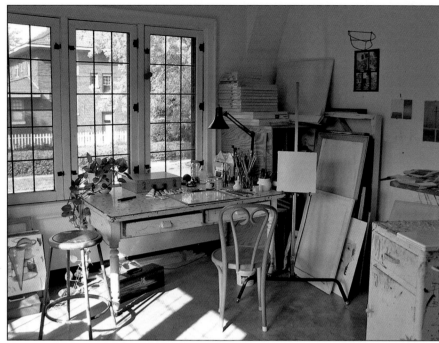

Figure 4-2:
A dedicated workspace. Looks homey, no?

If having permanent space isn't possible, and you're resigned to being a nomadic artist, you can make some adaptations. A toolbox to put things away, a shelf dedicated to your painting equipment, and a couple of nails in the wall to hang a painting transform a kitchen or laundry room into a studio. A glass palette wrapped in foil keeps your paint fresh for days. (See Chapter 3 for details.)

Wherever you work, you need access to a sink for cleanup. You can use a utility sink, a bathroom sink, or a kitchen sink. Along with being tidy in your work habits, being tidy when you clean up pays off as well. You don't have to leave smears and stains of paint at the sink. Review the directions about cleanup in Chapter 5 to cause the least amount of irritation for yourself and your living companions. Learning to properly dispose of trash in a way that doesn't endanger your household or the planet is absolutely essential for the environment.

The following is a list of pros and cons to consider when figuring out where to set up your painting space:

- **Basement:** Permanent to semi-permanent. A basement usually has lots of room, but it can be dark and unventilated. Be sure to have lots of light, paint the walls white, and install mirrors, if necessary, to visually expand the space.

- **Three-season porch:** Permanent to semi-permanent. This space has great light, but temperature is an issue (for you, not the paint — the paint will be fine). ***Bonus:*** You can pretend that you're painting outside — without bugs.

- **Garage:** Permanent to semi-permanent. A garage is similar to a basement, but it has great ventilation. It can be cold or hot and dark. Paint the walls white and make sure that you have lots of lights.

- **Utility/mudroom/laundry room:** Transient. These spaces are used for storage and work, so they usually have lots of shelf space and light.

- **Spare room or bedroom:** Permanent to transient. Protect the floor with plastic floor mats from an office supplier, and cover surfaces with vinyl tablecloths.

- **Kitchen:** Transient. Protect surfaces with newspaper and vinyl tablecloths. Pay extra attention to cleanup in this area where you prepare food and eat.

- **Off-site:** Permanent to transient. You have to factor in rent, zoning, parking, gas, and drive time, but you have *a studio.*

And what about having a real, dedicated studio?

If you're lucky enough to have the space, you may be able to design a studio to suit your needs and desires. If so, spend a bit of time reviewing the information here to help you decide what your work area needs.

Two key things to try to incorporate into your studio are a sink and a separate air source or exhaust fan. Windows provide natural light and give a sense of expanded space. Being able to see out is important for some people, and it can keep you focused and feeling good about where you are. Also, plan for your lighting needs by wiring the space for artificial lighting to go along with the natural light.

A regular-sized room (say 12 x 14 feet) is good, but bigger is better. The same goes with ceiling heights. Eight feet is fine, but space above your head leaves lots of room for ideas — and lifting large canvases. For furniture, find a secondhand table and an overstuffed chair to go along with your easel and props, but keep it sparse. Don't allow anything else to be stored in your space if you can help it. Figure 4-3 shows an example of a full-blown studio.

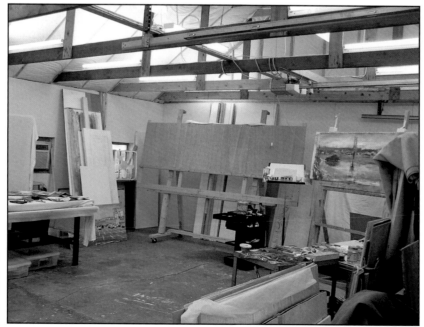

Figure 4-3:
A dedicated
studio.

Photo courtesy of Marc Jacobson.

Getting the basic furniture

You need some furniture so that you can set out your materials, supplies, and work. You can find many variations on this setup, but your basic furniture should accommodate a place to set up your painting, an area for your palette, a spot for your still life setup, and a place for your lights. Oh, and something for you to sit on. A table, lights, easel, and a stool should do the trick. These furnishings are traditional, but if you're creative, you can minimize not only the amount of space that you need, but also the cash that you have to lay out to get set up.

You can save space by using a wall as your easel. A stretched canvas can hang on two nails, and you can work on the painting while it hangs. If you're using canvas paper or a canvas panel, hang a drawing board on the wall and attach the paper or panel to the board with butterfly clips or tape. You wouldn't be the first person to staple the canvas directly to the wall, either, but be prepared to lose your security deposit if you do.

Your tabletop can function as a place to put your palette and still life, but you may also be able to set up a tabletop easel or prop your canvas against your paint box on it. (See Chapter 3 for more about easels.) You can use an old table or desktop, and you should be able to tolerate smeared paint and spilled solvent on it. Frequenting secondhand stores or garage sales and driving around the neighborhood the night before heavy trash pickup are great ways to recycle old furniture into new, glamorous incarnations as studio furniture.

You can protect your tabletops by investing in a piece of thin laminate that you can use and put away when you aren't working. Simply go to your local builder's supply store and ask the employees to cut it for you.

You need good lighting for working and for your setup. Natural light supplemented with artificial light is great. Arrange to have more light available than you think you need. Clamp lights, floor lamps, and shop lights work well. The Italian word for studio is *laboratorio,* and you need your space lit up like a medical lab in order to work safely and effectively.

Taking care of your safety needs

One important thing that you need to consider is the safety of your work area. Ventilation is your first concern. Changing the air in your place keeps you and anyone else on the premises comfortable and healthy. Operable windows, doors, fans, or exhaust hoods can provide fresh air and allow you to circulate airflow through your space. Be aware and sensitive to the fact that oil paint can be an irritant to some in your household.

Look over your space for fire hazards. Eliminate overloaded electrical outlets or wires on the floor (which can also trip you and visitors). Maintain a fire extinguisher in your work space as well.

Another safety concern is how to put your supplies and equipment away when not in use. Keep lids on jars of solvent and place them out of reach of children. Put paints away, clean your brushes, and place any paintings out of reach as well. Your children and pets can be very curious about your hobby when you aren't around! The paint stays wet for a long time. Small children put everything in their mouths, and you may have pets who like to "help." Concentrate on tidy working methods and habits to keep everyone happy and safe.

The following are some tips on tidy and safe work habits:

- Cover surfaces that are difficult to clean with dropcloths.
- Keep paint off your skin and clothes.
- Keep a rag to wipe up excess paint to avoid generating paper towel waste.
- Clean your brushes in solvent, wiping off excess solvent before you wash them with soap and water.
- Cover your palette with foil.
- Prepare a secure place to put wet paintings where they won't tip over or fall.
- Keep clutter off your work surface to avoid accidents.
- Make sure that jars for solvent are heavy to prevent tipping over.
- Keep paper towels handy for emergency cleanups.
- Keep lids on solvent jars and paint tubes when not in use.

Other considerations for your workspace

Even if you have a dedicated space in which to work, it may seem uninviting, or the hurdles may seem like too much to overcome. You don't have to invest in a remodeling project to make do with a space. If lighting is a problem and the walls are dark, paint the walls white. White reflects the most light and makes your space open up. Another issue with lighting is the type of light. Regular incandescent lights are yellowish and can affect the color in your work. Try GE Reveal bulbs that cast a cooler light than the regular kind. Fluorescent lighting is good, especially if you have a full spectrum lamp in your fixture.

Other items to include in your space are a bulletin board to pin up pictures and art postcards, reference books and other art books and magazines, and a trashcan. If you start to sell your artwork, you may need a desk and office supplies to keep records. Having an extra chair for visitors is polite. Photos of scenes you want to paint, and objects with vivid colors and interesting shapes can also find a place in your studio area and serve as inspiration for your work.

If your space is transient, you can make portable setups for your still lifes by arranging the items in a cardboard box. Cut away the top and one or two sides (see Figure 4-4 for an example). Fix your items down with tape rolls so that you're able to move the box to a shelf when you aren't using it.

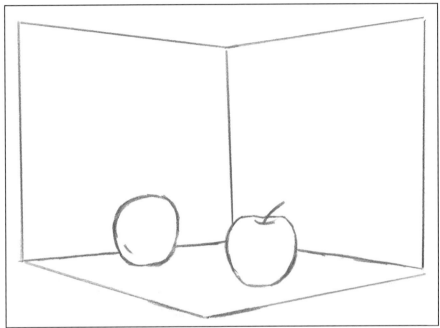

Figure 4-4: A cardboard box makes your still life setup portable.

Developing Strategies for Growing as a Painter

Occasionally, by the time an individual actually starts to paint, he or she expects success in five easy steps. Some painting programs on TV instill unrealistic expectations. Sparkling mountaintops and trees appear in 30 minutes! Remember that those folks have many years of experience, and their results often depend on specialized techniques. In this book, we intend to teach you to paint from the basics forward so that you'll be able to paint anything you set your mind to. The following advice should help:

✔ **Keep it simple.** Your study of painting should progress from simple to more complex, allowing you to build on your experience. Think of your artistic goal and then break it down to the simple, basic parts.

✔ **Give yourself permission to make mistakes.** Making art is putting your artistic heart on your sleeve, and it hurts when it doesn't come out perfect. That's why we call the initial projects in this book "studies" rather than "paintings." Of course, they *are* paintings, but if you refer to them as studies, it doesn't seem as risky or as distressing when they don't turn out as well as you'd like. Always remember when you're beginning to paint that you're a rookie. As such, you have permission to make mistakes!

✔ **Forget the great American masterpiece.** You have some fine paintings ahead of you, but learning to paint is about the process, not the product. So the learning is a far better indicator of your success than a single fine accomplishment. Besides, learning to paint is fun and the learning curve is straight up. Every piece you do will show improvement. You may create some awkard looking paintings, but everything falls into place with practice.

✔ **Make a commitment.** Making a plan for your work and sticking to it are important. This requires a commitment of time, especially in the beginning, so we suggest setting aside time to work each week. Two to three hours is ideal. Schedule it out and write it down in your daily planner or on your calendar. That serves as a promise to yourself to fulfill your commitment. Two hours at a time is minimum to allow for getting out the supplies, setting up your still life or other image sources, and sitting down to work. You also need at least 10 to 15 minutes for cleanup. In the long term, make a commitment of 6 to 12 months to be happy with your work.

Deciding What to Paint

So where to you start? How do you decide on an image? The first few works you make should help you become familiar with the paint, the process of applying it with the brushes, and the rudiments of making a simple image without tripping you up with techniques.

Start easy

Easy-to-see shapes, without details or texture, are best. These shapes also help you concentrate on the mechanics of painting. Some of the subjects we start you with in the very beginning are white objects. You use only black and white to paint them, giving you a comfortable start. Some ordinary subjects are eggs, white boxes, and white ceramic coffee cups. Then you move on to objects with color. Again, choose non-shiny geometric forms with little detail first, and then move along in complexity.

Paint simple subjects from around the house

You can find many sources for subject matter for your work. Your painting can communicate a particular idea through the objects represented. A collection of things from a vacation, the garden, or desk items can tell the viewer something about the personality of the individual painter.

Take your viewfinder around the house and outside to find an interesting composition of shapes. Look for scenes from your home, a view out a window, or a sleeping dog. Snapshots from a trip or the old family homestead make nice mementos as well.

Try simple landscapes

Landscapes are very popular, and you can start a project the same way. Start with something simple, like one or two trees, and continue from there. Add texture to your landscape after you experiment with making a variety of greens for the foliage and blues for the sky. In general, forms that have one color throughout, such as a tree with relatively uniform green leaves, are best. Save that *Maples in Autumn* painting until you have summer down pat. See Chapter 10 for more on this topic.

Copy a master

Another strategy is to copy a master painting. This technique for learning has hundreds of years of tradition in painting. Artists such as Durer, Raphael, and Van Gogh used this method in their work to study technique and composition.

Attempt a self-portrait

In addition to water, another troublesome subject is people. People aren't so difficult to paint, but it's distressing when the painting doesn't come out perfectly. You don't have to be an art critic to spot a less-than-perfect portrait. Any slight variation from a true likeness stands out. If you mess up a painting of an apple and it looks like a peach, you can just call it a peach. Mess up a painting of your mom, and you can't bear to look at it. Approach portraits the same way: Start simple with a self-portrait and continue from there. Another thing to remember is that people are easier to paint the older they are. (Babies are almost impossible!) In Chapter 11, we walk you through this topic step by step.

Chapter 5

Walking Through the Painting Process

. .

. .

A painting on display in a museum can be so compelling that it looks like it was created by magic. All the parts of the image work so well together that you just can't stop looking at it.

Oil paintings are created in layers, and if you understand this process, you can make it work to your advantage. The logic isn't all that different from painting any surface. It involves the proper preparation of the surface and applying the paint in one or more coats. An oil painting just has a few more steps. You must also create the image and make it presentable for viewing.

This chapter walks you through every step of the process of creating a painting. We provide an overview of all the steps — from setting goals for your work to framing the finished painting. We also address some questions that you may not have considered yet. How do you solve problems? What about titles? What do you need to know to take care of the painting? We cover these topics while we take you from the first marks on the canvas to the signature at the bottom.

Preparation

How many times have you heard someone say that good preparation is essential to the success of a project? It's true in painting as well. In painting, preparation is more than just squirting some paint out on a palette and picking up a brush. Here are some things that you need to do before you even think about putting paint on a canvas:

✔ Set a goal for the painting.

✔ Make preparatory drawings.

✔ Decide what surface you want to paint on.

✔ Assemble your materials.

By spending a little time on each of those steps, you lay a good foundation for your painting, and the process is a lot more productive and enjoyable.

Setting goals for your work

To prepare for any journey, you must know where you are and what your destination is before mapping out a route. Painting is a similar journey. You prepare by taking stock of your skills and abilities and deciding on your goals. It also helps you decide what you're going to paint, how big it will be, what it will look like, and your strategy for executing it.

Assess where you are

Look at the art that you've created and try to assess where you are with your artistic skills. Don't be hard on yourself! Be objective, but don't be overly critical. At this point, you're either starting a completely new endeavor or building on the knowledge you have from previous paintings. Either way, it helps to have a clear idea of where you are and set reasonable goals for your work.

You may judge your work harshly because you don't have anything to compare your work to — other than some master reproductions in books and magazines. That's pretty stiff competition, wouldn't you say? Instead, keep it simple and break it down to just a few questions you can ask yourself:

✔ **How's your drawing?** Are the forms in your drawing believable? Your drawing doesn't have any problem that being more observant won't solve. Most of the time, the problem is simply that the forms are too generalized. In other words, the shapes you've drawn are only generally like the actual form of the object. If you look closer at them, you can draw the shapes more true to their actual forms. This is true of painting the forms as well.

✔ **Are you painting your forms flat like cartoons, or can you make them look three-dimensional?** Being able to make them look three-dimensional is an indication that you can work with different values of paint.

✔ **If you've been painting a while, do you rely on stylized techniques to paint the forms in your artwork?** For example, are you flipping the brush a certain way or picking up colors on your brush in a prescribed manner? You should be working naturally and concentrating on developing patterns, textures, and colors, not focusing on narrowly defined ways of using your brush or applying color.

✔ **Do the colors look fresh and clear?** Have you ventured beyond painting colors straight out of the tube? If your painting looks too vivid, you may need to be a little more adventurous with your color mixing.

As you read over these questions, what do you think about your work? Maybe you do well in some areas but not in others. None of these areas is worth beating yourself up over. These questions merely help you establish a baseline for developing your goals and show you how you can break down your goals into specific areas to work on.

As with any set of goals, you want a specific main goal for your overall painting endeavor that can be broken down into sets of smaller goals. You can choose to emphasize any of these goals in each painting.

Early goals to improve your skills

Set a goal for your work as you begin each painting so that you can plan the steps you need to take for success. Is your goal to experiment with strong color? Tackle a complex subject? Work on a large canvas? Deciding on just one main goal for each painting helps you stay focused. Be tolerant of yourself on other issues aside from this main goal until you have more experience.

Beginning goals for your painting don't have to be lofty. Here are some sample goals for a painting that you can set for yourself:

- I will draw from observation so that I can become more confident in my drawing skills.

- I will make the forms in my drawing more believable.

- I will paint my forms more accurately.

- I will make my forms less stiff.

- I will use color more effectively.

These are beginning-level goals. You're either just starting to draw or paint, or you're picking it back up again after a long hiatus. You have some great work ahead of you, but setting your goals is important so that you can improve your skills step by step.

As your skills develop and your work improves, concentrate on these three things:

- **Work from life.** That means looking at something and painting a picture of it. Don't work from photos or other images. Just concentrate on working from the thing that's sitting right in front of you.

- **Concentrate on working general to specific.** This is our (and every other art instructor's) mantra. It means that you generally sketch an image and then go back to refine it. We speak of this in many places in the book. Refer to Chapters 7, 13, and 14 for more info.

- **Be patient.** The process is a lot of fun, but you're going to be a bit clumsy for a while. Concentrate on getting the basics down solidly before you try to dive into painting complex subjects.

Intermediate goals when you have skills to build on

When you've taken a class or been working for a while, you have some skills to build on. You can begin to set some intermediate goals. At this point, you're ready to explore new ways to paint or set some personal goals for your work to take it to the next level. Here are some questions you may ask yourself to determine whether you're ready for intermediate goals:

- ✔ Am I confident in my paint-application skills?
- ✔ Am I able to tackle a number of different subjects?
- ✔ Do I feel confident working with color?
- ✔ Have I met a previous goal, and am I looking for new challenges?
- ✔ Would I like to work with more expression in my painting?
- ✔ Do I have an interest in exhibiting my work, selling my paintings, or enrolling in an art program?

Advanced goals that challenge

If you decide that you're ready to give yourself more of a challenge, here are some things that you can do to advance to the next level:

- ✔ **Start to experiment with different materials.** Trying different types of media, supports, or brush and knife techniques keeps the learning process fun.
- ✔ **Start to explore new subject matter.** Think of the things that you haven't had a chance to work on yet, and set new goals.
- ✔ **Familiarize yourself with the art organizations and institutions in your area.** You can find like-minded individuals, a painting group, or an exhibit that will give you more ways to enjoy your hobby. Art can be a solitary pursuit, but finding others who share your interests is always enjoyable.
- ✔ **Work from life, but go to the museum, too.** Another way to help you set a goal is to take some time to look at art. Your local library and the Internet have lots of resources, but nothing compares to seeing the real thing. When you look at real paintings, you can see how paintings are made.

When you go to a museum, take your sketchbook to make drawings or notes. Pencils are the only drawing or writing instrument allowed in museums. Absolutely no ink pens! Also, be careful to keep your distance as you look at the paintings. Of course, never touch a painting. Artists often become overly enthusiastic and lean in too close to the works. At minimum, you make the security guards nervous, and you may set off a few alarms! (We've been guilty of *that* a few times, but we haven't been thrown out yet!)

Also, familiarize yourself with art centers and galleries in your area. Attend their exhibitions and artist lectures. Another resource that may be available to you is the art department of your local college, which may have exhibitions and visiting artist lectures free to the general public. You can find

informal resources by checking bulletin boards at an art supply store and talking to local artists at art fairs. Don't be afraid to consult high school art teachers and instructors at museums or art centers. (Expect that some people will be more generous with their time and knowledge than others.) Teachers of any sort are usually interested in passing on any information they have, but if you're inclined to take a lot of their time, ask whether you can hire them for a consultation or periodic private lessons or critiques.

Making preparatory drawings

Another key way to prepare to paint is to make drawings. Working out your compositional problems on a small scale is easier than working them out on your canvas, or worse, finding yourself disappointed in your final results.

You don't have to excel in drawing. As a matter of fact, the best drawings to use for painting are quick thumbnail sketches that are quite rough. They don't have to be refined at all. You *can* develop your drawing skills as you paint. Just be aware that your skills are developing in this area and your work may not be as sophisticated as you'd like.

Here are some basic methods to use (for an in-depth discussion, consult Chapter 13):

✔ If you're drawing from observation, use the viewfinder from the Cheat Sheet in the front of this book. It helps you set your format to vertical or horizontal and to see simple shapes in your subject matter. Make sure that the picture frame of your drawing is the same proportion as your viewfinder. Draw what you see in the viewfinder.

✔ When you make rough thumbnail sketches, you can use any type of paper, pencil, or pen you like. You may want to get a small sketchbook to keep your drawings and ideas for painting.

✔ You can also practice with photos. Make a tracing or grid enlargement of the large shapes you see (ignoring the details) onto your painting surface. Don't assume that you have to paint everything in the photo. Crop or mask out the area you want to use and eliminate anything in the image area that isn't contributing to the success of the work. Make sure that the shape of your photo and the shape of your painting (their picture frames) are proportionate with each other.

Deciding what surface to paint on

Each project has a different goal, and it determines the shape, form, and size of your support. Some of the options include canvas panels, canvas paper, canvas pads, prepared paper or cardboard, stretched canvas, and prepared Masonite. (See Chapter 3 for an in-depth discussion of painting supports.) Throughout this book, we suggest a canvas or board for each painting, but the following sections tell you how you can make decisions yourself.

Informal practice projects or studies

Initial paintings, such as the black and white study in Chapter 6, the color studies in Chapter 7, and practice projects are best done on inexpensive supports. Use canvas paper, paper or cardboard primed with gesso, or a canvas panel. Inexpensive supports are great when you just feel like messing around with the paint. They're inexpensive and if you don't like the results, you haven't risked much.

The only caveat to this guideline is experimenting with impasto painting (see Chapter 8). This heavy, gooey paint application needs a rigid support. Be sure to use a canvas panel or prepared Masonite for impasto painting.

Formal projects

At some point, you move from initial paintings to serious efforts — paintings that you want to keep for a long time, frame, or give as gifts. In other words, *real paintings*. These projects should be painted on stretched canvas or prepared Masonite. The sturdiness of the support makes framing, hanging, and storing your painting easier. A canvas panel may work nicely for this kind of project, but the cardboard base for the panel can be permanently ruined if the panel gets damp or if it's dropped on its corner.

If you happen to make a nice painting on paper or another less-rigid support, don't despair. Just frame it and hang it up. A frame provides the best protection for your work. See the section titled "Frame the painting" later in this chapter for instructions on framing.

Assembling your materials

Consult Chapter 3 to determine what you need. Think through what materials and equipment you need and carefully organize your space. Being organized helps you avoid disruptions in your painting while you pick up missing supplies.

First, locate all your supplies and lay them out within easy reach. Painting can be a messy business, and you don't want to tip things over as you reach for something. Be sure that you have good lighting and a close, unobstructed view of your subject. Sitting or standing, you must be able to look at your canvas and your setup by just shifting your eyes from one to the other.

Starting to Paint

Before you put any marks on your canvas, be sure to adjust the position of the canvas. Whether it's on an easel or leaning against a toolbox, the painting surface must be parallel to your face. Think of it like a TV screen or a computer monitor. This step is crucial to avoid any distortion in your image. Now you're ready to start.

You can use one of two basic approaches to beginning your work on the canvas. In the first approach, you begin drawing directly on the canvas with your brush and paint. Another method is to draw with charcoal on the canvas and then begin to paint. After the drawing, you proceed to under-painting. The following sections tell you more.

Laying out the drawing

Drawing with paint directly on the canvas maintains a fresh look on the canvas and requires no additional steps or materials. When you begin a painting by drawing with paint, you aren't tempted to spend too much time erasing, redrawing, and over-refining the image. In the initial projects in this book, we emphasize this method of painting.

The first marks on the canvas are done with a very thin wash of paint and solvent in a light color. Paint thinned with solvent dries quickly and allows for changes. After you draw the initial image on the canvas, stop and take stock of the image (this step takes only two to five minutes to get all the parts in). You can make changes to the drawing by switching to a slightly darker or more intense color. If you see any mistakes, just apply a new drawing over the top of the first lines. You can see an example of this in Figure 5-1. You can also wipe over the marks with a paper towel.

Figure 5-1:
A sketch in oil paint of a lighthouse.

Never try to wash marks or paint off your canvas with solvent or anything else. It will damage the canvas and just spread the problem all over you and your work surface. If you have to remove heavy paint, scrape off anything you can with a palette knife. Then wipe away excess paint with a paper towel. Set the canvas aside to dry and then restart the project.

Another approach is drawing on the canvas with a charcoal pencil and then finalizing it with thinned paint. This method is often reserved for painting projects that are planned out. The downside of this process is that the charcoal can mix into the paint and dull the colors. The advantage is that your drawing can be more precise and you can make corrections without removing paint from the canvas.

Don't use graphite as a drawing material for your painting unless you intend for the look of a graphite pencil to be a part of the work. Like charcoal, graphite can mix with your paint and dull the colors, but that isn't the primary reason you should avoid using it. Graphite bleeds through your paint like a felt-tip marker on a pristine wall. Like markers, graphite is especially persistent and can reappear years after it has been covered.

Underpainting

Next comes the underpainting. This is literally the first coat of color for the painting. Basic colors, without fussy details, are applied in large areas in a thin wash. Just like the drawing, this step allows you to experiment with the layout of your painting and still be able to make changes. Again, stand back from the painting and assess your progress. We show you an example of this stage of a painting in Figure 5-2. We blocked in the colors for the lighthouse, trees, water, and sky in a general manner to achieve the underpainting.

Underpainting also allows you to establish the basic colors of the forms. They can match the final layer of paint exactly or they can be contrasting, with small points of contrasting paint peeking through the later layers.

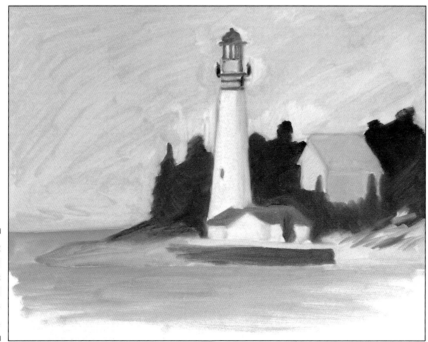

Figure 5-2:
Blocking in colors and underpainting.

At key stages of a painting, take stock of your work. Stop and back up from your painting to assess your progress. Don't be overly critical. Your drawing should look something like a thumbnail sketch done in color. The underpainting looks like a very simplified version of your goal. We give you more ways to assess and evaluate your painting at the end of this chapter.

When you finish the areas of flat color, back up at least 6 feet from the canvas. Use your imagination to envision how the painting will look when you add the lights and darks. Now is the time to critically assess your work. Check for lines that should be level, relative sizes of items, and the placement of forms. You can use your viewfinder to look at both the painting and the image that you have to help you focus. You can use your paintbrush handle to check the baselines of objects and the axis of an object. See the black and white study painting in Chapter 6 for illustrations of how to use these tools.

If you aren't happy with the underpainting, changing it is easy. But remember never to try to wash paint off your canvas with any liquid or solvent. If you have a huge thick mistake, scrape if off with your palette knife and then let the scraped surface dry before painting over it.

Make any changes you need to at this stage. You should have only about 20 minutes of painting time invested in this, so don't be afraid of changing your forms.

Laying on the Paint

When you have the basic forms blocked in, you can begin to apply another layer of paint to develop the image. You're working in a manner that's referred to as *general to specific.* That just means that you're putting down general shapes and colors and then gradually refining what you've made. At each stage of the painting, you begin adjusting and refining the main subject first, and then you move on to less-prominent parts of your composition. Enhancements to the painting begin with the focal point of the painting. So whether your focal point is the big red apple in a still life or a line of trees in a landscape, you concentrate on that focal point. Then you make adjustments to the parts of the painting that hold a secondary role, and so on. Usually foreground is the most important, and the middle and background are adjusted to harmonize with the main focal point.

Bringing it all up in layers

The paint application gradually becomes heavier and more varied, and your working method becomes slower as you refine the image. You have a chance to add a variety of color, brushstrokes, and detail to the image. In our lighthouse painting in Figure 5-3, you can see how we're developing the image with a variety of colors and brushstrokes to depict the detail of the scene.

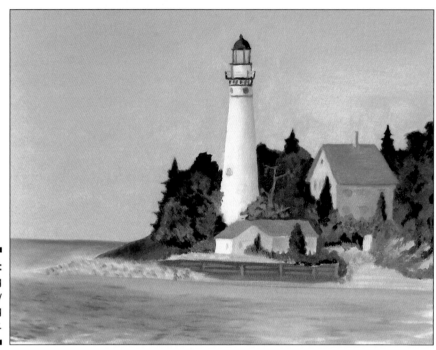

Figure 5-3:
The painting
is really
coming
together.

You can leave some areas with broad strokes or thin layers while others take on a rich, dense, and complex appearance. See the background of the painting in Chapter 1 for an example of this. The variety adds to the complexity of even the simplest subject.

Deciding when it's finished

Whether you're making a rough sketch or a highly refined and formal painting, your work isn't complete until all parts of the painting are fully resolved and together they create a harmonious whole. That can be difficult to determine! Much of what the art community admires about late 19th and early 20th century painting appears to be rough and spontaneous. At the time, some of the paintings weren't considered to be complete enough to be publicly shown.

You can find a lot to appreciate in a well-done study. The quickness and freshness of the mark of the brush and the directness of the color can hold drama that's lacking in an overly refined painting. But you must also consider that the study itself can be the base of a more-complete painting. Van Gogh sometimes completed a painting in less than an hour, but Leonardo da Vinci would sometimes spend years on a painting. In the end, it's up to you to decide what works best for you.

Evaluating Your Work

After the painting is done, or even while you're still working on it, assess the work. Of course you're assessing on a continual basis while you're working. You make corrections and try variations of each stroke. You stand back to assess a color or the placement of a form. But you can use a method to evaluate your work to help you progress to your goal and achieve even more.

Stand back and take a gander

We mention this tip several times, but it's a great device. It's easy to use while you're working and helps you get perspective on your work. You've probably had the experience of going to a museum and finding yourself walking backward away from a painting or walking right up to a painting for a closer look. Every artwork has a viewing distance and it exerts a force on you to move to that position. Find the viewing distance of your painting and then walk back from it until the details start to blur together, usually 6 to 10 feet for the projects in this book. The distance is greater for larger paintings.

When you stand back the proper distance, examine each area of the painting with your viewfinder and ask yourself whether you made a decision about what you see. Did you just fill in an area of the background? Be sure that you have something going on, something for the viewer to see, in all parts of the painting.

Turn the painting upside down

Viewing a painting upside down is a good way to check your total composition. Flip your work upside down or sideways and look at it from a distance. This trick helps you focus on the shapes in the painting and less on the subject. Assess the overall composition for balance and check for dead areas in your painting.

Try the mirror trick

This method is like the upside-down trick, only it helps you spot almost all problems, big or small. Either use a hand mirror and look at the painting over your shoulder or hold the painting up in front of you while looking in a mirror. Wobbly ellipses, leaning doors, and uphill horizon lines all jump out at you. When you get that quiet sense of unease about your work or just can't seem to solve a problem, try this strategy.

Ask for someone else's opinion

Asking for another opinion is a delicate choice because you're exposing yourself to the judgment of another. We give you a few reasons for doing this:

✔ They have a better perspective because they haven't been working on the painting for hours. And they see things fresh that you don't see.

✔ They can spot something incongruous. Be prepared to hear something like, "Wow, that orange really stands out!" when you didn't notice that you had created something day-glo in your painting.

✔ Art is about communication. Just like writing or playing music, you want your work to be enjoyed and appreciated by others. So it helps you in the long run to have someone help you check your work, just like you have someone proof your writing or check your sound in a large hall.

Get a critique

Critique (pronounced: Crit-eek!). Definition: A review of a creative work with comments on its qualities. Because of the similarity to the word criticism, many people think that a critique focuses only on negative qualities. But the word actually is open and not specific in the type of comments it may contain. It can be written, like a movie review, or in person, as is done in most art classes.

A critique is when an individual (or a group of people) talks about your work and assesses all parts of your painting. In the best possible situations, the person acts as a stand-in for the public, your audience. He or she tells you when you have a problem with your drawing and when your colors sing. A critique can be painful, but it helps you grow as an artist and get to know your work and yourself.

When you're in an English class and you get a term paper back with red marks all over it, you don't take it personally. You see each of the typos and grammatical mistakes and you make corrections. That paper isn't you — it's a paper. Same goes with your artwork. When something doesn't work in a painting, it doesn't have anything to do with you. If you don't agree with the assessment, ask someone else's opinion and then listen.

Cleaning and Storing Your Tools

Here's how to clean your brushes every time you use them:

1. **Wipe off any paint solids from your brushes onto a paper towel.**

2. **Swish the brushes in the solvent jar and knock off the excess solvent on the outside edge of the jar.**

 You'll see the solvent running down the inside of the jar; it should look transparent. Never leave your brushes standing in a jar of solvent. It warps the bristles and ruins the shape of the brush.

3. **Put a small amount of liquid soap in your hand and swish the brushes in soap, shampooing and rinsing until the suds are white.**

4. **Rinse the brushes thoroughly, wipe them dry, and allow them to air dry completely until you use them again.**

 Remember to wipe up any paint with a paper towel before it has a chance to dry.

5. **Store the brushes so that the bristles are protected from being bent.**

 Either roll them in a canvas sleeve or towel to keep the bristles in good shape.

Never put any solvent on your skin or clothing. If you get a little paint on your clothing, don't worry. Just apply a little dishwashing liquid with water and it washes right out. Then launder as usual. If you get any paint on your skin, wipe off the big gobs with paper towel and then simply wash with soap and water.

When you're ready to store your palette and brushes, you have a couple of options. If you know that you'll paint again within the next two days, you can keep your paint on the palette. If you have a glass palette, cover it with heavy aluminum foil. The paint will stay liquid for a day or two and you'll save your paint. If you're using a disposable palette, tear off the top sheet, turn it over, and put it down on the next sheet. You can store it as is.

If you aren't going to paint again for a few days, you can dispose of your paint this way:

- ✔ **For disposable palette pages,** allow the paint to air dry and simply tear out the page and throw it away.

- ✔ **For glass palettes,** allow the paint to dry for one day and then scrape it off using a razor tool (the same type of tool you'd use to clean paint off a window pane). If you need to clean your palette before the paint dries, use the razor tool to scrape the paint off and wipe it onto a paper towel. Never use solvent or water on your palette; it only spreads the mess everywhere. And never put any solvent or paint in a sink drain — it's very bad for the environment and your pipes!

Wrapping It All Up

When your painting is complete, you want to make it presentable to others. Framing the painting, signing it, and giving it a title help you to show the work to its best advantage and make it identifiable to the public. These steps aren't absolutely necessary, but they allow you to share your work with others.

Come up with a title

The title may be descriptive, like *Sunny Day in Michigan* or *The Ceramic Jug with Pears.* It may give the viewer the idea behind the painting, like *Memories*

of *Summer* or *Lost in Thought.* Many artists don't title their work. You see many untitled works or paintings with numbers, such as *Composition #46,* in museums. We suggest that you either title the work or mark it with the date to help you keep track of it, but it's completely up to you. Just remember that if all your pieces have the same title or no title, you won't be able to keep them straight.

Sign the painting

Look at the work of some famous artists. Albrecht Durer created a symbol with the initials A and D locked together. Some artists sign only their first name, and some don't sign the work at all. Each piece should be identified somehow, even if the work is signed somewhere that isn't readily visible.

Points to remember:

- ✔ **Practice on bare pieces of canvas.** You can use a very small brush, or if you paint with thick paint, you can scratch your signature in the wet paint with the tip of your palette knife.

- ✔ **The signature shouldn't dominate the overall effect.** Use a color that almost matches the part of the canvas that the signature will be painted on — just one shade darker or lighter or a slightly different version of the same color.

- ✔ **The signature shouldn't be too big.** The viewer must see your painting first, not the signature. The effect to aim for is "Oh, what a lovely painting! Who made it? Oh, here's the signature, I found it . . . "

- ✔ **Don't use pencil or ink to sign the work.** It should be the same oil paint that you use for the work.

Frame the painting

If the painting is on a stretched canvas, it's possible to just hang the painting from the wooden stretcher bars on the back, but this isn't a good idea. It isn't stable, and it puts undue stress on the stretcher (especially bad for large paintings). And it looks cheap. A solid frame protects the canvas and reinforces the structure of the canvas. If the painting falls, the frame takes the impact.

The frame should make the painting look good and not compete with the artwork. Remember that it will be seen as a part of the completed artwork, just like every other element in your painting. Be careful of bright colors, ornate molding, and overly large profiles.

Take a look at your favorite paintings in museums. Do you notice the frame first or the painting? The artwork should always come first. That said, you

don't have to spend a fortune on good frames. You have many options open to you:

- Buy a pre-made frame at discount shop or secondhand store. This option is the least expensive. Some artists buy secondhand frames and then paint over any scuffs or odd colors to harmonize with their own work. Make sure that the frame is strong and stable. It shouldn't wobble — it should be made of strong wood or metal.

- Look for frame-it-yourself places. Some frame shops sell you the materials and teach you how to build a frame for your painting and save money on the labor. They can help you decide on the profile of the wood frame and the color to go with your work. These places also frame it for you for a low price.

- Art supply stores and online retailers will sell you pre-made frames or frame kits, some that you can buy at a volume discount if you know that you need a lot.

- At the higher end, you can find galleries that provide framing service and take care of everything for you.

After the painting is framed, you can attach a fastener (either a wire or a clip designed to hang paintings) to the frame to hang it. If you use a wire, it should be attached solidly to the frame with an eye screw or something similar. Secure the eye screw a third of the way down each side of the frame and attach the wire to hang the painting at a good angle.

Don't put glass over a painting. It interferes with the curing, or drying, of the painting. The only exception is if the painting is old and you intend to hang it in a smoky bar or a busy kitchen. The glass prevents tobacco and food from sticking to the painting. If you must use glass, be sure to use a spacer under the glass to prevent it from resting directly on the canvas.

Take care of your paintings

You put your heart and soul in your work, so of course you want your paintings to last. Here's some advice to help make that happen:

- Don't varnish your canvas for at least a year or two — oil paintings aren't completely cured for months. Varnishing the painting too early seals in the curing action and creates some unsightly effects on the painting surface.

- Don't hang the painting in direct sunlight. Your colors are lightfast, but the sun will bake them and damage the painting over time.

- Don't hang the painting near an air vent. Heat or cold blowing on the painting leads to cracks.

- Hang the painting in a sturdy, solid manner to prevent the work from falling down.

Keep records of the work you make — even if you think of yourself as a Sunday painter. At least take a snapshot of your work before you give it away or sell it. Artists call this documenting their work. Don't assume that you'll never need it. Something may come up where you need to show a portfolio of work and you'll be sorry that you didn't keep a record.

Part II
Break Out the Brushes and Start Painting!

In this part . . .

Here we go! You have your shiny new brushes and your paints, you cracked the plastic off your canvas, and you're ready to begin this exciting journey.

In this part you really get down to painting. We show you how to set up a subject to work from, how to lay it out on your canvas, how to apply paint, and all the stages of the painting process.

If you're a beginner, this part has easy, step-by-step projects that allow you to build all the skills you need to continue. For those of you who have painted before, we include some practical and technical info as well. All the projects are good practice and lay the groundwork for more complex subjects.

Chapter 6

A Study in Black and White

In This Chapter

▶ Setting up a still life from objects around the house

▶ Positioning yourself and your still life for best results

▶ Using a wash to sketch in the objects

▶ Developing your painting with a range of gray values

The best way to start learning how to paint is to make a simple oil study in black and white. This study gives you the chance to use your paints and equipment, and you can try out your work area to determine whether it's comfortable and whether it will work for you. A *study* is less formal than an oil painting, and it's intended to be completed in one sitting. If it doesn't turn out well, you've invested only a small amount of time in the project, and you've learned a few things about drawing on the canvas and blocking in the main darks and lights.

In this chapter we discuss, step by step, all the items that go into this study. When you've worked with black and white to your heart's content, move directly on to the next chapter — painting with color!

Starting Simple: A Black and White Painting

An oil study is just a quick painting, similar to a sketch. Making a study allows you to practice a bit and take the pressure off the idea of making an *Oil Painting*. By doing a study, you give yourself permission to make all those mistakes that you need to make while you're learning to paint.

Before you get started, make sure you have the following supplies:

✔ 14-x-18-inch canvas

✔ Palette

✔ ¼-inch flat or bright bristle brush

✔ ½-inch flat or bright bristle brush

- ✔ #1 round bristle brush
- ✔ Oil colors in white and black
- ✔ Viewing square
- ✔ Palette knife
- ✔ Turpenoid or Gamsol in a small jar

Setting up your still life

Start by scouting around the house to find some simple objects to paint from. Anything white will do: Eggs, paper towel or toilet paper rolls, Styrofoam cups, plastic bottles, and small boxes covered with white paper make good subjects. Collect five to ten objects so that you can experiment with different arrangements. Don't select objects that have a lot of print on them; plain objects are best.

Although white objects may not be glamorous, painting them simplifies your task while you're learning how to work with the paint. You have to think only about their forms and light and shadow; working with color brings a lot of other stuff to the table.

For the study that we use to illustrate the process in this chapter, we chose a box, an egg, and a coffee cup — nothing elaborate.

Here are a few rules to follow when arranging a still life:

- ✔ **Use an odd number of objects:** Three objects in a setting make a fairly balanced composition, as you can see in Figure 6-1.
- ✔ **Vary the size of the objects:** Objects that are small, medium, and large work nicely, although you can merely use one or two of the same type of item if you like (check out the different sizes in Figure 6-1).

For this still life, make an arrangement of the objects on a white cloth, and put a strong light on it so that the objects cast long shadows. A clamp light or lamp with an adjustable shade is perfect for this study. Group the objects together so that you can see each object, but don't group them so tightly together that you don't have any space between them. Try to arrange them to get interesting shadows as well.

A still life has a *foreground* and a *background,* and both are important. Many beginners concentrate so much on the objects that they're painting that they forget to think about their backgrounds. Arrange your objects so that the areas around them (the *negative space*) make interesting shapes as well.

You must be able to see the objects and paint without moving around too much, so position yourself and your canvas so that you're comfortable. You should be able to see the objects, your canvas, and the palette without shifting your body in a major way. Be sure to place your palette, paint, solvent jar, and brushes so that they're within easy reach.

You should be relatively still while you paint, moving only your eyes from the objects to your canvas. For more complete information on getting comfortable with your setup, see Chapter 4.

Using your viewfinder: Seeing things like a pro

Now that your work area is set up, you're ready to select an area of your still life to paint. A viewfinder is a handy tool that helps you compose strong pictures. You can find one in the Cheat Sheet at the very front of this book.

A *viewfinder* acts like a window onto your still life setup. It crops away the parts of your setup that you aren't going to use, making it easier to see what you're going to paint. To use it, hold it with your spare hand (that hand you're not painting with) and find an interesting section of your setup. If your viewfinder has marks, use the marks to help you transfer what you see in the viewfinder onto your canvas. The marks help you establish where the halfway and quarter points are, both in the viewfinder and on the canvas. Think of it like a grid of windowpanes.

Draw the shapes the same size and in the same position as you see them in the viewfinder. If an object is in the middle of the window in the viewfinder, put it in the middle of your canvas. You can also visually measure how tall and wide the object should be by comparing it to the marks on the viewfinder.

The height and width of the viewfinder window must be proportionate to the height and width of your canvas. If the window is horizontal, the canvas must be horizontal. If they aren't proportionate, your viewfinder will be about as much help as a carrot stick — and not as tasty!

Don't change the distance of the viewfinder from your eyes while you're laying in the drawing (see the upcoming section "The initial sketch" for more details on drawing); it will change the sizes of the objects in the window. If you must put it down, compare the view inside the window with the marks on the viewfinder and the objects in your drawing to help you reestablish the position.

As you lay in your drawing, make sure that all your vertical lines are parallel to the sides of your canvas, and that all your horizontal lines are parallel to the top and bottom of your canvas. Lining it up makes your drawing look much more solid, even if the shapes and proportions are off.

The initial sketch

Now that you're ready to start laying in the drawing on your canvas, you're going to be adventurous and begin by drawing with your brush and paint directly on the canvas.

You don't want to draw with graphite pencil on your canvas. The graphite will eventually bleed through the paint just like a marker bleeds through the paint on a wall if you paint over it.

Follow these simple steps to complete your initial sketch:

1. **Put a pool of white paint and a pool of black paint on your palette.**

 Each pool of paint should be about the size of a quarter.

2. **Use your palette knife to take a small amount from each pool and make a third pool of paint that's medium gray.**

 Be sure to wipe off your palette knife to avoid transferring and adulterating your colors.

3. **Dip your round brush into the solvent to dampen it, knock off the excess solvent on the side of the jar, and then touch the brush to your rag to take off the last drip.**

4. **Take a small amount of gray onto the brush.**

 Because the solvent is already on your brush, you end up with a wash of gray that's about the consistency of chocolate milk.

5. **Sketch in the egg (or the object that's closest to the bottom of the scene) with this wash.**

 You can see in Figure 6-1 how the wash is used to draw in the shape of the item. The placement of the egg toward the bottom of the scene tells you that it's closest to you. The egg appears roughly oval and horizontal, which indicates that it's lying on the table.

 Make the egg and all other objects about life-size or larger. The hardest thing to paint is a miniature!

6. **Still using the wash of gray, sketch in the cup on the right, and then sketch the box on the left.**

 Go back to your palette and pick up more wash whenever you need to. When you run out of the mixed wash, you have to dip your brush into the solvent and then the gray paint from time to time, mixing as you go to maintain the consistency of the wash.

7. **Use the wash to draw a line that indicates the back edge of the table.**

 This drawing stage — Steps 5 through 7 — should take only a minute or two.

8. **Lean back in your seat and take a look through your viewfinder to check the positions.**

 The points where the objects overlap one another tell you which objects are in front and which are behind. Check to see that the intersecting points are correct from your point of view. Look at the bottom of all the objects in your setup; the point where they rest on the table is called the *baseline.* Check to see whether your objects' baselines match the objects in the setup. Check to see whether the relative positions are correct now. It's early in the painting, and you can make corrections easily.

9. **Make corrections with a slightly darker shade of gray, drawing right over the top of the first marks.**

 Mix up a new pool of gray that has a bit more black in it this time. Use your solvent to make a wash as you did before. You can use the same brush without cleaning it because the colors are so similar.

 Draw right over the top of your previous drawing. Don't try to wipe out mistakes or use any solvent on the canvas to make corrections. As you continue to develop your painting, the mistakes will disappear under the additional layers of paint.

Sighting and measuring

It's a good idea to check your drawing on your canvas by using a technique called *sighting and measuring*. You don't need any special equipment — you can easily do this with just your paintbrush handle.

Sighting is a way of checking to see whether your objects are drawn correctly. You use your paintbrush handle (or anything that's straight and about 12 inches long) to visually compare the actual object to the painted object. Follow these steps to give it a try:

1. **Find an edge of a table or an edge of a box to practice on.**

2. **Hold out your paintbrush handle at arm's length and visually lay it along the edge of the item.**

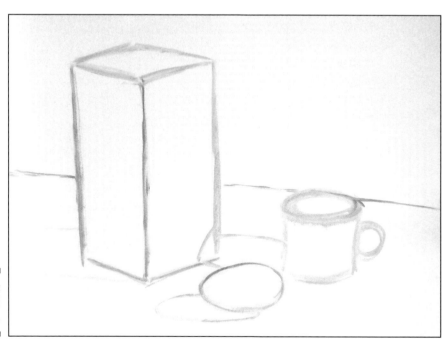

Figure 6-1:
The initial sketch.

3. **Close one eye to get rid of the double image.**

4. **After you're sure that you have the correct angle, lock your wrist and open your other eye. That's the angle that you're trying to draw on your canvas.**

Blocking in major shadows

Find the shadows in your setup, and lay the basic value pattern for your painting. A *value pattern* is the basic arrangement of darks and lights in a painting.

1. **Look at the still life and note the direction of the light.**

 Because you have a bright light shining on one side of the object (if you don't, check out the "Setting up your still life" section earlier in the chapter), each object should have a light side and a darker side. Notice how only the change in lightness and darkness distinguishes one object from another. The edges of many of the objects are defined by the difference between how light or dark the object is and the lightness or darkness of whatever is behind it.

 Squint as you look at your setup to help you see the patterns of dark and light more easily.

2. **Pick up the ½-inch brush, dip it into the solvent, and knock off the excess — but, this time, leave it fairly wet.**

3. **Pick up some of the gray wash you used for your initial sketch, and paint in the dark side of the egg, the cup, and the box (in that order).**

4. **Locate the shadow inside the cup and lay in that shadow as well.**

 Notice how the shadow inside the cup is on just one side (the opposite side of the shadow on the outside of the cup). This indicates that the cup is empty.

5. **Lay in the shadows cast by each object on the tabletop or any darkness in the background.**

 In Figure 6-2, you can see the cast shadows of each item. The shadows start at the bottom of each item and are roughly parallel. This indicates the source of the light. The background of this scene was outside of the reach of the light, so it's darker than the shadows in the setup.

6. **Back away from your canvas and take stock of your work.**

This manner of creating a painting is called working *general to specific*. You establish all the big shapes and patterns first. Don't get bogged down in painting details in the beginning stages of the painting. Or the middle stages. Working general to specific means that you start with all the big shapes and patterns of the composition, and with each layer of paint, the form of the objects becomes more defined. You think about how the whole composition is developing rather than concentrating on small areas.

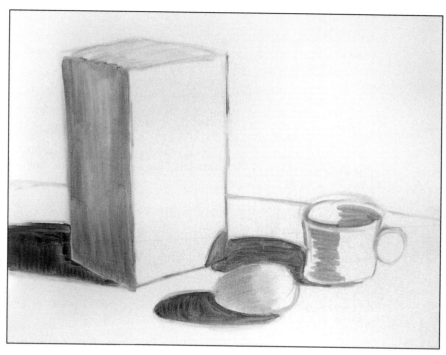

Figure 6-2:
Adding
in the
shadows.

Developing the image

The rhythm of the painting process is that you paint the main objects first, and then the secondary areas (in this case, tabletop and shadows), and then the background. Don't try to blend colors; just apply the paint in a blocky fashion until you fill the scene completely.

Now is the time to start using more brushes and different colors of gray. As you develop the image, you apply the paint in a thicker manner than you do in the initial sketch. The paint will be about as thick as a thin layer of butter on bread.

1. **Mix three versions of gray (light, medium, and dark), and use a different brush for each.**

 Use the different brushes to avoid cleaning a single brush every time you use it.

2. **Locate the areas of your scene that have middle gray shadows, and apply the medium gray to those areas first.**

 The side of the box or a cast shadow of the cup may be middle gray in your particular setup. Block in all the areas that have similar values.

3. **Find the areas of your still life that are the darkest, such as the area behind the edge of the table, and fill them with the darkest gray.**

 Filling in the background value helps you define the edge of the objects in the middle ground and the foreground. At this point, you don't have

to work all the way to the edge of the canvas — just block in the area around the main objects for this step.

4. **Now that you have the major values blocked in, continue to lay in more paint to indicate all the values that you see.**

 Don't blend the shades of gray just yet; leave them as they are.

 Adjust the amount of gray for each area as you go. Use the lightest gray to fill in those areas that are light and the medium and dark grays for the darker areas. Don't paint every last detail of any object — just block in the values in a general manner. You can work on the entire painting as you do, so that the image develops as a whole.

5. **Continue to develop and refine the image, making adjustments to the shape and values as you go.**

 Pick up more paint and apply a heavier layer of paint over the entire scene, item by item. Continue to use one color of gray with each brush to keep the values distinct and to keep things from getting confusing.

You're learning the rhythm of painting general to specific. As you develop the painting, you make changes to the main subject of the painting first. Then you adjust and resolve the secondary items to match the main subject's level of completeness. Then you do the same for the background. You'll find yourself naturally switching brushes and colors as you paint. This process continues until the painting is complete. Figure 6-3 shows the completed painting.

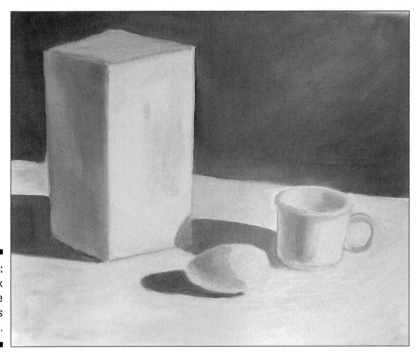

Figure 6-3:
The black and white study is complete.

Paint all the way to the edges and cover all parts of the canvas. Don't leave the white of the canvas showing, even in the area of your setup that's all white. If any part of the white primer is left uncovered, it will eventually yellow and ruin the effect of your painting. Establish light, medium, and dark areas on all the objects, the tabletop, and the area behind the objects. Find any cast shadows and be sure to include the background. Now that you've established a pattern of lights and darks, stand back and note your efforts.

Assessing Your Work and Making Corrections

After you've completed a still life study, it's time to assess your work. As you begin to paint, you may find that you're unsatisfied with your work but you can't identify why. Something just seems to be wrong. Lots of artists go through the same thing. Here we offer some points about how to look at your work and check the drawing and composition for your painting:

- ✔ Look though the viewfinder to determine whether the shapes, sizes, and positions of the objects look correct. Do they look like they were drawn from the correct eye level? Often just looking through the viewfinder makes the mistakes apparent.

- ✔ Use your paintbrush handle to sight the angles and sizes of the objects as described in the "Sighting and measuring" section earlier in this chapter. You can also use this sighting technique to find the central axis for the geometric objects, and check to see whether the objects look plumb. Use the paintbrush handle held horizontally to check the baselines for each object and compare them to the baselines in your painting for the relative positions of the objects.

- ✔ Do the sizes of the objects have a proportional relationship to the size of the format? Do they look like they're lost in space, or are they too cramped within the edges of the canvas?

Checking the painting:

- ✔ Did you create a wide range of value? Can you find dark grays, middle grays, and light grays in your composition?

- ✔ Did you pay attention to the background and other parts of the painting, aside from the objects?

- ✔ Have your objects been painted as a series of areas of different values? They shouldn't look outlined and filled in like objects in a coloring book.

Remember that this project is a learning device or an experiment. If you see things that you want to change, here are some tips:

✔ You can redraw through the wet paint with the tip of your palette knife. Just use it to scratch the correct line. Then you can paint up to that edge.

✔ If you have excess paint of the wrong color in an area, you can remove the paint with either a palette knife (if it's very thick) or with a rag (more likely). Don't apply any solvent to the canvas — it will only create a mess. Cover your finger with the rag, and wipe the excess paint off. As you wipe, turn the rag to expose a fresh, dry area, and continue to remove paint until you've removed the excess. You may have to wait until the canvas is a bit dry to repaint.

Relentlessly picking at a painting is like beating a dead horse. Paintings should look fresh. If you can't leave the painting alone, get another canvas and do another study of the same setup.

Chapter 7

Mixing Color and Three Oil Studies

In This Chapter

▶ Some basic color terms

▶ Mixing a wide variety of colors from a small number of tubes

▶ Using color to create lights and darks in a painting

*M*ixing and matching colors can be daunting. When you try to duplicate the colors of a juicy apple, you use your instincts and make red with black and white, but the results are dull and lifeless. Between trying to draw the apple and match the colors, the results can be frustrating. In this chapter we guide you through several projects that show you different ways to mix color.

We think that the best way to learn to mix color is to make a color chart. You can use a lot of colors and concentrate on making various tints and tones without worrying about making the colors match something real. A color chart is usually a big, labor-intensive project, but we have an abbreviated version that still walks you through all the spectrum colors and shows you how to make subtle variations of each color.

After you make a color chart, take the time to put your knowledge into practice with some oil studies (a study is just a quick informal painting). We instruct you to paint some studies with a *limited palette,* meaning that you don't use every color you have. You discover how to make lights and darks with color instead of black and white; this technique helps you avoid making the dreaded muddy colors that most beginning artists make on their first paintings. The studies are fast and increase in complexity with each project. We finish off the chapter with a painting using all the colors possible.

Project: Using the Color Chart to Mix the Color You Want

When you're ready to paint, start with a color chart — a user-friendly way to get to know color. By making a color chart, you can learn how to mix the tube colors that you purchased and begin to get a feel for applying paint to the canvas in a uniform manner.

Create a grid

The first step in this project is to create a grid. Mark off a 14-x-18-inch canvas with a grid of squares (see Figure 7-1 for an example). The chart is 12 x 12 inches, 6 squares high and 6 squares across. Each square is 2 x 2 inches. Use a 12-inch ruler and draw the squares lightly with a #2 pencil.

Don't use a charcoal pencil or a graphite pencil that will make heavy black marks; it will interfere with the color chart.

Across the top, label the columns as you see in Figure 7-1: Hue, Tint, Shade, Tone, Shade, and Tone. The following list gives you more information on each label:

- **Hue:** The hue is the color's name (such as red, green, blue, or another color) and refers to the color's position on the color wheel. You may want to think of these hues as sports teams' colors, like Bengals Orange, Colts Blue, or Cardinals Red. A *pure hue* is the brightest version of a hue.

- **Tint:** A tint is a lighter version of a hue. You make it by adding white to a pure hue.

Hue	Tint	Shade	Tone	Shade	Tone
Yellow Cadmium Yellow Light	Mix hue with white to make a color one step lighter	Mix hue with black to make a color one step darker	Mix hue with black and white	Mix hue with *complementary color to make a color one step darker *Violet	Mix hue with complement and white
Orange 1 part Cadmium Yellow Light 1 part Cadmium Red Light				*Blue	
Red 1 part Cadmium Red Light 1 part Alizarin Crimson				*Green	
Violet Ultramarine Blue with a touch of Alizarin Crimson and a touch of White				*Yellow	
Blue Ultramarine Blue with a touch of White				*Orange	
Green 1 part Cadmium Yellow Light 1 part Ultramarine Blue				*Red	

Figure 7-1: The diagram for the color chart with the formulas for each color.

✔ **Shade:** A shade is a mixture of the pure hue plus black. Another way to make a shade is to use the hue's complement rather than black in these mixtures. A *complement* is the hue directly across the color wheel from the hue that you're working with. In this project you mix shades with both black and the complement.

✔ **Tone:** A tone is a mixture of a shade plus white, or you can think of it as the pure hue plus black and white. You can also use the complement rather than black in the mixture. For a more complete discussion of color mixtures, see Chapter 17.

Down the left side, label the rows from top to bottom like this: Yellow, Orange, Red, Violet, Blue, and Green. Figure 7-2 shows a completed grid.

Work on a table or other flat surface for this project. Open your book on your work surface so that you can clearly see the instructions and the example. For the rest of this project, arrange your equipment so that your palette is right in front of you. Concentrate on the palette so that you can mix the colors accurately. Place your canvas with the grid marked on it off to one side and position your book on the other. Follow the directions in the following sections step by step.

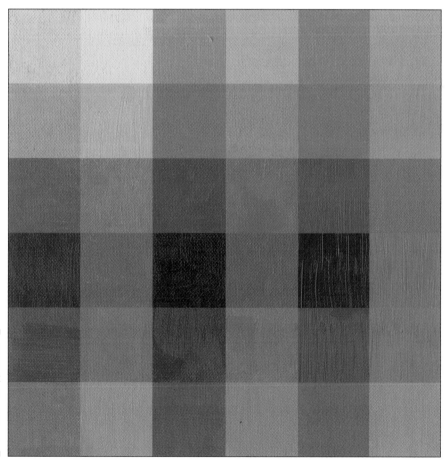

Figure 7-2: A completed color chart with all the hues, tints, shades, and tones.

Paint a hue

Because we can't be there with you to demonstrate how to paint the color chart, we describe the process step by step. To start filling in your grid, follow these steps:

1. **Start with cadmium yellow light.**

 Yellow is the easiest color to begin mixing because it's perfect right out of the tube. The first square of the top row starts with a pure hue — the pure unadulterated color of yellow.

2. **Onto your palette, squeeze out a half-dollar-sized pool of the cadmium yellow light that's about ⅜ of an inch thick.**

 This amount should be enough to last through the entire yellow row.

3. **Use your ½-inch bright or other square-ended brush to pick up a small amount of yellow and paint the first square.**

 Refer to Chapter 6 for step-by-step tips on applying paint to canvas.

 The first square falls in the row labeled *yellow* and the column labeled *hue*. Lay the paint on so that it completely covers the canvas and no white shows through.

Paint a tint

The next square is a tint, which is a lighter version of the pure hue. Follow these steps to paint the tint:

1. **On your palette, take a small, dime-sized amount of the yellow and put it over to one side.**

2. **Put a nickel-sized amount of titanium white on your palette.**

3. **Use your palette knife to pick up a very small amount of white (about the size of half a pea) and add it to the yellow.**

4. **Mix the yellow and white with your palette knife until the color is uniform.**

 Use the flat side of your knife to scrape the paint toward the center of the pool of color. If it isn't light enough, add a bit more white, but be careful to use a clean palette knife to pick up the color. You don't want any yellow in your white.

 You're learning the strength of the color as you go along. Adding colors together in small amounts means that you see the changes gradually and avoid making huge mistakes. You can always add more if it isn't enough, but you can't take it out of the mix, so take it slow.

5. **When you have a tint of yellow, apply it to the second square that corresponds to *yellow* and *tint*.**

 Do you feel like a painter yet?

Paint a shade

The next color that you mix is a shade of yellow. Use your knowledge of painting tints from the previous section and check out these steps:

1. **Take a small, dime-sized amount of the pure yellow and put it over to one side on an open area of your palette.**

2. **Add a *very* small amount of mars black.**

 Black is a strong color, so add it in tiny bits at a time.

 Your color will look green! It shouldn't be too dark; it should be a kind of pale green. If it's too dark, just add more yellow until you get it right. See Figure 7-2 if you're not sure whether you have it right.

 Sometimes when you mix a color, it's so far off that you find yourself using a ton of paint just to fix it. In these cases, cutting your losses is best. Correct a too-dark color by putting a small amount of the bad mixture off to one side and then mixing more of the hue with it until you get a better color. Don't discard the bad mixture; you may be able to use it later.

3. **Use the shade of yellow that you just made to paint the next square that lines up on your chart with *yellow* and *shade*.**

Paint a tone

A tone is a combination of the hue with black and white. You can mix this one just as you mixed the tint and the shade, by starting with pure yellow, but you may have enough of the yellow tint or the yellow shade left over to use one to make the tone.

If you have enough shade, just add white to it. If you have enough of the tint left over, add a tiny touch of black to it. This tone of yellow will look like a dull institutional green. Apply it to the *tone* square.

Pay attention to what you're doing because it's easy to lose your place by mixing the color on your palette and forgetting to actually put it on the chart!

Try yellow with complements

The next square in the yellow row is also a shade, but this time you don't use black; you use the complementary color to create a shade. Yellow's complement is violet (also known as purple). So at this point, you make violet according to the recipe from the chart. Just follow these steps:

1. **Mix together equal parts of alizarin crimson and ultramarine blue.**

 The color will be so dark that you'll have trouble telling exactly what color you have.

2. **Add a tiny bit of white (about the size of an ant) to the violet until you see the color (see the violet square in Figure 7-2).**

 This is the color you use to make a shade of yellow.

3. **Put a quarter-sized pool of pure yellow on your palette and then add a tiny amount of violet to make a shade of yellow.**

 Violet is a very strong color, so add it only in tiny amounts until you get something that looks like army green. You need enough for this square and the next, so make a pool about the size of a quarter, ⅜ of an inch thick.

4. **Paint the yellow *shade* square.**

5. **Take what you have left over, add a little white to make a tone, and paint the last square.**

Now your yellow row is complete. But wait, if you're going to do this work with the violet, you may as well just do the violet row! Check out the next set of directions to do that.

Make a violet row

Make enough violet (as you do in the previous section) to make a pool of color the size of a half dollar and about ⅜ of an inch thick. Go through the same steps as you do with the yellow:

- ✔ The first square is pure violet hue according to the recipes you see in Figure 7-1.

- ✔ For the next square, take a dime-sized bit of violet and add a little white to make a tint.

- ✔ To make a shade for the following square, take some of the pure violet and mix in a little black. It will be really dark!

- ✔ Make a tone for the fourth square by mixing the hue with black and white.

- ✔ At this point, you need some yellow to make violet's complementary shade. You should still have some on your palette. If you don't, the yellow that you need is fine right out of the tube.

 Use the yellow and violet to make a mixture that looks like a dull violet. If it looks greenish, you added too much yellow. To fix it, just take away a small amount of this bad color and add in more violet hue to it. Then you can paint in the next square.

- ✔ Finally, fill in the last square with the tone. Check the squares that you've completed to be sure that each square has a good coat of paint and that no white canvas shows through. You can make corrections now while you still have paint on your palette.

Take a break

Sit back a moment and take a break. You've completed two rows of your color chart. We hope that you can see the sequence that we're walking you through. You're learning how to make a pure color and how to use it to make five other versions of that color. Now you can continue on. Clean your brushes in a glass jar of Gamsol or Turpenoid and wipe them off well so that no residue from the old colors remains. Make sure that you have enough space on your palette to

make the next set of rows. If not, get out another sheet of palette paper (if you're using disposable sheets) or use your razor tool to scrape off a clean area on your glass palette.

Complete the remaining rows

Consult the color chart in Figure 7-1 for the recipes for each color that you need to create the hue column. The chart also includes the recipe for each of the tints, shades, and tones. Do the orange row next, followed by its complement, the blue row. Then complete the red and the green rows. At each stage, make the hue, the tint, the shade, the tone, and so on until you finish the row. Try not to stop your painting session in the middle of a row. Completing a row during a single painting session ensures that your color is harmonious and uniform. Compare your completed chart with the one in Figure 7-2. Don't worry if your color chart is lighter or darker overall. That's part of working with your own judgment.

Sit back and assess

To assess your work, note the following:

✔ Each row should go together. The yellow row has colors that look yellow and green, and the orange row has colors that look orange and others that look like a brownish color, but otherwise they all look like versions of the original hue.

✔ Vertically, the hue column looks very intense. The tints column looks pale or light. The shades look intense, but darker than the hues, and the tones look dull.

✔ If you find that the last two squares of a row look very different, like they don't belong in that row, you likely added too much of the complement. Don't worry about it. You're learning how to mix color, and if isn't just right, you have plenty of time for more practice with color in Chapter 17.

Project: Finding Your Local Color: An Analogous Painting

Painting objects in color can be tricky for the beginner. Your instincts tell you to use black to make a color darker and white to make it lighter, but the effect just kills the intensity of the color. The problem with black and white is that they neutralize the color, and everything starts to look rather gray and blah.

In this section, we tell you how to use closely related colors to make things appear sculptural and three-dimensional without killing the color. We describe, step by step, how to use analogous color to make things appear lighter or darker.

This is a study — not a serious painting — so making mistakes is fine. We just want you to feel comfortable trying out new ideas.

You're learning to use color to make the objects you're painting appear lighter and darker. For this painting you won't use any black or white. Put the tubes away so that you aren't tempted to use them. We recommend a 14-x-18-inch canvas for this project.

Set up your still life

If you want to follow along with us, gather a green apple, an orange, and a lemon. The fruit should be real, but if you use fake fruit, be sure that it looks realistic. Funny-looking fruit makes a funny-looking painting! Arrange the pieces of fruit on a cloth similar to the one you see in the example in Figure 7-3. Set up your arrangement and your lighting as closely as you can to the photograph of our setup.

You may be tempted to work from Figure 7-3 rather than your own setup, but we can't stress enough the importance of working from observation. Painting from observation is like learning a new language, and like language, practice is important.

If you want to work with different objects, look for objects that are only one color. The citrus fruit and the green apple are good because they're the same color top to bottom. Objects that are medium or light in color are best for this exercise, so avoid eggplants, dark red apples, and other dark fruits and vegetables. We walk you through working from these types of items later in this chapter. You can also use boxes covered in plain, vividly colored paper.

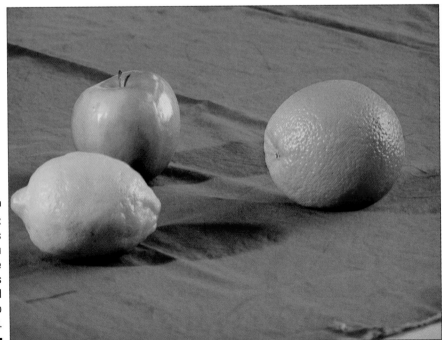

Figure 7-3: In this photo, you see the objects arranged and ready to paint.

For the table and background, select bright fabrics. Felt is good choice, but any non-shiny fabric will do. (Avoid using satin. It's pretty, but it will make you crazy if you haven't painted before.)

For this exercise, limit your setup to three items and light it with a strong spot from a low angle (see Chapter 16 for more info on lighting). Study the example in Figure 7-3 to see how to do this.

Frame and sketch

Use a viewfinder to frame your scene — if you've already done the black and white painting in Chapter 6, you've had some practice at framing your scene. Next, you begin sketching in paint with a light color. Cadmium yellow is a good choice. Make a wash of the color with your solvent, and use the wash to draw the objects out — again, just like in the black and white painting (see Chapter 6). Be sure to make the objects nice and big, at least life-size. (See Figure 7-4 for an example of the still life with some color blocked in.)

Now put down your brushes and study your drawing. Ask yourself the following questions:

- ✔ Are the objects running off the edge and cut off by the edge of the canvas? Redraw so that most of the objects fit.

- ✔ Are the objects nice and big? If you're using small items, make sure that each item is about the size of the palm of your hand but no larger than the size of your entire hand.

Having a good setup is half the battle! Make corrections to your drawing by choosing a color slightly darker that the first. As you can see in Figure 7-4, we use cadmium yellow for the initial drawing, and then switch to yellow ochre. Be sure that the mixture is thin; it will look like colored water, not paint. Using a different color helps you keep track of which line to use when you begin to develop the painting.

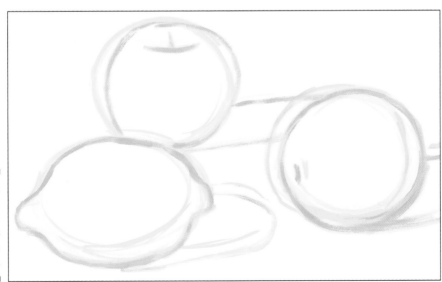

Figure 7-4:
A drawing in yellow with corrections made in orange.

Find the local color

Look at the objects you have and ask yourself what colors they are. The green apple is more yellow-green than green; the orange is, of course, orange; and the lemon is yellow. This is called their *local color,* the natural color of an object as it appears in normal light. Don't worry about the effects of lights and shadows yet; just concentrate on the local color.

Now mix a small pool of color to match the local color of one of your objects. You need about the same amount that you use for each square of the color chart (see "Project: Using the Color Chart to Mix the Color You Want" for details). The recipes from the color chart will help you get the color you need. Start with the orange, and mix a color similar to the orange on the color chart. You may have to adjust the actual color by using more cadmium yellow light or cadmium red light to get the color just right.

To match color perfectly, put some of your paint on your palette knife and hold it up to the object. Make sure that you hold it up to the side of the orange that's evenly lit — not the shaded side or the highlighted side. If you see a color in the object that's missing on the knife, add that color. For example, if your orange (the fruit, not the color) looks more yellow than the paint on the knife, add yellow; if it looks more reddish, add red. Experiment with the cadmium yellow light and cadmium red light as well as yellow ochre to get it just right. It takes practice, but like tasting soup for enough salt, you try and try and add just a little bit at a time until you get it right.

Choose analogous colors

Refer to the color wheel from the Cheat Sheet in the front of this book. Find the color that comes the closest to the color of the orange in your still life. What colors are on either side of it? For orange, you see yellow-orange on one side and red-orange on the other. If you go one more step out, you see yellow on one side and red on the other. These colors are *analogous,* or closely related, to orange. Find the tubes of colors that match these colors and put them on your palette as well. You don't have to mix anything at this point — just squeeze out small amounts, about the size of a dime, and arrange them on your palette about 3 to 4 inches apart. If you're concentrating on the orange, you have cadmium yellow light, cadmium red light, yellow ochre, and alizarin crimson.

Begin applying color

Take the orange paint that you made and apply a thin wash to the orange on your canvas. Cover the middle and shaded side of the orange with this color. As you get to the part of the orange that's lighter, pick up some cadmium yellow with the same brush and add it right to the canvas. It will look yellow-orange; you can also add more pure yellow to the exact point where the light hits the orange.

For the shaded side, make a color that's more red-orange. Use a fresh, clean brush to apply it to the underside of the orange on your canvas. Now your orange fruit is orange with yellow highlights and a red-orange shaded side. You can use a red that has a bit of alizarin crimson for the very bottom of the orange.

Don't blend the colors. Apply them in a blocky fashion. Don't get too picky — just block in the colors and leave them. Don't remove the color from your palette; just leave the paint on your palette and move on to the next object.

Paint objects with analogous colors

You can use any related color as an analogous color. You can paint an orange by using cadmium yellow light, cadmium red light, yellow ochre, or any yellow-orange-red type of color. You can paint a green apple by using cadmium yellow light, yellow ochre, or any green made with a blue and a yellow.

Continue with the rest of the painting

Now you can work on the remaining elements of the painting.

Lemon

The lemon is a little tricky because its local color is cadmium yellow light right out of the tube, and that's the lightest color you have. Yellow is the lightest color on the color wheel, so it functions as the highlight. With yellow objects, you have to figure out which direction to move on the color chart to find the analogous color (a color similar to yellow) to create a shadow of yellow that looks like it belongs on a lemon. Paint the entire lemon cadmium yellow light, and then move on to the shaded side.

Your analogous color options are green and orange. When you look closely at the lemon on the shaded side, you notice that it looks greenish on the darker side. So use yellow for the highlight and yellow-green for the shaded side. Experiment with different greens for your lemon. You may have a tube of green, or you can make green using yellow and a blue — either ultramarine or cerulean. You can try yellow ochre or some of the orange types of color, but the color may end up looking more like a squash than a lemon.

Green apple

Move on to the green apple. Your sketchy line is going to be basically round, but you know that the shape of an apple is significantly different than that of an orange. The stem comes out on the top through an indention. Refer to Figure 7-5 and follow these steps:

1. **Using a yellow wash for your drawing, adjust the shape of the apple.**

 It may be more squat than a perfect circle, or it may have tapered sides.

2. **Find the little indention at the top of the apple, and use your yellow to make a mark.**

 Too low or too high? Change it with the next analogous color (like yellow-green).

3. **Use yellow to establish the structure of the apple by making a center line right through the middle of the apple like you're stabbing it.**

4. **Draw an ellipse on the top of the apple (as you see in Figure 7-5), and then make a second ellipse to mark the shoulders of the apple.**

 You've established the structure of the apple.

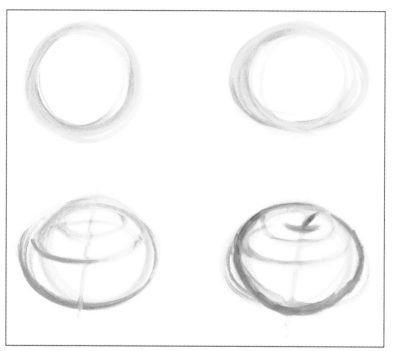

Figure 7-5:
How to
draw an
apple.

A green apple's local color is yellow-green, so mix that up first. The apple also has yellow highlights and a green-shaded side. Use cadmium yellow, and a tiny bit of both ultramarine blue and cerulean blue. These colors are analogous to the apple's local color of yellow-green. See how that works?

Find the shaded side that's away from the light, and paint it in with a thin wash of yellow-green. Continue to fill in the lights with yellow and the shaded side with green. The green is in the top indention and also off to one side of the indention. Use yellow or a lighter version of yellow-green to fill in the lightest part of the green apple.

The cloth and background

Establish the correct color for the cloth and for the cast shadows on the cloth. We use a blue cloth, but you may have something different. Identify the local color of your cloth first, and then the analogous colors. Don't get fancy. The right answer to the question could be what you'd hear from a 5-year-old, "What color is it? It's blue." If your cloth is blue, refer to your color chart to

help you mix the color on your palette. For our cloth, we use cerulean blue and ultramarine blue. Find all the blues, blue-greens, and blue-violets that may work for your cloth. The shadows cast by the objects onto the cloth are a darker version of the color of the cloth; they have nothing to do with the color of the object casting the shadow.

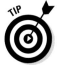

Don't worry about the effects of light on the cloth. If you're getting some shine off the material, just ignore it for this study.

Take the color of the cloth and the color for the cast shadows and apply them to the painting in a thin wash.

The final area you need to consider is any of the background that hasn't been painted yet. No matter what you see beyond your setup, you want to paint it very simply. For the purposes of this exercise, choose a dark, cool color, such as blue or blue-violet, and fill in the background with a thin wash.

Assess your work

Stand back about 6 to 8 feet and assess the result of your still life. Remember that this is a study; don't worry about details. The painting will appear bright, vivid, and rather gaudy, as you can see in Figure 7-6.

Ask yourself these questions:

✔ Can I tell the direction of the light?

✔ Is the lighting consistent and believable looking?

✔ Can I tell what each object is? That's a bonus!

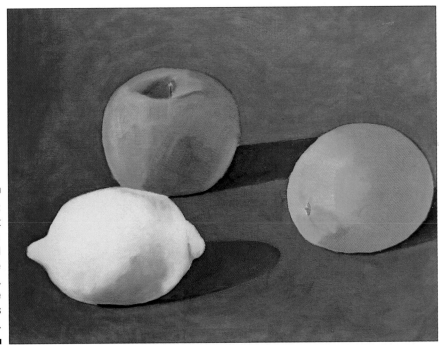

Figure 7-6: Not bad. At least you can tell what the objects are, and the lighting is consistent.

You have a successful study. Now you can go back and apply a heavier layer of paint on each item, the cloth, and the background. As you work, you can vary the color that you put on the items to create more complex color. In each case, try the analogous colors to experiment with the tube colors that you have.

Project: Using Complementary Colors

Complementary colors are colors that are opposite each other on the color wheel. The opposite of orange is blue; the opposite of green is red. Use complementary colors to add depth and complexity to your paintings.

For this study, start out the same way you do for the previous project on finding local color. Draw the items on the canvas so that they're life-size or larger by using a light version of the local color. Continue painting by blocking in the major colors and highlights as you do in the analogous painting. But in this painting, you add complementary colors to the mix. This is how it works:

- ✔ For the middle value of each object, use the local color, as you do in the previous project.

- ✔ For the highlights, use the lighter analogous color to indicate the direction of the light.

- ✔ For the shaded side, use the darker analogous color plus a little of the complementary color to make a shade of your local color, just like you do on the color chart in the first project in this chapter.

Start this project with the same objects, equipment, and supplies that you used in the previous project. You're still using only colors — no black or white.

Think about the colors

You may have to figure out what complementary colors you're using. Oranges are easy — the complement is blue — and lemons are yellow, so their complement is violet. But what about that green apple? It's more yellow-green than true green. The complement is the color directly across the color wheel (see the Cheat Sheet in the front of this book). In this case, the complement is red-violet. In every case use a little of the complement for each color in the shade. Learn as you go and experiment.

Paint your study

1. **Start your complementary painting as you do the analogous painting ("Project: Finding Your Local Color: An Analogous Painting").**

 Start with a wash of yellow (or live dangerously and try another light color, such as yellow-green or cerulean blue) and sketch in all the objects in your setup.

2. **Continue the painting with the local color for each object, and use the analogous color that's lighter for the highlights.**

 Don't go forward with the cloth just yet — concentrate on the fruit for this step.

3. **Start with the orange and mix up some orange paint with a little bit of blue paint; apply this color to the underside of the orange.**

 See the color chart from Figure 7-1 for more info. The result should look brownish; if it's going toward green, add a tiny bit of red until you have something that looks like dark orange.

4. **Adjust the colors on the orange until you have a broad range of value and the color looks true, as shown in Figure 7-7.**

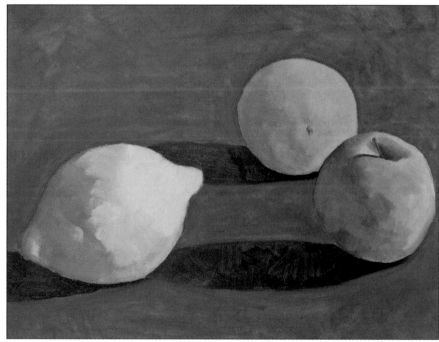

Figure 7-7: A completed still life study using analogous and complementary colors.

Fine-tune your colors

In each case, mix the local color of the object and the analogous colors to create a variety of lights and middle color. Then add a bit of the complement for the shaded areas. Here are some tips:

- ✔ For the green apple, try cadmium red.
- ✔ For lemons, try violet made with ultramarine and alizarin crimson.
- ✔ For red peppers, use a green made with ultramarine blue and yellow.
- ✔ For green peppers, use alizarin crimson (the cadmium red is too light and it won't create a shadow).

Now paint the cloth by using the complement for the shadow, and paint the background simply as you do in the previous project on finding local color.

Assess your work

Sit back and assess your work. You're giving the oil paint a chance to set up a bit, and you're gaining some perspective on what you've achieved. Some objects will look pretty good, and some may look a bit iffy. Don't worry, and don't hold yourself to too high a standard. You're still practicing!

Consider these questions: Are the objects well drawn? Can you tell the direction of the light?

The colors are way over-the-top bright on both the analogous painting and the complementary painting. It looks like Matisse in North Africa. The sun is intense and it lights up all the colors until it's difficult to look at them. Whew!

Did you cover all parts of the canvas? Touch up any blank areas and then put them aside to dry.

Project: Full Color Painting

Now you're ready to start on a painting that includes all the colors. Use the same-size canvas, equipment, and paints as you do in the other projects in this chapter, but now you can use black and white paints, too.

Set up your still life

You can use the same objects for your still life setup, or you can branch out and try something different. We use a white sugar canister, a red apple, and a lemon on a blue box and it all sits on a green cloth.

Paint with all the colors

Refer to Figure 7-8 to see the initial sketch for this project. The following steps walk you through this painting:

1. **Begin with a wash of color for your drawing, and then add a wash of the local color of each object, the analogous color for the highlight, and the analogous/complementary color for the shaded side.**

 For example, we start with the apple at the stage where it has color all over it and it's sitting on a cloth with a cast shadow. (Skip forward to Figure 7-8 to see what we mean.) The colors are all blocked in, and it's super bright.

Figure 7-8:
Initial
sketch for
the still life
painting in
full color.

2. **Make up the color that you use to apply a thicker coat.**

 We have red for the middle area and red-orange for the highlight.

 Add a little white to the red-orange — just enough to look like a highlight. The wash for the underside of the apple has some red-violet plus some blue. It may look just great as it is! But experiment and make up the same color again — red, red-violet with a little blue — and then put a touch of black in it. Apply this to the apple. Does it improve the effect, or does it look dull and weird? That's the issue with black.

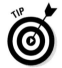

 Many artists for many years have said that black shouldn't be used in painting. They say that it kills the intensity of the colors, makes things look dull, and is an easy crutch to making paint darker. Most artists use the complement to make a color darker or a combination of other dark colors mixed with the local color along with the complement. This is a truism that you'll hear, and many people get really intense about this issue. But sometimes you just have to use black to either correctly match a very dark color or to depict a color that isn't brightly lighted. The important thing to remember is that it's your painting, and you can decide for yourself whether using black is effective or not.

3. **Continue with this approach for the canister, the lemon, the box, and the cloth.**

 Use the analogous colors first. Adjust them with some white in the highlights and in the complementary color on the shaded side. You may or may not want to add some black in the shadows. Some of the objects present some challenges.

4. **Paint the canister — or any other white object that you use — just like you do in the black and white painting (see Chapter 6).**

 As an object with no color of its own, it picks up some reflected color from other surfaces (see Figure 7-9). See how the underside of the canister picks up just a bit of the green? You can also see a bit of red reflected from the apple.

5. **Paint the darker objects — like the dark red apple — by using a combination of everything we tell you about in this chapter.**

 The apple's local color is made with alizarin crimson and cadmium red light. The highlights have white, and the shaded side has the local color plus ultramarine blue and viridian. These colors are all transparent (see Chapter 2 for more information); you may have to add a touch of black to make the paint opaque. This will happen whenever you use the transparent colors.

6. **Complete the rest of the painting as you do in the projects throughout this chapter.**

 Use all the colors you have and experiment a bit to become familiar with the way they interact. Be sure to cover the entire canvas with paint — leave no bare areas of canvas showing. You can repeat any of these studies for more practice, but you're ready to move on to some other subjects.

Figure 7-9:
The
completed
still life.

Chapter 8

Putting Paint to Canvas: Brushstrokes and Glazing Techniques

In This Chapter

▶ Using basic brush techniques and different types of brushes

▶ Glazing and other fancy tricks

▶ Trying a painting technique project

*Y*ou've most likely painted something in your life: a kitchen, a garage, or a poster for a school event. So, you know that brushes pick up paint and then spread it evenly over a surface. But fine art painting is more than just covering a wall or lettering a sign. Artists' brushes can do many things, from making a clean edge to showing the texture of foliage to blending the blush on a baby's cheek.

In this chapter, we cover all the brushes out there, including sizes, shapes, and their uses. We explain some basic ways to use brushes and then move on to some interesting ways of creating layers of color.

Painting with Your Brushes

At this point, we assume that you have your equipment and have already made a few paintings. After the first three or four paintings, every artist begins to develop a preference for a particular brush. You'll catch yourself staring at the brush and saying endearing things to it. Maybe it's the shape or the size or just that it's a different (better quality) brush than the others you picked up. You're getting to know brushes and what they can do.

Working with a good brush that suits your painting methods means that the painting process feels more natural. So, make a note of the shape, size, and brand of your favorite brush. Write it down. When it's time to go brush shopping, you can make some informed choices. In the following sections, we go over some of the basic features of your brush so that you know what to ask about.

Paintbrush basics

A paintbrush is made up of bristles, the handle, and the *ferrule* (that little sleeve of metal) that holds the bristles to the handle. Brushes are usually about 12 inches long, which allows you to vary the brushstrokes just by changing the way you hold the brush. Here are some examples:

- By holding the brush down by the ferrule, you use the small muscles of your hand and fingers and have fine control over the strokes.

- By holding the brush farther away from the ferrule, you have a looser hold on the brush for loose, expressive strokes. Some artists make specific use of the brush to get this quality. Swiss artist Alberto Giacometti attached extensions to his brush handles to make them as long as possible in order to have the least control over his brushstrokes.

The handle also makes a convenient tool for measuring and sighting. Use the handle of the brush as a bridge to steady your hand while you work. Balance the end of a dry, clean brush against the side of the canvas or easel to support your hand while you paint with another brush. *Mahl sticks* are tools made especially for this purpose.

The size and shape of the bristles determine what type of mark the brush makes:

- A short, square-ended bright makes square corners and tight edges. You can easily control it. This brush is great for geometric shapes or man-made objects.

- Long, floppy filberts make elegant, organic, lozenge-shaped marks, perfect for organic, natural objects.

- In addition to regular bristle brushes, you also see brushes with sable or synthetic fibers. These brushes are more delicate than the bristle brushes and leave less of a mark. So, you have a choice of shape, size, and type of bristle.

Choosing the right brush

Brushes come in four basic shapes: filbert, flat, bright, and round (see Figure 8-1). Each makes a distinct mark and is useful, so get one of each! Check out the following list for more info on each brush:

- **Filbert:** Paint natural organic forms, leaves, clouds, and living things with this brush.

- **Flat:** Paint large areas of color, geometric forms, square corners, and clean crisp edges; or make blocky marks for a cubist manner of painting.

- **Bright:** This brush is shorter and stubbier and holds less paint than a flat, but you use it in a similar manner.

- **Round:** You can use this brush like a filbert, but it's also great for drawing lines.

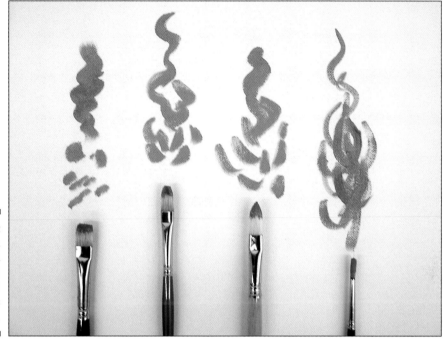

Figure 8-1:
Bright,
flat, filbert,
and round
brushes and
the marks
they make.

In addition to the basic shapes, you may also be enticed by some fancy brushes and even brushes that aren't intended for oil painting at all. Cosmetic brushes may even find their way into your box. Many artists use unorthodox tools to get the job done. Here are some of the not-so-basic tools that you may want to try:

- ✔ **Fan brushes:** Use these brushes for fine blending. They aren't absolutely necessary for blending, but many artists find them useful.

- ✔ **Extra long filberts:** These brushes make very loose, expressive marks.

- ✔ **Watercolor brushes:** Although they aren't made for oil paint and the solvent eventually damages the fibers, some artists use them anyway.

- ✔ **Stencil brushes:** Chubby and round, you can use a stencil brush for dry brush.

- ✔ **House painting brushes:** These come in large sizes for big projects. Latex house painting brushes are great to apply gesso when you're preparing your canvas. House painting brushes can be used for blending and dry brush as well.

- ✔ **Foam brushes:** These brushes aren't made for fine art painting, but you can use them to pick up excess paint and for dry brush.

- ✔ **Painting knives:** A painting knife is a palette knife that's more rigid. Use it to pick up paint and apply it to the canvas like a trowel. Painting knives come in various shapes and sizes.

In Chapter 3, we recommend that you get only china bristle brushes. They have stiff, off-white bristles. They're tough and no-nonsense and stand up to the abuse of a rookie painter. After you've painted for a while, try out some of these other types of fibers that are available:

✔ **Sable:** Use these for soft blends. They're delicate and need more care than bristle, but they create a quieter kind of mark, or no mark at all.

✔ **Synthetic brushes:** These brushes come in soft fibers similar to the natural sable, as well as stronger fibers. They aren't as tough as natural bristle, but they aren't as soft as sables either. They behave much like sables, but they're a bit more durable.

A soft bristle brush, whether natural sable or synthetic, allows you to make soft gradual blends and work with more delicacy. Only you can decide whether this is a key part of the way you paint.

Once upon a time, using synthetic brushes with oil paint wasn't recommended. The solvent damaged the synthetic fibers, and the brushes ended up bald or hard as a rock. Synthetics were for acrylic only. Now, the new synthetic bristles are tough and as long lasting as hog bristle. But always check when you buy them to make sure that your brushes are designed for oil painting.

Examples of brushstrokes

In Chapter 10, we cover several ways to apply paint to canvas in an immediate, direct painting manner. This manner of painting is also called *alla prima,* meaning "from the beginning" or "all at once." Alla prima paintings are completed in one session. We painted Figures 10-5 and 10-9 on small 8-x-10-inch canvases, so we had to use relatively small brushes. Remember that the brush size depends on the overall size of your format. Generally speaking, you use small brushes on small canvases and larger brushes on larger canvases. The size of the mark they make has a proportional relationship to the size of the canvas. Check out the figures in Chapter 10 and this list for some examples of how this works:

✔ Figure 10-5 is a simplified painting of a building. We painted the three sides using a #1 flat brush for the corners and a #4 flat to fill in the color for each side. Use a #6 and a #8 flat for a 14-x-18-inch canvas.

✔ A study of grasses is in Figure 10-9. We painted all the various blades of grass with a #2 round. Use a #4 round for a 14-x-18-inch canvas.

✔ A painting of a bush in Figure 10-9 shows how to apply paint in small dabs of color. We painted the leaves and small bits of shadow using #2 and #4 filberts. Use #4 and #6 filberts for a 14-x-18-inch canvas.

✔ A painting of two pine trees, also in Figure 10-9, shows how to apply paint in patches of color. We used a #4 filbert. Use a #4 or #6 filbert for a 14-x-18-inch canvas.

We started each of the landscape paintings with larger brushes in the darker colors, and then we added middle values with smaller brushes. We added the highlights last with the smallest brush.

For example, in Chapter 7, Figure 7-6 is a still life on a 14-x-18-inch canvas. We applied the patches of color for the shadows on the fruit by using a #4 and #6 bright. We established the local color and painted it in with the larger brush, and then we added the shadows with the smaller brush.

This really isn't a science. Your humble authors each have a preference for the type of brush that we use. One of us paints almost everything with round brushes and the other prefers flats and brights. You know what brushes you prefer after working on three or four paintings. Trust your gut instinct and buy the brushes that you know you'll use the most.

Exploring Different Types of Glazing

One of the advantages of painting in oil is that you can work in layers of color. The big overall term for this technique is *glazing*. Glazing is one of those confusing art terms that has two meanings:

- Glazing can refer to any type of painting that allows you to see two distinct colors at the same time. You can see this definition in layers of color thinned with medium, or when paint is scraped or scratched off a surface. You can also see it when paint is stippled in small spots of color.

- Glazing also refers to the particular type of painting in thin layers where you dilute a transparent color with a painting medium. We do this experiment in Chapter 2 when we tell you about the different properties of oil paint.

Up to this point, we've concentrated on establishing a good uniform layer. Now you can explore some other properties of oil paint. As a bit of history, oil painting owes a lot of its knowledge to the Renaissance artists. So, now you get to learn some fancy Italian terms for painting as well.

Bringing out the undertones: Imprimatura

Imprimatura refers to starting with a colored surface instead of a white ground. Use it to establish the undertones. You can achieve imprimatura through two different methods:

- **Method 1:** When you make your own canvas, tint the last coat of gesso with acrylic paint (not oil paint — it won't mix). Keep the color subtle. The color you choose has an effect on how the overall color of the painting turns out.

- **Method 2:** When you have a pre-made canvas, stain it with a fast-drying coat of paint. You can leave a uniform field of color or wipe some color off in a pattern for your initial drawing for your image. (In our example in Figure 8-2, we applied a wash of yellow ochre to the canvas.) Allow the paint to dry just a little bit, and then take a rag or a clean, dry paintbrush and wipe away some of the paint to establish the light areas of your image. Let it dry completely before continuing with the painting. This technique works a lot like a *subtractive drawing* (drawings made by covering the paper with charcoal and using an eraser to pull out the light areas of the drawing rather than laying in dark areas as the way you normally do).

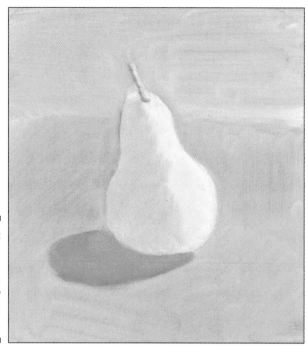

Figure 8-2:
Imprimatura
applied to a
canvas with
yellow
ochre using
method 2.

Painting with transparent paint (also called glazing)

To create a glaze, you need a glazing medium. Follow these steps:

1. **Start with a transparent color, and dry the paint by letting it rest on a piece of paper until you see a ring of oil on the paper (it should take about two hours).**

2. **Transfer the stiff paint back to your palette and use your palette knife to mix the paint with a glazing medium until you have a syrupy consistency.**

3. **Apply this glaze with a soft, dry brush in a thin uniform coat over dry paint.**

 Glazes are usually a dark color applied over a light color. You may have to work on a flat surface if your glaze is too syrupy and drippy.

In Figure 8-3, artist Michael Schulbaum used a classic glazing method on this still life painting. He painted the entire image — bottles, cloths, and gold medallions — in shades of gray only. After the paint was dry, he added the glazes over parts of the images so that the gray remains visible but you see the images through the thin layers of color. Look closely at the bottle with the red liquid. On the top half of the bottle you see the glass in grays only; the artist added the liquid by painting a glaze of vermilion and other reds over the gray. You can still see the lights and darks of the gray underpainting while you see the red liquid at the same time. The artist used the same method to paint the yellow bottle and the cuff links.

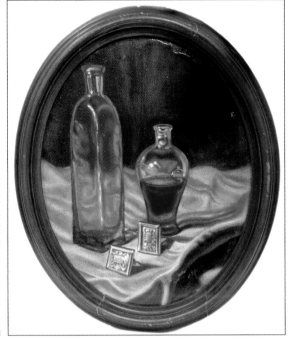

Figure 8-3:
A still life
painting
using glazes
of reds and
yellows.
Courtesy of
Michael
Schulbaum.

Scumbling and sgraffito

Scumbling is a thin or transparent layer of paint that's rubbed or scraped off. Start with an area of your painting that's dry and apply a thin wet layer of oil paint. Then rub or scrape off enough so that only a residue is left behind. This technique works well with opaque colors, especially a light color over a dark color.

Sgraffito is similar to scumbling but you scratch off the paint to make definite marks, lines, or textures.

Figure 8-4 shows an example of both scumbling and sgraffito.

Figure 8-4:
Two
techniques:
sgraffito
(left) and
scumbling
(right).

Trying the dry brush technique

Dry brush is the application of a stiff, dried paint with a dry brush on a dry surface (see the earlier section, "Painting with transparent paint [also called glazing]" for more information). The effect is small specks of paint that stand up on the surface.

Use a light touch and a stiff, dry brush as you drag the brush over the painting. Hold the brush at a shallow angle in relation to the canvas. The paint sticks only to the parts of the painting that are prominent. A rough-textured surface is more effective than a smooth canvas, and it produces more specks. This technique works best when applied with a slightly hard brush over a textured surface. In our example in Figure 8-5, the artist used dry brush to paint the light and dark creases of the denim jeans. The close-up of the details is shown as well.

Adding texture with impasto

Impasto is painting with thick paint to add texture to an image. You can apply impasto with a painting knife or with brushes. Use the paint right out of the tube or make it heavier and stiffer by adding purchased impasto mediums to the paint. You can also dry the oil paint before application by first mixing the approximate color that you want to use, and then leaving the paint to sit for an hour or two until it becomes more firm. You can also dry the paint as described in the earlier section, "Painting with transparent paint (also called glazing)". After an hour or two, transfer the paint to your palette and apply it with a brush or a knife to the canvas.

Figure 8-5:
Painting with dry brush marks. Detail at right.

Courtesy of Heather Shebeck

As you can see in the self-portrait painting in Figure 8-6, impasto painting can add quite a bit of energy to your work. With impasto painting, the vigorous marks of the brush or knife stay apparent on the canvas.

The paint sticks up above the surface (see Figure 8-7 for the detail) and adds dimension to the painting. It creates an expressive and fragmented dramatic quality in the work.

Figure 8-6:
Painting
with
impasto
brush
marks.

Courtesy of Lisa Kleindorfer

Figure 8-7:
Impasto
painting
detail.

Courtesy of Lisa Kleindorfer

Project: A Study Trying Different Strokes

The project in this section allows you to try as many of the fancy ways of putting paint on a canvas as possible. The best way to try various brushstrokes and glazing methods is to work on an old painting. By now, you probably have a canvas that didn't turn out well — maybe an abandoned first effort, or a painting that you completed but just isn't strong. Be sure that the canvas is *completely* dry. It can't be tacky or even a bit soft. The experiments that you're going to do can soften the old paint up again and interfere with your tests. See the before version of our painting in Figure 8-8. Then follow these steps to complete your own project (and check out our completed version in Figure 8-9):

Figure 8-8:
A before photo of an old painting that was never finished.

1. **Assess the overall painting.**

 In our example, the underpainting on most parts of the canvas is good, but the lower portion is completely bare and the color is inconsistent in the sky. The image is good, and nothing needs to be corrected in the drawing, so we started the painting from this point.

 If your drawing or image needs to be corrected, you can go ahead and start the project anyway and make the changes in the drawing or image as you go. This is a great project to try to save an otherwise discarded painting.

2. **Start your painting by adding color to areas that need a change or an additional layer of color.**

 In our example, we started the painting by adding a new layer of pale blue to the sky and parts of the water. We thinned the light blue with a painting medium to allow the underpainting to show through in places. We also

painted over the water with a glaze of Prussian blue, viridian, and cobalt blue. For the reflection of the green hill in the middle of the painting, we used a glaze of viridian and Prussian blue to paint over that area of the lake. In your painting you may want to start with an area of color that you can adjust in a similar manner, such as a background in a still life.

Figure 8-9:
An after painting that we finished using various painting techniques.

3. **Find an appropriate place in your painting to practice flat, horizontal brushstrokes.**

 When you're painting anything that lies on the face of the earth, such as water or roads, try these flat, horizontal brushstrokes. They make the surface lie down and look believable. We applied the brushstrokes for the water in strokes parallel to the horizon. This can also work for the flat surface of a table in a still life.

 You can also add other types of brushstrokes if you don't have something flat in your painting. For example, you can enhance the appearance of the leaves of a tree or flower by adding spots and dashes of color to improve the look of the texture of the form.

4. **Practice the scumble technique.**

 We applied a scumble to the face of the dune. For the sand, we mixed together raw sienna, burnt umber, and white. The color was too vivid, so we grayed it down a touch with some purple that was left over from a previous painting. We applied the scumbling and then scraped it off with a palette knife to give the sand dune its distinctive texture.

5. **Practice dry brush techniques.**

 For this layer, we started with the same paint we used for the scumbling in Step 4. For the dry brush techniques, we added more white to this sand color, and we applied it to the sand dune using a dry brush.

6. **Hold the brush loosely to achieve a natural look.**

 We made the tree at the top left of our painting by using a small round brush that we twisted between our fingers to make the limbs and leaves appear random. When you're painting something natural, making it look like it grew in a normal way can be difficult. The more you try to get it right, the more control you exert, and the tree ends up looking fake. By holding the brush loosely and slightly twisting it in your fingers, you have the least control, and your form has a more natural look.

7. **Dry some paint, transfer it back to your palette, and apply the stiff paint to your painting with a palette knife.**

 We made the dark green in the foreground with burnt umber, viridian, Prussian blue, and a little cadmium yellow light. We put this paint on a piece of drawing paper (computer paper works too) and let it dry for two hours. Then we transferred it back to the palette and used it to paint the dark green juniper shrubs. We scratched some of it away using the sgraffito method. We applied the rest of the texture with a combination of dry brush and sgrafitto and then blended a bit with a dry brush.

Part III
People, Places, and Things

In this part . . .

We cover three of the main categories of painting, often called *genres*. We cover each topic — the still life, the landscape, and the portrait — in a separate chapter with a project or two to help you master the specific challenges of each. Whether it's the reflection in a body of water or challenges of painting a portrait, we show you the special methods of drawing, color mixing, and paint application that are appropriate to each genre.

You're now getting into the real substance of painting. Be sure to take some time to visit museums and galleries while you continue your progress through this part. Seeing real paintings (not images in books or on the Internet) allows you to see a wide variety of techniques, brushstrokes, and compositions that are possible for these fascinating subjects.

Chapter 9

Tricky Still Life Subjects Made Easy

In This Chapter

▶ Discovering the basics of painting metal and glass

▶ Working with a painting medium

▶ Practicing with plants and flowers

▶ Painting expressively

*T*he world is full of beautiful things. You see sparking light and complex colors on the surfaces of flowers, glass, and metal. The world is all opening up to you as you build your skills in painting. Painting difficult subjects is a feat — a test of your skills — and you're ready for the challenge.

After you complete the projects in the previous chapters, you know color and how to use it to create the illusion of a three-dimensional form. After you work through the previous chapter, you have a variety of ways to apply color to anything that you choose.

We present here three subjects that cover a wide range of surfaces — both man-made and natural. These projects explain how to capture the glimmer of glass and the glowing patina of metal. The last project covers plants and flowers so that you can learn to paint natural-looking organic shapes. This chapter sets the stage for experiments with working expressively with your materials and allows you to put something of yourself in your paintings.

Metal and Other Shiny Objects

A tin can is a quite humble thing. However, a painting of a tin can has all the complexity of a 19th-century tea set — but without all the pressure. It also has the advantages of being readily available, doesn't need polishing, and comes in an easy-to-draw geometric shape.

You can try other shiny metal items: chrome appliances, scissors, flatware, or tools. The shapes are more complex, and they may trip you up a bit as you try to get the forms just right, but they make good subjects. All have the quality of being reflective. Some may have an inherent color to work with as well — brass, for example. And all these items add to your repertoire of objects that you can paint.

To tackle painting metal in easy steps, though, we start with that humble tin can.

Project: A Tin Can

The tin can you need for this project is, of course, cylindrical, rather small, and has ribs on it. You may find cans without ribs and some with dozens of ribs. Find a medium to small can (6 to 15 ounces) with some ribs, but not too many (ten is ideal). Otherwise, painting all those lines just gets too confusing.

You can paint an image of the can by itself, or make a small still life with the can. Place the can on a surface with some color and experiment with the lighting and placement of other items around the can. Anything near it will be reflected on the metal. Put some pencils in the can, place a brightly colored object nearby, and play with the reflections. Don't place more than three items in the setup — that way, you can concentrate on painting the can. Refer to our examples in Figures 9-1 through 9-3 while you review the steps, and then get started on your own painting.

As with every painting, you have to be able to easily see your setup and your canvas. The still life should be about 2 to 4 feet away from you. You should have good lighting for the surface of your canvas, as well as for the objects that you're painting. Be sure to make yourself comfortable as you start to work. (Review Chapter 5 for details.) A good setup for your still life and your work makes a more successful painting.

This painting takes more than just one session. Make sure that you can leave your setup in one place without the items being moved.

Figure 9-1:
Starting the
tin can
painting
with a
drawing in
yellow.

Drawing

Start by drawing the tin can and any other objects in your setup on the canvas. In the example in Figure 9-1, we used a wash of yellow to draw the can and box. We laid in the can, its cast shadow, and the box with light sketchy lines so that we could easily correct them.

1. **On a 14-x-18-inch canvas, draw the tin can by making ellipses for the top and bottom and then connect them for the sides.**

 This step uses the transparent construction method that we describe in Chapter 13. The tin can is just a cylinder with ribs. Remember that ellipses are best made by keeping your hand steady and making a circular motion using the muscles in your upper arm.

2. **At the top of the can, make several ellipses, one on top of the other, and then select the best one and darken it to emphasize it.**

3. **Repeat Step 2 for the bottom of the can.**

4. **Sketch in more ellipses for the top and bottom ribs, and then draw the ones in between.**

 This step allows you to evenly space the remainder of the ribs. Keep your hand steady and try to mimic the ellipses that you drew for the top and bottom of the can.

 Draw the entire ellipse even though you see only the forward edge in the finished painting. When you fill in the other ellipses, they'll look stacked. This creates the ribs of the can.

5. **As always, continually assess your work; take a moment to check that the verticals are nice and straight.**

 They should be parallel with the sides of the canvas. Use your paintbrush handle for sighting and your viewfinder to help you focus and check the forms in your painting.

6. **Sketch in a horizontal line across the top ellipse to make sure that it's level.**

7. **Divide the ellipses by sketching in a vertical line through the center of your can.**

 Is your ellipse symmetrical? Making the corrections now is easy; doing it now rather than later saves you tons of time.

Finding the patches of color

So, what color is steel? When you look at the can, you see gray, but you also see the reflection of other colors. Look at the shapes and patterns of the different values and colors in the can. Try to see it as a paint-by-number painting where you have larger shapes of color that break down into smaller shapes. In the tin can, you also see bands of colors that move around its contour (as shown in Figure 9-2).

Don't forget the process. Even though the focus of this project is painting a metal can, you don't want to abandon the normal process of painting; don't focus solely on painting the can. As the rhythm of the painting develops, you paint the main subject, your can, and then work on the other areas of the painting. The whole painting should come up at the same time, in layers (see Chapter 5).

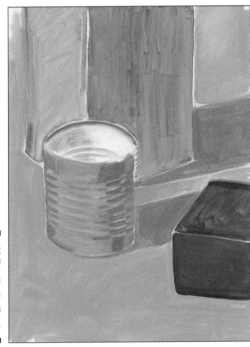

Figure 9-2:
A painting of a tin can with the major colors blocked in.

1. **Apply the colors that you see in a thin wash.**

 Look at the example again. Notice how the light and dark on the ribs creates a series of dashes? Across the ribs of the can, they stack up like bricks. Does your can have a similar pattern?

2. **Paint the patterns that you see on your can as patches of color — don't blend anything.**

 Painting metal is about painting patterns. Painting without blending is what makes metal look like metal.

3. **As you paint, look at the can and examine the reflections that you see on its surface.**

 Take a moment to try to locate what's being reflected. It could be a light from a window, the cloth the can is sitting on, or even *you!* Knowing what's reflected helps you identify the colors that you see on the can.

4. **Add the reflection in the dashes along the ribs and be sure to match the color to its nearby source.**

5. **After you lay in the basic colors and values of the surrounding area of the still life, stop to assess your work, making corrections and continuing to develop the patterns by using the colors that you see and adding them in spots and patches.**

 If you continue to shift your attention back and forth from the subject to the background, you also allow the paint to dry a bit. That makes it easier to work with the paint if you have a really wet painting.

Ending the first session

After you have all the colors blocked in and you have a couple of layers of paint on the canvas, you've arrived at a stopping point. You can set the canvas aside to dry a little before you continue. You can tell when you reach this point because you have a good, solid drawing, the colors are all blocked in, and you have a good coat of thin paint on all parts of the canvas. You can start to work on it again the following day or two days later.

When you come back, the paint will still be wet but it won't be as greasy and messy to work with. Some parts of the painting may feel completely dry while others have started to develop a tacky surface. They'll be wet again as soon as you add more paint. That allows you to blend and mix your colors right on the canvas.

Working with a painting medium

From this point on in this painting, you must use a painting medium rather than solvent as your wetting solution for your brushes and paint. A *painting medium* is a mixture of linseed oil and other liquids that allows the painting to dry properly. Whenever you spend more than one session on a painting, you must switch to using a painting medium rather than straight solvent.

A painting medium adds back in a little of the linseed oil that the solvent dissolves out. Using a painting medium allows you to paint with fluid strokes and to blend, but most importantly, it slows the drying time of your painting. If an oil painting dries too quickly, it damages the layers of paint, causing the painting's surface to crack. This process is called working fat over lean. You can find more information on this topic in Chapter 2.

You can either make your own medium using linseed oil and Gamsol or Turpenoid, or you can use a commercially prepared painting medium. If you make your medium, a 50/50 mixture of Gamsol and linseed oil is fine. If you buy a commercially prepared medium, just get a regular painting medium, not "fast drying," or "slow drying," or anything fancy.

Use the painting medium to wet your brush as you work. The medium makes your paint fluid and creamy. It's very different from working with plain solvent, which can make your paint runny and drippy. The oil in the medium also helps to remoisten the previous layers, which allows the new layers to bond with the previous layers.

The second session

When you return to work on the painting, continue to apply paint to the canvas, gradually building up the layers.

1. **Try to work with patches of color as you did before, developing and refining the patterns of values and colors as you work.**

2. **Keep blending to a minimum so that you can maintain clear edges and convincing reflections.**

 If you have an area that needs a blend, as in our example on the tin can's metal rim (see Figure 9-2), experiment with blending in a finite area to get the hang of using the medium.

3. **Continue to apply a new layer of paint to all parts of the canvas, developing the image as you go.**

4. **Build up the layers of paint by applying your brushstrokes in one direction and then the other, crisscrossing each other.**

 If you have an area where it just doesn't seem like you can get the paint to cover the canvas, you may be using a transparent color. Ultramarine blue and alizarin crimson are transparent. If you're using either of these or any of the other transparent colors, you have to mix the color with something opaque to make it cover well. White is an obvious choice, but other colors are opaque as well. In our example, the blue boxes are ultramarine blue, which is a transparent color. By adding titanium white and cerulean blue, the problem is solved. See the section on oil pigments in Chapter 2 for a complete list of transparent colors.

Finishing off

The last bits you add to finish off the painting are the glints of light on the surface of the can. These glints are white and may stand up pinpoint-like from the metal. To create these glints, take up a little dab of white with a small dry brush with no solvent on it at all. Applying glints feels more like putting the icing on a cupcake than stroking on paint. Just touch the brush to the point you need and leave it alone. You can see the finished work in Figure 9-3.

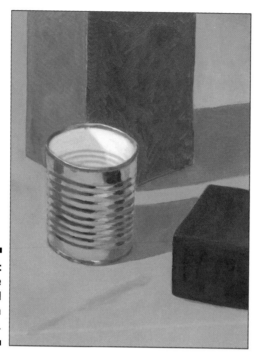

Figure 9-3:
The completed painting of a tin can.

Glass: Transparent, Reflective, Difficult

If you look at a glass, whether clear or color, it seems impossible to know where to start. It's transparent, but it bends and distorts the things you see through it. It catches the light and reflects it back to you with intensity, but it can also include dark spots where the glass is dense. Sometimes, you see a line, an edge along the side of the glass, and sometimes the edge just seems to disappear. You can also pick up reflections on the surface of the glass from objects in the room. The glint of light you see on the bottle is a light fixture in the ceiling or a window. Look closely and you see a reflection of yourself in it, too! It's like a crystal ball capturing the world in miniature.

For this project, start the way you do with the tin can project earlier in this chapter, with a relatively small canvas and a simple setup. You may want to limit the painting to just the glass item. Call it a study and give yourself the space to make it a practice piece.

But what piece of glass should you paint? Some of our favorite objects for this project are wine bottles, with the labels removed, and glass vases. A drinking glass also works for this project; a plain glass, without any pattern or decoration, like a juice glass in a restaurant, is best. A clear glass is okay, but glass with color is better.

Project: Painting Glass

This painting is a single green or blue wine bottle or plain vase with no orna-mentation. We used a green wine bottle for our example.

Take a minute to look at the glass, really *look*. Look at the shapes of the colors you see in glass — they're like amoebas of color. Jump forward and look at the example in Figure 9-6. Find the shapes in the glass: the dips, swirls, and liquid freeform shapes. Those shapes are what make glass look like glass.

Start this painting as you do the painting of the tin can earlier in this chapter. The object that you're working from — a glass, a bottle, or a vase — is likely a cylinder, so you have a chance to work on your ellipses again. (If you skipped the tin can project, flip back to it and read about drawing your object.) Sketch it in with a wash, check it, and make corrections as needed. See Figure 9-4 for the drawing of our wine bottle. Then follow these steps:

Figure 9-4:
A wine bottle painting at the drawing stage.

1. **After you have the bottle and other parts of the still life drawn in, find the three largest shapes in the glass and draw them in.**

 They're freeform shapes and they probably look rather goofy. Sketch in only the largest shapes at this time.

 As you establish the major shapes in your bottle, try to identify the sources of the reflections that you see. For example, if you see the reflec-tion of a window in your bottle, notice how the shape of the window is distorted by the glass.

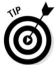

When painting glass objects, draw and paint the objects from as close to the same point of view as possible. Every time you move, the shapes of the reflections in your objects change, sometimes dramatically. If you maintain the same viewpoint, the shapes are easier to capture.

2. **Mix washes for the color of the glass bottle and the other parts of your setup and apply the colors to each area as we did in Figure 9-5.**

 Here are some tips to help you with this step:

 - Concentrate on the largest shapes and ignore the small bits for now.

 - Some areas inside the bottle are a mix of both the color of the bottle *and* the color from behind the bottle. Make up these colors and apply them as you see them.

 - Save the *highlights* (the reflections from light sources on the bottle) for last.

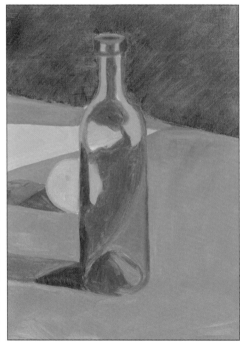

Figure 9-5:
The wine bottle painting with the colors blocked in.

3. **After you block in the major shapes in the bottle, find the medium shapes and then the smallest shapes and block them in.**

4. **Continue to develop the other parts of the canvas so that you have a consistent surface over the whole painting.**

5. **At this stage you may need to let the painting rest overnight or for a day or two.**

6. **When you start again, use the painting medium to go back and refine the application of color to the glass (see "Project: A Tin Can" for details on painting mediums).**

 For the second (or third) session with the painting, you can apply a relatively thick application of paint to make your bottle look more fluid and more glass-like.

7. **Find the highlights and apply them with tiny points of white paint (see the points on Figure 9-6 at the base of the neck of the bottle).**

 In our example, you can also see a more-subtle highlight. The big patch of light on the right side of the bottle is the reflection of a window.

8. **Complete the painting by developing all areas of the painting to the same degree.**

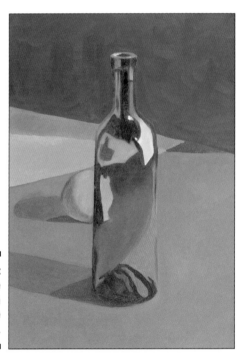

Figure 9-6:
A complete painting of a green wine bottle.

Organic Shapes: The Life That Surrounds You

Making lifelike plants, trees, and flowers is a goal for many beginning artists — most are fascinated by the beauty and variety of natural forms. For centuries, artists have strived to create an image of nature as a symbol of the ideal. You can start by practicing with individual examples of nature in your studio.

Up to this point, you've worked with geometric forms. But nature is made up of organic shapes, things that are freeform and follow their own symmetry. These natural forms are also perfect for your first experiments at working expressively in painting.

You may already have good drawing skills and feel confident in your ability to draw flowers and other natural forms. If not, here are a few steps that you may want to take to prepare for your painting:

1. **Carefully select the items that you'll paint from.**

 Painting a plant with lots of leaves can be daunting. Start with a small houseplant. An artificial plant or flower is a good choice. It won't wilt under a spotlight, and you can bend it into the shape that you like.

2. **Practice drawing the item first.**

 One way to get the hang of making organic shapes is to trace the shadow of the flowers and leaves. Put a bright light on the plant and place it close to a wall. Put a piece of paper on the wall and trace the shadow. Notice how the leaves, stems, and flower shapes overlap one another. This is the shape you'll draw for your painting.

3. **Set your plant up against a wall so that it casts a shadow that you can draw.**

 See our painting up ahead in Figure 9-9. The shape of the shadow mimics the shape of the flower and leaves.

Project: Painting a Natural Form

For this project, we recommend painting a silk flower in a small bottle. Pin a sheet to the wall and put a strong light on it to create interesting shadows. Take a look at our example in Figure 9-7.

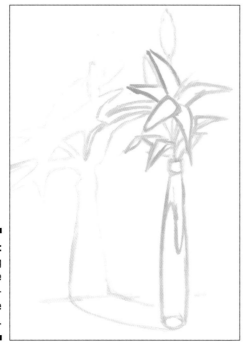

Figure 9-7:
The drawing stage for the lily-in-a-bottle painting.

Procedure

You work on this project the same way you do the others in this chapter. Start with the drawing, block in the colors, and finally refine the painting. Be sure to take time to set up your items and light them well. Experiment with this stage to get just the right scene, and then follow these steps:

1. **Sketch your setup on paper.**

 This step gives you a chance to try out the composition, including the orientation of the canvas (either vertical or horizontal), and to see whether you need any extra items to augment your setup. An interesting shadow can balance and stimulate an otherwise simple setup.

2. **Sketch in the shape of the flower, leaves, and bottle using a wash of a light color on your canvas. (We used blue for the example in Figure 9-7.)**

 The lines for organic objects should be fluid and loose. The shapes of the shadows imitate the shapes in your objects.

3. **Block in the basic colors, using a separate brush for each color so that the colors remain bright and clear (see Figure 9-8).**

 As you paint, study and paint the shapes of the patterns of value and hue that you see. Don't blend anything at this early stage of the painting.

4. **After you block in the basic colors and shapes of your objects and their shadows, fill out the rest of the composition with white and very light versions of any other colors you see reflected onto your background.**

 Painting in the negative space, or background, last allows you to correct any drawing problems that come up while you're working.

5. **Allow your painting to rest before you work back into it.**

 Read over the following discussion of our example before continuing on with your own painting.

Figure 9-8:
The lily's starting to look pretty with a little color.

Examining our example

Of course, the colors in your setup may be a little different from our example in Figure 9-9. The colors in the Asiatic lily are alizarin crimson and white. We painted the bottle by using a mix of ultramarine blue and a little Cerulean, which makes it a more opaque color. The greens were made using all the tubes and colors in our box.

Green is a great color. Every shade of green in a landscape is different! Tree leaves aren't the same color as grass. Grass in May is a different color than grass in August. If you consult your color chart in Chapter 7, you know that you can make green with ultramarine blue and cadmium yellow light, but you can also make green with cerulean blue or with yellow ochre. That gives you four combinations of very different greens.

Then you have the various hues of green, yellow-green, and blue-green. What if you use both the yellow ochre and cadmium yellow with one of the blues? And you haven't even tried the permanent green light or the viridian yet. Don't forget the tones and tints and shades of green. Remember that you can tone down the green by adding a touch of red or even orange. Sooner or later you'll rediscover that yellow and black make a green as well. This can go on and on. Here's what you should work on in your painting:

1. **Closely examine the leaves in your setup and find the various colors of green.**

 You likely have some bright greens that are well lighted. They may have yellow in them like the buds of the lily in our example. You also have some medium greens, like the leaves. These greens could have a little bit of white in them where the light hits the leaf. You also have some darker greens. You see these greens on the underside of the leaves, or maybe they're the actual colors of the leaves.

2. **Experiment by using more ultramarine blue or viridian green, if you have it, to make the dark areas.**

 Don't blend these colors in your painting; apply them in a blocky fashion. Now move on to the rest of the canvas.

In our example, we used blue-gray for the shadow on the wall of the flower and bottle. We made the color with cerulean blue, cadmium red light, and white. We drew the shadow for the flower and filled it in with the wash of gray. We covered the background with white, which allows the opportunity to cover up any mistakes made in the drawing of the shadow. At that point the painting was pretty wet, and it needed to dry a bit before we continued on it.

Cover the entire canvas with paint, even if you're painting white oil paint over the top of your white canvas. The canvas has been covered with a priming coat of gesso. The gesso turns yellow over time if it's exposed to light and air. So always be sure to put paint everywhere on your canvas.

The next day, the paint in our example still wasn't dry, but it was much easier to work with. We mixed a painting medium — a 50/50 mixture of Gamsol and linseed oil — to continue the painting. Some areas of the painting looked very good with the loose brushwork and some areas needed adjusting.

The petals of the lily were only one color of pink and needed more variety, so we added a touch of ultramarine blue to make the shadows that fall across the petals. The pink of the petals looked a bit dull because it was a combination of alizarin and white. Sometimes putting two colors together gets you unexpected results! Some colors dull down very quickly when you add white to them. You get the value that you want, but not the intensity of the color. We corrected this problem by making a glaze of alizarin and adding it to the petals to brighten the color. To make a glaze, you simply mix a tiny amount of the color you want with the painting medium. In this case, it was easy to do because alizarin is a transparent color anyway. You can find more details about glazing in Chapter 8.

The cast shadow had too many different versions of gray, so we simplified and lightened it. The blue bottle was made almost entirely of ultramarine blue. The cerulean blue didn't match the color of the bottle. We applied an

ultramarine blue glaze, and the result was a clear color that also looked fluid. We blended the edges of the cast shadow slightly to make them appear fuzzier. That allowed the bottle and the lily to be the main focal point of the painting.

Getting back to your painting

Now that you know the history of our example, you can apply some of the strategies to your own work and complete the painting. You can see our completed work in Figure 9-9.

1. **Mix up a painting medium that's one part Gamsol and one part linseed oil, and use it as your new wetting solution for your paint and brushes.**

2. **Work back into your objects, developing and refining their patterns and colors.**

 Be sure to continue to look very closely at your setup and incorporate what you're seeing into the work. Becoming involved in the painting without looking at what you're painting is easy to do and can lead to mistakes.

3. **As you work into the background, look closely for the nuances of color that may be reflected onto the backdrop.**

4. **Check the brilliance of the colors and make glazes for areas that need them.**

5. **Find your areas of highlight and lay them in (check out "Project: A Tin Can" for more on highlights).**

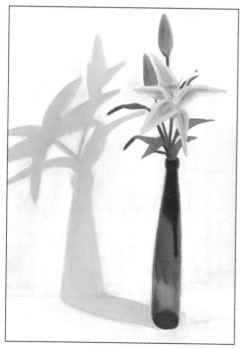

Figure 9-9: The completed painting of an arrangement of a lily and its cast shadow.

Working Expressively

Expressionism is a term that many are familiar with even before studying art. It's a big term that encompasses many types of art from many parts of the world. To define it in concise terms for painting, *expressionism* is a way of working that allows the artists to depict their responses to things instead of showing only a visual description.

So the emphasis is on how the artist feels about the subject and not just on what the objects look like. An artist can show how he or she feels about something through the handling of the paint itself or by distorting the forms in the painting. Other characteristics in expressionist paintings are exaggerated brushstrokes and heightened color. Here are some examples of distortion:

- Color can be distorted by using exaggerated color or a substitution of another color. (Example: Yellow sky and red trees in a landscape.)
- Distortion of form changes the shape of an object. Form can be distorted by exaggerating the scale or by stretching the form.
- Materials can be distorted by using thick paint strokes, or by scratching into the paint.

The overall goal is to make an emotional impact on the viewer. Some well-known examples of expressionism in painting are Van Gogh's *Starry Night* and Edvard Munch's *The Scream*.

Expressionism doesn't mean that just anything goes. It isn't an excuse for self-indulgence. For expressive art to be successful, it needs to heed the same criteria for success in other artworks. That means a harmonious combination of color, value, form, space, and so forth.

This topic can quickly become a subjective argument. One way to think of expressive art is to ask yourself how well it connects with the viewer. If the viewer finds something to admire in the work — the idea behind the work, the expressive use of color or brushstrokes, or the subject matter depicted, for example — then the work is successful.

You may find that working expressively with your paintings is something that connects with you personally. But art doesn't have to be expressive to be good. The flipside of expressionism is *formalism,* and that may describe your working methods more closely. Sometimes artists work in a blend of these two approaches. We have examples of both types of artists in Chapter 19.

Project: Experiment with Expressionism

For this experiment with expressionism, find a subject that you feel comfortable with. It can be something that you've painted before, but in any case it should be manageable. It can be another setup of organic shapes — even exactly the same thing that you paint in "Project: Painting a Natural Form" earlier in this chapter. Rearrange the lighting and the backdrop to give it a fresh look.

We use five wine bottles in this example. (Jump ahead to Figure 9-12 to see the completed work.) We have a variety of shapes and colors, and they're fun to work with (all those ellipses!). You need all the standard supplies for this project, including your painting medium. Our example is done on canvas paper taped down to a Masonite board.

You're going to make three drawings of your setup, one on top of the other, right on your canvas. Make each drawing in a different color.

1. **Start the first drawing by using a wash of an unexpected color.**

 In our example in Figure 9-10, we used cadmium red light for the first drawing. The red contrasts with the dark glass of the wine bottles, and it sets the tone for a bright painting. We drew ellipses for the bases, the shoulders of the bottles, and the mouths. We drew centerlines for each bottle and sketched in the edges.

2. **Use a second color for the second drawing, making corrections as you go.**

 We used ultramarine blue over the top of the first drawing. We made corrections and added the pattern of the shadows and the edges of the table that the bottles are sitting on.

 As you draw your own painting, hold your brush loosely, back from the tip so that you have less control. Draw over this image, going outside the lines and through the image each time. You can also exaggerate the forms and distort them.

3. **Choose a third color and make your last drawing.**

 We did the last drawing in permanent green light. We drew the bottles in the example so that they're taller than they actually are. This sets the stage for something that's experimental and loose.

 The position of the bottles changed a bit as they we drew them, but we left the red of the first drawing on the canvas. Leaving some of the color from the drawing adds a random, expressive effect.

Figure 9-10:
The drawing stage of wine bottles in an unexpected red.

4. **Block in the forms with a wash of color.**

 We painted each section of the bottles a slightly different color in Figure 9-11. With each color, we painted up to, but not over, the lines in the drawings. We blocked in colors for the background, the table, and the cast shadows. These colors are brighter than what was actually there.

5. **Adapt the colors and shapes to fit the demands of the composition.**

 Be flexible while you work. You may find that your original plan is too conservative to be called expressionistic.

6. **Complete the painting by applying successively heavier layers of paint.**

 If you like the lines from the drawing stage and they start to disappear, draw over the top of them again. If it gets too wet to keep your colors clear, let it rest and go back to it another day. As always, apply the later layers of paint with a painting medium, not just the solvent.

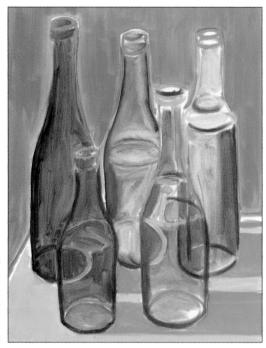

Figure 9-11:
The colors are blocked in.

7. **Keep working until you have paint on all parts of the canvas and you're happy with the results. Our completed work is shown in Figure 9-12.**

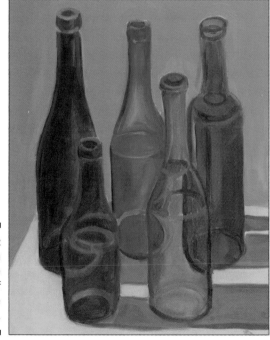

Figure 9-12:
An expressive painting of five wine bottles.

Chapter 10

Take It Outside: Landscapes

*N*othing evokes the romance of painting like setting up an easel in a beautiful locale and putting a brush to canvas. If that's your entire motivation for taking up painting, it's a good one. It can be one of the most rewarding of the painting genres. What beats going outside on a beautiful day and losing yourself in a landscape painting?

This chapter helps you make the transition from working in the studio to painting the natural environment. We provide you with the tools to deal with its special challenges and look at ways you can bring the outside back into your studio for longer projects. At the end of the chapter, we give you step-by-step directions for painting your own one-day landscape painting.

The Nuts and Bolts of Painting Outdoors

You have to think about the same sorts of things when you paint outdoors as you do when you paint in the studio. Painting outdoors does have some special challenges, however. Thinking ahead so that you have what you need on-site and setting up so that you're comfortable are primary concerns. Dealing with changing conditions and subject matter of which you have little experience are others. With a little thought, patience, and perseverance, however, you can experience thoroughly satisfying painting sessions.

How working outdoors is different from working in the studio

When you paint in your studio, you have a relatively controlled environment with comfortable furniture and all your supplies nearby. You can set up something to paint and light it however you want to. You can shut the door if you want privacy. You have snacks and drinks in the fridge.

Painting outside can be inspiring, relaxing, engaging — you name it. You can set up in the shade of a tree and spend hours absorbed in painting and enjoying the environment. Life is rarely better for a landscape painter.

It can also be hot and sweaty, buggy, and physically demanding. You can forget your brushes or other critical materials. People can look over your shoulder. You can get hungry and thirsty, or worst of all, you may have to go to the bathroom when none is nearby. Your back can hurt, and, to add further insult, a sudden shower can soak you.

All these problems can be overcome, though. Painting outside can be one of your most rewarding experiences, but you must plan ahead.

Painting scenery outdoors from direct observation is called *plein air painting*. *En plein air* is a French term that means "in open air." Even though artists had always made paintings of outdoor scenes, it was the Impressionists in the latter half of the 19th century who popularized painting outside the studio.

Deciding where you're going

Take a little time to prepare for your outing and it will be much more successful. Have an area in mind before you head out so that you can prepare. Consider these criteria as you select a spot:

- ✔ **Does it have an interesting landscape or area to paint?** It doesn't have to be Yellowstone National Park, but it should have potential for a great painting.

- ✔ **Is it public or private?** If it's private, be sure to ask for permission to work on the owner's property. Also, have a good idea of what the property is used for. If you accidentally wander onto a shooting range, you could have some real problems! Here are some good possibilities for public areas to paint: parks, trails, nature reserves, cemeteries, museum grounds, riverbanks, scenic rest stops, and beaches.

- ✔ **What kinds of accommodations are available?** Are food and water available? Is a restroom within a reasonable distance? (Bushes don't count.)

- ✔ **Does the area have seating that you can use?** If picnic tables are available, you can set up a makeshift easel on them; otherwise, you have to consider other options.

- ✔ **If a companion who doesn't paint is coming with you, will he or she have something to do while you're working?** You're there to work, not to entertain someone else. Consider this your time and make sure that your companion can respect that.

Deciding what to take

Unless you're going to paint in your backyard, you have to do a little more than throw some things in a bag and take off to paint. The obvious things that

you need are your paints, brushes, equipment, and something to paint on, but you need to consider a few other things, especially for painting outdoors.

An easel and stool — or not

Much like your initial investment in painting, you can invest as little or as much as you want to in pursuing this genre. Packing everything you need in a canvas bag is possible, and you may do fine working on a picnic table. Or you can lay out $100 to $200 for a field easel with storage for your paints and palette and a stool. If you want to paint outdoors regularly, investing in a field easel and stool may be worthwhile. Here are some ways to set up an on-site work area with items you already may have available:

- ✔ **Set up on a picnic table.** Prop your canvas or board against your art box. Stand or sit to paint. You have a ready-made work area.

- ✔ **Sit on a blanket spread out on the ground and prop your canvas against your art box or a tree.** The ground can be hard, but if you were ever associated with a Girl Scout, you know what to do: make a "sit-upon." Take a few sections of newspaper, stack them neatly, and tuck them into a trash bag. Fold the bag around the newspapers and duct tape it in place. *Voilà!* A seating pad. (We won't make you decorate it.)

- ✔ **If you can park your car nearby, you can bring any transportable easel and a lawn chair.**

- ✔ **Try tailgating if you have a vehicle with a tailgate.** Artists have a long tradition of pulling over to the side of the road and painting as they sit in their cars. Open the doors for a nice breeze and you're in business. (Be sure to turn off the interior light so that you don't run down your battery.) If you get a shallow metal butcher's tray (available at art supply stores) or even a shoebox to hold your solvent jar and other potentially messy items, you won't get paint or solvent on your seats. Throw a tarp or sheet over them to avoid inadvertent drips.

A painting surface

Any painting surface is possible, but some are easier to handle in the field than others. These are our recommendations:

- ✔ **Canvas paper.** If you tape canvas paper by the corners to the backside of a drawing board, you can carry it around easily by its handle. It props up well against your tackle box for a comfortable work surface. You have to paint the corners under the tape after you return home.

- ✔ **Canvas board and other prepared boards.** Bring newspaper to put under the bottom edge of the painting so that you don't get paint on other surfaces. Leave a small section on a corner unpainted so that you can carry it back to the car without damaging it.

- ✔ **Pre-stretched canvas.** You can carry it securely by the stretcher bar and prop it against your tackle box easily. You can paint to the edges of the canvas.

The rest of your supplies

Here's the rest of the stuff you need:

- **Paints.** Because of the variation of greens in the environment, you may enjoy picking up a tube of permanent green light at the art supply store. It gives you a brighter set of greens to fill out the range of greens you can mix with your other colors. For browns, good choices are raw umber, burnt umber, and burnt sienna.

- **Solvent.** Pour about an inch of solvent into a small jar with a tightly fitting lid. A short, wide jar is best because it won't turn over.

- **Palette.** Bring an unbreakable palette or a disposable palette and cover any paint you want to bring back with foil. Dispose of unwanted paint properly.

- **Brushes and a container to hold them.**

- **Sketchbook and charcoal pencils.** Use your sketchbook to make thumbnails, but also use it to record information that you may need to continue painting when you go home.

- **Other supplies.** Some of the following aren't the first things that may come to mind when preparing for an outdoor painting session, but they'll probably come in handy:

 - Paper towels

 - Barrier cream for your hands

 - Tackle box and canvas bag

 - Suntan lotion

 - Lip protection

 - Mosquito repellent

 - Spray bottle of water

 - Snacks and water or other drinks

 - Trash bag

 - Foil

- **Optional stuff.** You may also need plastic sheeting, a poncho, or trash bags in case of rain. If you want to be reached, carry a cellphone. And if you want to keep the sun off your head, wear a hat.

Working comfortably and safely

Taking care of your health when you go out on these outings is important. Follow these tips to stay safe and comfortable:

- Be sure to put on suntan lotion and reapply it during the day.

- Wear mosquito repellent if the little critters are around to make you miserable.

✔ Apply barrier cream to your hands.

✔ Consider wearing a wide-brimmed hat or a bill to shade your face and your eyes. Sunglasses are an option, but they affect the way you see light and color.

✔ Check the weather. If you see a chance of rain, bring something to cover you and your work area in case of sudden showers.

✔ Cool yourself off by misting yourself with water from your spray bottle.

✔ Bring a snack or lunch and drinks if you're going to be out for several hours.

Your safety is also important. People who paint outdoors are magnets for people who are curious. Treating everyone with suspicion isn't necessary. Just keep your radar up, and if something seems like it isn't right, it probably isn't. Here are some suggestions for taking care of your personal safety:

✔ If you're going out alone, tell someone where you're going and approximately when you'll return.

✔ Get a painting buddy, take someone with you, or join an outdoor painters group.

✔ Try to paint in populated areas. If you're isolated, be aware of your surroundings and the people approaching you. Don't attract attention to yourself.

✔ Bring only what you need in terms of money, credit cards, and identification.

✔ If you have a cellphone, juice up the battery before you go and keep the phone within easy reach. Take it out and put it in an inconspicuous place next to you.

Protecting the environment

Do your part to protect the groundwater by taking your discarded paint and solvent with you and recycling it or disposing of it properly.

Under no circumstances should you pour solvent out on the ground.

You're someone's guest everywhere you go to paint. Be considerate. Don't leave trash behind. Don't steal their stuff. (If it's on their land, it's their stuff.)

Setting up your work area

Just as you do at home, set up so that you have a clear view of your subject matter and have to move only your eyes to see your scene as you paint. Make sure that you have a spot where you have a clear view of the scene you want to paint.

Look under the "An easel and stool — or not" section in this chapter for ways that you can set up your painting surface. Arrange the rest of your space around that.

Consider whether you want to set up your space in the sun or shade. Even shade is best. Dappled shade on your painting can be very distracting. The sun does move, so you may set up in a great shady spot and find yourself in full sun an hour later. Try to predict the path of the sun and set up accordingly.

Transporting your work

You can find products that are designed to protect your work while you carry it. Some field easels and backpacks have built-in carrying devices, while other devices allow you to carry stretched canvases independently.

 Prepare a place in your car for your wet canvas *before* you set off to paint. Ideally, you should lay it flat so that it's well supported and unlikely to slide, fall, or tip. So clean out the trunk, fold down the backseat, or otherwise make room. Don't lay your canvas on objects that are likely to poke into it from the back. Don't lean it against the backseat of your car, because it can tip or slide if you brake suddenly.

When you arrive home, immediately put your painting in a safe place to dry.

Developing a Strategy for Painting Outdoor Scenes

You want to have a strategy for painting when you arrive at your site. You can choose from several possibilities, including the following:

✔ Make sketches or paint the scenes as single-session paintings. Sketches and single-session paintings are the best way to start when you're working with a new subject.

✔ Paint longer multi-session paintings.

✔ Take photographs, make sketches in the field, and bring them back to the studio for longer painting projects.

✔ Do a mix of blending your outdoor work with your studio work.

Painting on-site is working from observation, which is always the most desirable way to work. It isn't always possible, though. If you're on vacation or had to travel some distance to the spot, painting on-site over several sessions can

be a luxury or impossibility. In that case, the more information you can collect while you're there, the more you have to work with when you get back to the studio.

Gathering the information you need to work from later

When you plan to work on a painting away from the site, you need to collect as much information as possible. It may seem that taking a few photographs of the area is all you need, but photographs have limitations. Cameras don't focus on the subject matter the way your eyes do, so what you see isn't necessarily what you get in the photograph.

Cameras are excellent tools, but you need to complement photographs with other material. Here's a list of information you can collect that will support your painting:

- ✔ Photograph the scene from the same point of view as your painting. Try to match the scene of the painting as closely as possible.

- ✔ Make additional detail photographs of objects.

- ✔ Make a sketch of the entire scene and write notes about vegetation, lighting, colors, and anything else that will remind you of the scene. (See Figure 10-1 for an example of how you can incorporate information into your drawing.)

- ✔ Make color swatches or spots of color that are close to the colors you're observing. Most people's memories of color are notoriously bad.

- ✔ Make a sketch of anything that you think will cause you trouble in the studio. That way you can work out the problems while you have the scene in front of you.

- ✔ If you plan to work solely from photographs, you need one good photograph that can serve as a master for your scene. You should still take supplementary photographs and make sketches and notes as we discuss throughout this list so that you have plenty of material to cover what you can't see in your master photograph.

The visual material you collect to work from as you make your painting is called *reference material.*

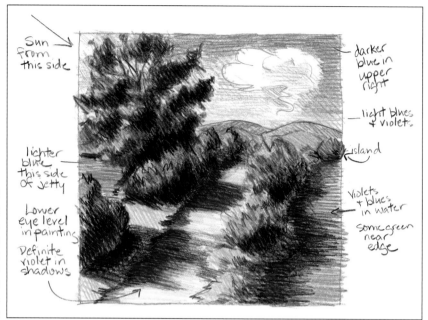

Sun from this side

darker blue in upper right

light blues & violets

island

lighter blue this side of Jetty

Violets + blues in water

some green near edge

Lower eye level in painting

Definite violet in shadows

Figure 10-1: Make a working sketch with notes to work from later.

Finishing in the studio

If you plan to finish your painting in the studio, you should work back into it within the next few days. The scene will still be still fresh in your mind and you'll still have some enthusiasm for it.

The first things you want to do when you come back to it are set up the painting and assess what you've done. Some areas will be quite good while other areas will still need to be resolved. Don't assume that the whole thing needs a layer of paint.

Lay out the reference material you brought back with you so that you can see it while you paint. Refer to it as you make a plan to resolve the areas that still need work. Usually, it's best to work on your worst problem first.

Don't try to copy the photographs; you're using them only for information to complete what you've already done. Paint those areas the same way you painted the areas from observation.

Painting from photographs

Even if you don't plan to do any painting on-site, you should still do some sketching from observation there. It provides a good foundation for your painting and allows you to work out any potential problems before you start. It also allows you to bring the experience of being there to the painting. You can't get that by working only from photographs.

Rather than trying to *copy* the photograph, try to think of it as a starting point for your painting that provides a general composition, value pattern, and color palette that you can build on. Your painting will be your own *interpretation* of the photograph. (In the painting in Figure 10-2, the artist began by referring to a photograph but then moved away from the photo to develop and complete the painting.)

Put all your reference material out where you can see it the entire time that you're painting. It will inspire you, but you're also more likely to use it if it's out.

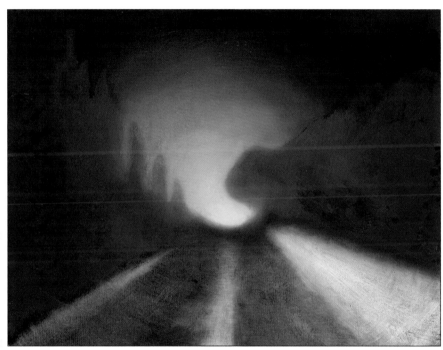

Figure 10-2: Paint your own interpretation of the photograph.

Finding a Subject

When you arrive at your locale with your equipment, what are you going to paint? If you have the luxury of time, a scouting trip minus your equipment is a good idea. Otherwise, narrow the general area down to a spot with good potential and use your viewfinder to find the scene you want to paint.

When you first look for areas to paint, focus on the colors and value patterns rather than a specific kind of subject matter. Some beginning artists go out looking for a quaint landscape scene to paint. If you do, you may be looking for a very long time. For now, concentrate on scenes that will help you develop your painting skills rather than finding the perfect landscape.

Take a page from Monet

Claude Monet was an Impressionist whose paintings of his garden are well known. Capturing color and light was the goal of Impressionism, so many of Monet's paintings are flooded with light and sparkle with color.

Monet was interested in capturing a variety of different kinds of light and would paint the same subjects at different times of day and in every season — even in the dead of winter — and he painted it in every kind of light that you can

imagine. When you see several of them together on a wall, you notice that they all have nearly identical compositions, but some are cool in color, while others are warm. Some have strong light and contrast, while others have the similarities of value that you see at twilight. They're simple, beautiful, and remarkable in the use of color.

From Monet you can learn to make simple compositions and revisit them as many times as you like. Your goals for each can be different and you can learn something new with every experience.

Here are some other characteristics to look for:

- ✔ A mix of large, broad fields and clusters of trees and bushes
- ✔ A variety of light and dark greens and blues
- ✔ A mix of different kinds of leaf textures

For now, avoid painting leafless trees. They require too much detailed work at the expense of the rest of your painting. Stick with leafy trees that have interesting shapes.

Painting Your Landscape

When you find a spot, you're ready to set up to paint. Start by drawing in the major shapes with your thinned paint. (Refer to Chapter 5 for information about laying in your drawing.) As you work, avoid drawing the individual leaves of trees and bushes. Instead, draw the overall shapes of the trees and bushes without details.

Next, start to lay in the colors of the major shapes, working *general to specific,* and paying special attention to the value pattern. As you build each succeeding layer of paint, refine and define the shapes until the painting is finished.

Dealing with light and time

When you paint the vegetation in a landscape, you notice that everything has a dark side and a light side. The light side, obviously, is lit by your light source — the sun. While you paint, look for the patterns of light and shade that the sun creates, and paint the shapes of patterns in these areas rather than trying to paint individual leaves.

Observe how light affects the color in your scene. Rather than mixing a dark green for your patterns of shadows and then adding white to it for the sunlit light patterns, think about using a range of analogous colors. Use cooler greens on the dark-shadowed side (or even blue-violet in the deepest, darkest shadows) and a range of warmer greens on the light side. Also, consider using shades, darker tones, or even tints of an area's local color when a shadow is cast upon it. For example, a shadow cast across a green lawn may be painted with a green shade mottled with green tones and tints, and variations of other analogous colors. (Check out Figure 10-3 to see how the shadow is shades and tones of green when it falls on grass but changes to violets as it crosses a path.) Read Chapter 17 for more information on color.

Light and time present special challenges in landscape painting. In the studio, the lighting is fixed. Outdoors, the lighting changes as the sun moves across the sky. That means that the drawings of your trees and bushes remain constant, but their light areas and the shadows that they cast are undergoing constant change.

You can deal with this challenge by creating a set drawing for your painting and quickly laying in the shadowed areas that you want to remain dark. While you paint and the shapes of the shadows change, refer to the characteristics of the colors in the current light and shadowed areas to paint the areas that have changed from their original shape. Keep the shapes of the objects and shadows in your painting the same as you paint, but refer to the landscape for the kinds of colors to use. Keep in mind that you'll see some subtle differences throughout the day. Sunlight in the morning and evening is a warmer color than sunlight at noon, so noontime colors are more true to the actual color of the object.

Figure 10-3:
Use shades and tones of green, as well as other analogous colors.

Depicting distance

Creating deep space is one of the special challenges of painting outdoors. This is where you put your knowledge of atmospheric perspective to work. A few tips to remember:

- ✔ In the areas that are closest to you, paint strong lights and darks, brighter colors, and more detail.

- ✔ To depict areas that are farther away, drop your darkest and lightest colors so that you work only with a range of middle values of light and dark. Blur the edges and details for areas that are farther away.

In Figure 10-4 you can see the change in colors as they move toward the horizon line. They become duller and change value. When the objects are added, you can see how the values of the objects in the distance are similar to the value of their backgrounds. When the objects are closer, you have more contrast.

Refer to the discussions of atmospheric perspective in Chapters 16 and 17 for more in-depth information.

Figure 10-4: Colors become duller and objects lose contrast as they move closer to the horizon line.

Painting buildings and people

Buildings and people may seem to be special challenges, but they don't need to be. Applying what you know from doing still life painting can be helpful in each.

When painting buildings and people, forget what they are and break them down into simple forms. Refine them more if they're closer in the scene and less if they're farther away.

The buildings in your landscape

To ensure that your buildings look right, do these things:

✔ **Make sure the perspective is right.**

Just check these three things:

- The building is placed correctly in relation to your eye level.
- The lines for the sides of the building seem to converge on that line.
- The verticals are plumb.

✔ **Check your lighting.** Did you light the building on the same side as the light from the sun? Is the other side darker? Do you have a different value of color on every plane of your building? (Figure 10-5 shows how the values and the intensities of colors change on each side of a building.)

✔ **Simplify your shapes.** Don't try to put more detail in the building than you can actually see in person. Just because you know it's there doesn't mean that you have to put it in. Too much detail can make your building inconsistent with its surroundings or reality.

Figure 10-5: Every plane of your building is a different value.

Painting people in the landscape

Unless human figures are seen close-up, keep them simple. This is the time to simply observe and avoid stressing over what subject you're painting. Keep these points in mind:

✔ Break the figure down into basic shapes and patterns.

✔ Don't paint any details that you can't see from where you're sitting. That means that you may paint only a glove shape for a hand. The face may be a simple pattern of lights and darks.

See Figure 10-6 for examples of how you can refine or limit the refinement to show figures at different distances.

Figure 10-6:
Refine the
shapes
more in
figures that
are closer to
you and less
in figures
that are
farther
away.

Depicting trees and bushes

Trees and bushes (along with clouds and water — discussed later) have no
specific geometry to work with, so they may seem to be more difficult, but
they don't need to be. You can approach them by analyzing their patterns,
but their textures are different. Vary the sizes and kinds of brushstrokes
you use.

Drawing trees and bushes

Because trees seem to be so complex, many people tend to generalize them
instead of looking at their real shape and breaking it down into smaller
shapes.

Here's a good way to draw a tree (see Figure 10-7 for an example):

1. **Draw the basic overall shape of the tree.**

 Don't start at the trunk and work up the branches. Find its height and
 width and shape first.

2. **Refine the shape of sections of the tree and the visible lower trunk.**

3. **Draw the big negative spaces where you can see sky through the tree.**

4. **Add only the sections of trunk and roots that you can see.**

5. **Mark the pattern of the shadowed areas of the tree.**

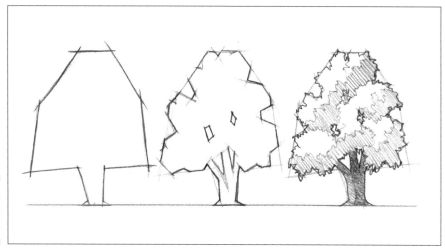

Figure 10-7:
Drawing
a tree.

These steps make drawing bushes a breeze (Figure 10-8 accompanies this list):

1. **Look at the shape of the bush's silhouette and ask yourself if it's more like a circle, triangle, or rectangle.**

2. **Lightly draw the geometric shape.**

3. **Refine the geometric shape so that you can see the true shape's variation.**

 Think of the geometric shape as a block of marble, and you're going to carve away the sections that you don't need.

4. **Mark the pattern of the shadowed area.**

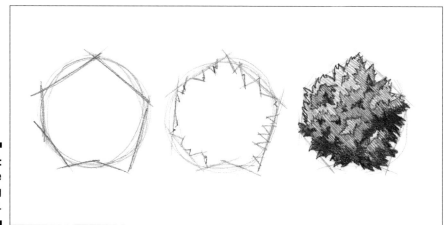

Figure 10-8:
An example
of drawing
a bush.

Brushstrokes that work for all those leaves on trees and shrubs

You can use general strategies for most trees and shrubs, but what sets one apart from another is the type of brushstrokes you use to create the texture of each. You can use long, linear strokes for tall stands of grasses, for example, while you may use short, choppy strokes for evergreen shrubs. At the same time, you don't want to immerse yourself in too much detail. Think of the painting as a collection of textures that becomes softer and more blended the farther away the objects are.

See Figure 10-9 for examples of strokes that you can use.

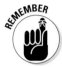

Your landscape painting skills will come very easily to you if you keep these three ideas in front of you at all times: value pattern, texture, and atmospheric perspective.

Figure 10-9: Examples of strokes that you can use for trees and shrubs.

Capturing water and clouds

Water and clouds can drive everybody a little crazy because they're in constant motion.

Water

Here are a few tips for tackling water:

- ✔ Make sure that any distant water horizon is level and that no water looks like it's running uphill.

- ✔ Deep areas of water are darker and more violet-blue than shallow areas.

- ✔ Reflections are mirror images of objects that look like they've been jiggled and broken up by blue ripples. A simple way to tackle them is to paint the object mirrored in the water, curve the lines, and add blue ripples (Figure 10-10 shows you this approach). Look closely to see what exists in your own scene. Sunlight and cast shadows may complicate it. The secret is to simplify.

- ✔ Most large expanses of lake water are choppy and have a variety of light and dark blues and analogous colors. If you think of them as little waves, the crests are light and the low areas are darker. Look for lines of little waves moving toward the shore. Use linear strokes, unless you're viewing the water from above and capturing the patterns. If you want to do a little research, look at Monet's water scenes for inspiration.

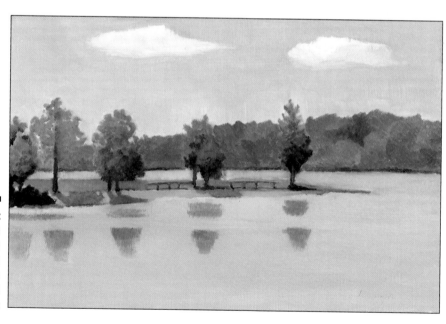

Figure 10-10: A simple approach to painting reflections in water.

Clouds

In a scene in the movie, *Girl with a Pearl Earring,* the artist Vermeer describes the colors in a cloud for the maid who cleans his studio. Blues, violets, and yellows shimmer in the cloud on the screen. Of course, the scene was fictitious, but you can clearly see the same colors in the clouds in the real Vermeer's paintings.

Clouds seem pure white, but they're made of water vapor, which is the same stuff that makes the colors in a rainbow. It makes sense that you can see the entire spectrum in a cloud. Blues and violets make up the shadowed areas of the clouds, while red-violets, oranges, and yellows appear in the sunlit areas.

You can see several different kinds of clouds, and each kind has a particular shape associated with it. Look at the clouds in the sky and paint what you see rather than painting your notion of what a cloud should look like.

Clouds change over a short period of time, so capturing them quickly is essential. Here are the steps to painting beautiful clouds, and check out Figure 10-11 for an example:

1. **Draw the larger shapes of the cloud and then break down the large shapes into smaller shapes.**

 If you have a typical fair-weather cloud, it may be made of large circular sections surrounded by smaller circular sections.

2. **Note whether the cloud has a flat bottom and how much of it you can see; draw the shape of the bottom of the cloud if you can see it.**

 A flat bottom is more typical of clouds that are close than clouds that are distant. You see only straight lines for the bottoms of distant clouds in cartoons.

3. **Draw the shapes of the darker values.**

 Just like anything else, a cloud is lit on one side by the sun and has patterns of shadowed areas. The bottom of the cloud is the darkest if the sun is high in the sky.

4. **Fill in the color.**

 Use grayed blues and blue-violets for the shadowed areas. Use violets for transitional areas between shadow and light, and use very light oranges and yellows for lit areas. Save the white for the lightest areas of all.

5. **Paint the blue sky so that it defines the edges of your cloud.**

 Because clouds can be wispy, allow the edges to blur in areas.

Figure 10-11:
Painting a fair-weather cloud.

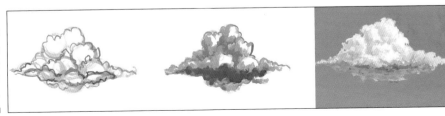

Regarding seascapes

Much of what we say about landscapes applies to seascapes, but we can say a few things about differences in approach, dealing with distance, and painting those frustrating waves.

You can use one of two general approaches to painting seascapes:

- ✔ The most common is the combination of land, sea, and sky, which you can paint as you would any other landscape.

- ✔ The second is an atmospheric approach that emphasizes sea and sky, primarily painted in blues, violets, and greens. These paintings are simple in composition but rely heavily on sophisticated use of color.

In atmospheric seascapes, you achieve the appearance of distance by using the rules for atmospheric perspective, but it can be difficult because you have only the color and texture of the sea and sky to work with. If you have waves crashing on a beach, you have a little more to work with because you have a contrast of light and dark and details in the surf. Otherwise, you have to rely on color and texture to create distance.

Here are some ways to create distance in seascapes:

- ✔ The closer the surface is to the viewer, the greater its texture. It smoothes out as it approaches the horizon.

- ✔ The colors of the sea and sky are brighter the closer to the viewer they are and become grayer as they approach the horizon. This is true regardless of whether the sun or moon is near the horizon.

Painting waves can be very challenging because they're always moving, and they can vary from beach to beach. Of course, you can always take a snapshot, but if you're on your own, here's a process that you can follow:

1. **Spend some time relaxing and watching the waves come in.**

 Don't try to paint them. Just observe and analyze their shapes, colors, and movement. You'll notice that each wave is similar to the ones that follow.

2. **Pick the point of the wave coming in that you want to depict and, as you watch each wave roll in, take a mental snapshot of what it looks like at that point.**

 Some waves are rounded mounds at a distance, becoming peaked as they approach shore, and finally tumbling over themselves. Others may be a series of oversized ripples.

3. **As you develop your mental picture, start to look for the dark areas in the wave and details you can use.**

4. **Now you can begin to paint.**

 You may be surprised at how easy it is.

Keep these things in mind as you paint your waves:

✔ Keep your brushstrokes loose and fluid. You especially want to avoid making them look stiff and frozen.

✔ The brushstrokes for ripples and the top sides of the waves should run generally parallel to the shore. When the wave crests and breaks, run the brushstrokes in the same direction that the water is moving.

Evaluating your outdoor paintings

For the most part, you evaluate your outdoor paintings the same way you evaluate your other paintings, but with the goals of landscape painting in mind. Here's a checklist that you can use:

✔ How is the drawing? Do the objects in your landscape look reasonably realistic?

✔ Can you see depth or distance in your landscape? Did you treat the foreground differently than the background?

✔ Are the colors in your background duller than the colors in your foreground?

✔ Are the objects in your foreground more detailed and do they have sharper edges than the objects in the background?

✔ Does everything in your painting seem to have the same source of light? Is everything light on the same side and dark on another side?

✔ Did you vary your colors by using analogous colors and contrasting warm and cool colors rather than by adding only white and black?

Project: A One-Day Landscape Project

Gather your stuff and go out to paint! Find a spot, set up your outdoor studio, and you're ready for your first *plein air* experience.

1. **Use your viewfinder to find the scene you want to paint.**

2. **Begin your drawing with a brush and thinned ultramarine blue (see Figure 10-12).**

 Refer to Chapter 5 for info about drawing on your canvas. Set your canvas aside as soon as you're happy with the drawing.

3. **Prepare your palette of colors.**

 Look at your scene and mix five to seven stock colors that represent the major colors in its palette. You'll modify each of these colors with white and other colors as you paint. For example, you could use two blues (one leaning toward green and the other leaning toward violet) for sky and water; yellow-green, green, dark green, blue-green, and dark blue-violet for trees, shrubs, and shadows. Also squeeze out a little of each of your tube colors.

To improve your use of color in your painting, don't wait until you need it to put paint out on your palette. You're more likely to use it if it's already out. Don't worry about wasting paint; you're more likely to shortchange your painting than your pocketbook.

4. **Go back to your canvas and, starting with the areas of the landscape that are closest to you, do your underpainting.**

 The *underpainting* is the thin coat of paint that you lay in first (you can read more about it in Chapter 5). With your darker green, lay in the patterns of shadows on the forms that will be green with thinned paint. Do the same on the objects that have different local colors.

5. **Lay in the sunlit areas on your objects with thinned light versions of your colors.**

 Yellow-green may be appropriate for these areas.

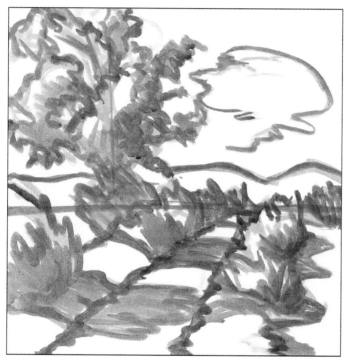

Figure 10-12:
First draw the major shapes in your landscape.

6. **Paint the bodies of the objects with their local color and brush the colors together slightly using a stroke appropriate to the texture of your objects (see Figure 10-13).**

 Don't blend the colors or lose your dark areas by brushing too much of the lighter colors into them.

7. **Move to your middle ground and background.**

 Lay in the darker areas of the forms using a lighter, duller version of the colors you used for shadowed areas of the objects in your foreground.

One approach that creates distance is mixing the pale blue you use near the horizon with the colors you use in the foreground to make the colors you use in the middle and backgrounds. For example:

- If you paint a tree in the middle ground, you might mix one part blue with two parts green for the leaves.

- If the color is in the far distance, you may choose three parts blue to one part green. This will work only with a pale sky-blue color.

The brighter blues you use in the sky at the top of your painting, representing the areas closest to you, are too bright to help you achieve distance.

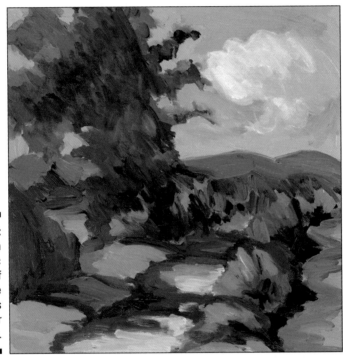

Figure 10-13:
Block in the basic colors of the large shapes in your landscape.

8. **For the sunlit areas, mix a slightly duller, darker version of the light colors in your foreground; paint those areas in.**

9. **Mix duller versions of the local colors than you have in the foreground and paint the bodies of the objects.**

 Loosely brush them together so that they have less texture than the objects in the foreground.

10. **Paint your sky.**

 Starting at the top of your canvas, loosely brush together the brightest versions of your blues. As you move closer to the horizon, slightly dull and lighten the colors and add violets to the mix.

11. **As you paint around trees, treat the sky as negative space (see Figure 10-14).**

 Use it to help you shape the trees. If trees are in the background, blur the edges slightly.

12. **Go back to your foreground and continue to develop the textures and values of the objects closest to the viewer (see Figure 10-15).**

 Make sure that the shadows of these objects are darker and deeper than the shadows in the background.

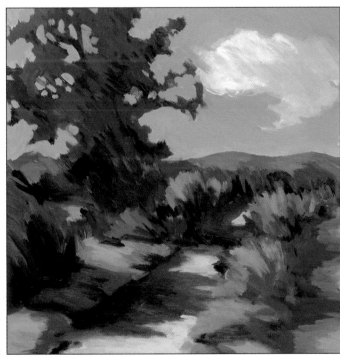

Figure 10-14:
Treat the sky as negative space as you refine the forms in your landscape.

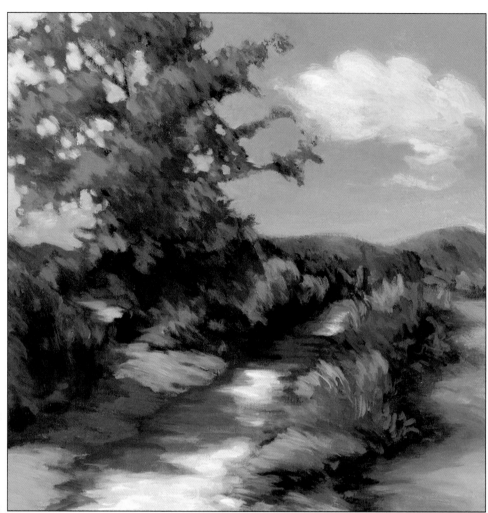

Figure 10-15:
A finished
one-day
landscape
painting.

Basic Portrait Painting 101

*I*mages of the human form have been a part of art since the very beginning. Whether it relates to a record of historic event, an allegory, documentation of a powerful individual, or the communication of human expression, other people are fascinating.

Painting the human face is also one of the most challenging things you can do. Actually, painting a likeness isn't that difficult, but everyone has very high standards. If the eyes don't line up right or if the mouth is a bit off, you spot it right away. Even people who have no interest in art become art critics when they see a less-than-perfect likeness.

Although painting portraits can be a bit frustrating in the beginning, with practice you can develop the skills necessary to create a true likeness and a beautiful painting. We offer some basic points to consider as you pursue this subject.

Doing Some Prep Work for Portraits

The layout of the proportions of the face may look familiar to you already. You've seen an oval divided up for placement of the eyes, nose, mouth, and so on. Therefore, whether from drawing lessons, a book, or your own experience, the placement of the features is easy to figure out. If you've ever had an interest in sketching faces, you've probably tried this already.

If portraits are new to you, or if it's been a while since you tried to draw an image of someone, practice drawing the features of the face a bit first. You can start by drawing from the upcoming diagrams in Figures 11-1 and 11-2 to teach yourself how to make the different features of the face. You can draw from photos or from your image in the mirror. Practice drawing eyes, noses, and mouths until you feel comfortable with them.

Practicing the proportions of the face

Before you start painting, examine your face a bit to see whether the features are always in the same place. Take a look at the illustration in Figure 11-1 and follow these steps:

1. **Gather your materials — a mirror, piece of paper, pencil, and a long paintbrush handle or a skewer to use for a measuring tool.**

 You can use the mirror in your bathroom or a wall-mounted mirror.

2. **Draw an oval on the paper and then look *straight* at the mirror to see a full-face, frontal point of view.**

3. **Take one of your long paintbrushes and put the handle right down the middle of your face, touching your nose; adjust the placement of the brush so that the top end of the brush stops exactly at the point at the top of your head.**

4. **Pinch the other end of the brush so that your thumb and index finger mark the bottom of your chin.**

 This is the length of your head.

5. **With your other hand, pinch a place on the handle right between your eyes.**

 This marks your eye level. When you look at the paintbrush, do you notice how your eye level comes almost exactly halfway between the top of your head and your chin?

6. **Mark your eye level on your oval.**

7. **Place the handle so that it measures from your eye level to your chin and find the point for the base of your nose; mark this point on the oval.**

8. **Do the same for the position of the mouth, using the opening of your mouth as the measuring point.**

If you compare your measurements to those in our illustration, you probably find that they're a little different. No one's face is exactly the same as someone else's. Everyone has measurements that vary from the standard benchmarks you find in books about art techniques, but these benchmarks give you a general idea of the placement of the features of the face.

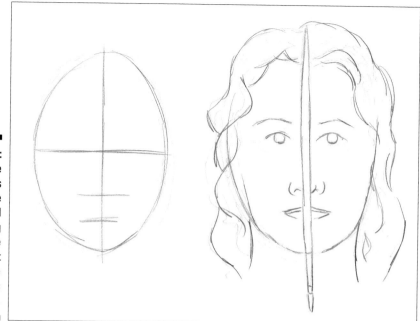

Figure 11-1:
The
proportions
of the face
(left), and
measuring
the
placement
of the
features
(right).

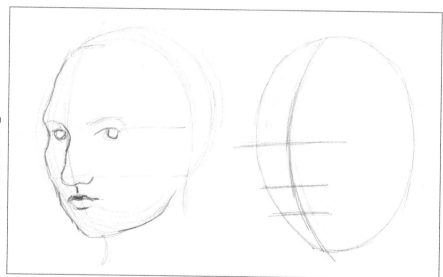

Figure 11-2:
The
proportions
of the face
in three-
quarter view
(left) and its
contours
(right).

Choosing the best point of view for a portrait

If you look through art books or go to the museum, you see portraits in many different positions. For the most part, you see the head slightly turned to one side. In a three-quarter view, the sitter is recognizable and looks natural. On the other hand, you're least likely to see profiles. A profile is the easiest point of view to depict, because most of the likeness is tied up in the contour of the face. If you get that contour right, the rest works out quite well. The problem with profiles, however, is that the position looks unnatural. A full-face portrait is another option, but it's the most difficult because the nose is pointed directly at the viewer, which makes it very difficult to capture. In addition, if the symmetry of the face is even slightly off, it's very apparent.

We think your best option is to try the three-quarter view. Place the brush before your nose (see the preceding section for details) and turn your head a quarter-turn to the left. Notice how the eye, nose, and mouth level are the same, but your centerline is off to one side. The centerline isn't a straight line anymore — it curves and follows the contours of the face. This curving line starts in the middle of your forehead and ends in the middle of your chin, but it gently bends to the left to follow the line of the nose. The right cheek is a wide surface, but the left cheek is reduced to a sliver.

Finding the relative position of the features is easy when you use the landmarks of the face. Use your paintbrush handle to find some of these landmarks. Hold it horizontally or vertically and see what parts of your features line up with others. Again, every face is different, but here are some examples:

- ✔ The inside corner of the left eye is right above the middle of the lips.
- ✔ The inside corner of the right eye is right above the right corner of the mouth.
- ✔ The bridge of the nose is higher, lower, or exactly in line with the eye level. Where is it on your face?
- ✔ The top of the ear lines up with the level of the eyes, and the bottom of the earlobe lines up with the lip line.

Project: A Self-Portrait in Black and White

As we emphasize throughout this book, a study is just an informal painting. This study is a little experiment in black and white. As with any new subject, simplifying the elements for the first try is best.

Your first study is a self-portrait. Now, don't panic. We know that painting yourself may make you feel self-conscious, but we have a couple of good reasons for doing self-portraits. The model is always available when you are, and if it doesn't turn out as well as you'd like, you disappoint no one but yourself.

Also, self-portraits have a long and esteemed history in art. Many artists create self-portraits during their careers, and it's a very well-respected tool for teaching students the basics of painting and drawing people.

Work through the following steps to get started, and then move through the steps in the upcoming sections to create your self-portrait:

1. **Gather your supplies.**

 You need a face-sized canvas — approximately 10 x 12 inches — a mirror that's at least 12 x 12 inches (or park yourself in front of the bathroom mirror), black and white paint, a variety of brushes, solvent in a couple of jars, a palette, and a palette knife.

2. **Set up so that you have a three-quarter view of yourself in the mirror, and arrange a clear light source directed at your face from the side.**

 You need this light source in order to see the contours of your face. A lamp with the shade tilted toward you or a bright window works well.

3. **Mix up some light gray paint to make a wash and draw an oval on your canvas; use the steps for drawing that are in the earlier section, "Practicing the proportions of the face."**

 The oval should be about the same size as your face; don't make it smaller. Anything small is always more difficult to paint.

4. **Make a very light line for the level of the eyes, nose, and mouth, and draw the location of the hairline.**

 Check your work and make any necessary corrections.

Drawing the big contour of the edge of the face

After drawing in the proportions of your face, you add a line for the contour that you see on the far side of the face. This contour line is important for finding the placement of the facial features. Follow these steps and use Figure 11-3 as an example to add this contour line to your self-portrait:

1. **Start at the top of the forehead, and curve the line outward to the brow.**

2. **Dip the line in to follow the hollow of the eye socket.**

3. **Curve the line out for the cheekbone and down along the line of the cheek, gently curving in to the chin.**

4. **Curve the line of the chin in to join the neck.**

 Don't be concerned if the chin extends beyond the initial oval that you drew. You're still sketching in the basic form.

If you wear glasses, ignore them until later in the study. We give you instructions on how to make glasses at the end of this project.

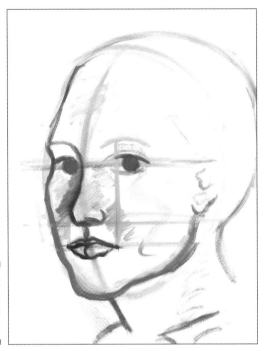

Figure 11-3:
Developing
the contours
of the face.

Filling in the back of the head

The next step is to add some volume to the back of the head for the brainpan. Follow these steps:

1. **Start at the top of the head near the hairline and draw a circular shape that connects with the head at a point that's even with the bottom of the ear.**

 The connection point may be hidden by the hair, but it's there. You can make this point at approximately the bottom of the ear. You're still drawing and you can refine it as you work. You can also line up this point to the level of the lip line to be more precise.

2. **Sketch in the contour of the neck under the chin and draw another line from the back of the head.**

 Looking rather human, yes?

Working on the contour of the nose

Make another line with your wash to indicate the contour of your nose. This line runs from your left eyebrow to the base of your nose. These steps walk you through the process:

1. **Start at the point where the eyebrow extends the farthest, close to or meeting the contour of the side of your face.**

2. **Follow the contour of your eyebrow to the bridge of your nose, down the angle of the nose, and end at the base of your nose.**

3. **If yours is apparent, add the *philtrum*, that funny little vertical groove under your nose that leads from the base of the nose to the lips.**

Adding in the features

Now you add the other features of the face: the eyes and the mouth. Take a moment to really look at your features. If you mentally simplify your face, you see it as some lines and some dark spots or light spots. Notice how the whites of the eyes aren't really white. Your eyelashes aren't big, curling things, but a rather jagged dark line. Many people exaggerate the features, and the face ends up looking pretty wacky with big false eyelashes, outlined lips, and huge nostrils. Concentrate on painting what you see, not what you know, and check out Figure 11-4.

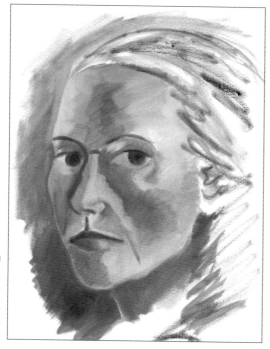

Figure 11-4:
The details
of the face
take shape.

Just about everybody has made an eye at one point or another. An eye is shaped sort of like a football with a round iris in the middle and a little black dot for the pupil. These eyes are at three-quarter view, however, and you're

concentrating on drawing just what you can see, so hold off on drawing those football shapes. Keep working with the wash so that you can easily make corrections while you follow these steps:

1. **Find the iris of the eye on the far side of your face and put it in using the contour of the nose to help you place it.**

 See how your iris is tucked into the bridge of your nose? Although every face is different, it probably seems to be resting right in the inside corner.

2. **Add the line that you see on the top eyelid and the line that you see on the bottom lid if it's clear.**

 Whether you can see the bottom lid clearly depends on whether you have fair or dark skin or if you have heavy lashes on the bottom eyelid.

3. **Find a landmark on your face and draw a line to help you locate the corner of the lips.**

 Use the features that you've already made to find the position of the mouth. Compared to a full front view, the far side of your lips is smaller and the nearside may appear to be a bit bigger. To use other parts of your face to locate the position of the lips, see whether the far corner of your lips lines up, for instance, with the tip of your nose. Or maybe it's right below the edge of the left iris.

4. **Find the points for the corners of the mouth, and then locate the centerline; make the line of the lips by connecting the two corners.**

 The *centerline* is a continuation of that little divot below your nose, the philtrum.

5. **Use the near corner of your lips to line up the position of the near eye.**

 The corner of the near eye is above the corner of the mouth.

6. **Measure the base of the nose or the width of the mouth and use the measurement to find the width of the near eye.**

7. **Carefully observe their shapes while you draw in the iris and the eyelids.**

Don't be shy about putting the dark circles under your eyes or the bump on your nose. It's a part of you and it needs to be in your self-portrait. Failing to observe well and idealizing your image undermines your goal of capturing your likeness.

Evaluating your image

Take a minute to assess the sketch you just made. Back up and use your paintbrush to line up the forms. Then check the position of your own face. Make any corrections that are glaring, but don't overdo it. This is only for practice.

The next step in your portrait is developing the lights and darks of your face. Follow these steps:

1. **Mix two pools of gray paint in light and medium values, using a different brush for each.**

 You use two brushes, one for each pool of gray paint, so that the values stay true to your mixes.

2. **Find the shapes of the darkest areas of your face — the shaded side, the upper lip, the background, and maybe your eyes if they're dark — and paint the medium gray in those areas.**

3. **Find the lightest areas — where the light hits your face on a cheek-bone, the whites of the eye closest to the iris, and along the nose — and indicate those areas with the lighter gray.**

 Don't blend, just work up the face in patches of light and medium gray.

4. **Fill in the middle tones that you see by picking up a little of both the light and medium grays and adding it to the face.**

 You usually see the middle values in the middle of the cheek and forehead, on the bottom lip, and around the eyes.

5. **Cover the rest of the face with the appropriate grays.**

Adding the finishing touches

Stand back and assess your results. Play with the values a while. Your canvas will be very wet, and you have to stop working when the wet paint gets too difficult. Leaving the study incomplete is fine, but you can also experiment with other parts of the study — the background, the hair, or maybe an ear — while the wet areas are drying a bit.

Glasses

At this point, you can put in glasses if necessary. The trick is to avoid giving yourself Groucho Marx-style glasses — unless you wear Groucho glasses.

Take a minute to look at your glasses and concentrate on what you really see. Then follow these steps:

1. **Find the points where you see the light glinting off the frames, and add them in with light gray paint.**

 That glint doesn't go all the way around the glasses, just on a small portion.

2. **Find the darkest part or area of your glasses, and add it in with the darker gray paint.**

 It doesn't go all the way around either, just a portion near your nose or along the temples over your ear. You may see points along the frames of your glasses where seeing the edges is difficult.

3. **Continue to paint only the little glints and lines, not the entire frame.**

 Don't try to connect the light lines and the dark lines. Take a look at Figure 11-5 for an example.

Hair

Finally, paint in your hair. Paint it as patterns of light and dark shapes, not as individual hairs and not as a solid color; otherwise, it will look like you have a bowl on your head! Many people have darker hair around the nape of their necks, and everyone has light areas around their crowns, either because of the effect of light or because their hair is naturally lighter there. (Well, maybe not *naturally*, but you know what we mean!) Pay attention to your light source, because your hair will be lighter on that side and darker on the other.

If you like, you can experiment with textures that simulate the texture of your hair. Everyone's hair is different. Long fine hair looks smooth, and coarse hair looks more textural.

Try to put some paint on every part of the canvas. When you're finished, evaluate your work. Again, don't pick at it. Doing another study is better than obsessing over a study and trying to make it perfect.

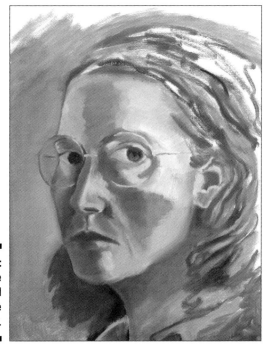

Figure 11-5:
A complete black and white portrait.

Preparing for a Color Portrait

After you've had a chance to experiment with black and white, try a portrait in color. There are, of course, many colors of skin in the world, and each individual has different colors in his or her skin. Skin tones are also affected by exposure to sun, wind, and temperature. Throughout history, artists have experimented with many different colors to create rich, complex, and authentic skin color.

Recipes for mixing flesh tones

Human skin is made up of reds, yellows, and blues. You'll encounter that basic formula in any research that you do. You also may recognize these as the primary colors. When you mix the primary colors together in the right proportion, you get a rich, natural brown. Other variations give you a variety of muted red and yellow-oranges that can serve as the basis for many different skin tones. Depending on the darkness of the skin, you may also use titanium white to bring out the contours of the face and the highlights on the skin. So, now the only issue is which of the reds, yellows, and blues do you use?

- **Yellows:** Yellow ochre is a wonderful old color that's been used as an art pigment since the beginning of human history. Another yellow that some artists use is Naples yellow, which was created specifically for portrait painting, but it's made with lead and is *very* toxic. You can also use raw umber or burnt umber for dark skin.

- **Reds:** Cadmium red light is perfect for a florid complexion, and alizarin crimson works well for dark skin tones. Examine the reds that you see in the lips, try to determine whether you see orange-reds or red-violets, and then experiment!

- **Blues:** Ultramarine blue is a warm blue that works well to dull the brilliance of the orange that you make by mixing red and yellow. When you mix the blue and orange, the resulting color makes a natural-looking skin color. You can also try other blues, such as cerulean.

- **Titanium white:** This is the perfect white to use. The old masters used lead white, but you should avoid it because of its toxicity.

Review the oil pigments in Chapter 2 for more details about these colors and possible substitutions (like cadmium red light hue instead of true cadmium red light).

A basic formula for skin

For lighter skin types, you can start by adding small amounts of cadmium red light to yellow ochre until you have a bright orange color. Check the orange against the skin tone you're painting and modify it if it needs to be more red or yellow. Add white until you have a color similar to what you see on the inside of the arm or the lower portion of the cheek. Your mixture will be close to what you want, but the color will be extremely bright, like stage makeup. Add just a touch of ultramarine blue until you have something that looks more natural.

For darker skin tones, start the same way, checking your orange against the skin tone that you're painting to see whether it leans toward red or yellow. Then, rather than adding white at this point, start adding ultramarine blue until you have a color near the value of the skin tone that you're looking for. Finally, add white to lighten the color and make it look more natural. You can also experiment with using raw umber and burnt umber in your mixtures.

The main mistake that people make when working with darker skin tones is relying solely on white to lighten the color. White may make the color too dull and ashen to look natural for many people. Keep a stock of your orange set aside to brighten the color if it becomes too dull as you lighten it.

To get a feel for the kinds of colors that you need for darker skin, look at your model's face and hands in bright sunlight. The exaggerated light helps you see how the colors change as the skin gets lighter. Often, the color of the skin is warmer when it's lighter and cooler when it's darker. When you see areas of sunlit *hot spots* (spots of bright light reflecting on the skin), you need more white without warming the color, but don't use it exclusively.

The colors for all skin types get warmer as they get lighter, except in hot spots, and cooler as they get darker. This warming of the skin color is less noticeable in light skin tones.

Other formulas incorporate more than just the three primaries. Some formulas use greens instead of blues. Some use a complex formula based on a double split complementary set of colors. With practice, you'll find yourself picking up many different colors as you develop your color instincts for painting portraits.

Project: A Portrait in Color

For this project, you can use yourself as a model again and make a self-portrait. Of course, you can ask someone else to sit for you, but sitting for yourself is the most convenient way to work on this project. You know your own face the best, and you can peer into the mirror as closely as you want to examine your own eye or ear; it may seem creepy to do that to a model. You can indulge in a little ego-tripping, as well. If, however, you ask someone else to sit for you, remember that adults are easier to paint than children are, and they don't get bored sitting still for a while.

When you're ready to begin, follow these steps:

1. **Use a wash of a light color to make your drawing on a small canvas.**

 You start your color self-portrait the same way you do the black and white portrait. Look at "Project: A Self-Portrait in Black and White" earlier in this chapter for more info on setting up your lighting and mirror. A canvas that's 14 x 18 or 16 x 20 works well.

 Try to draw the head on the canvas so that it isn't in the dead center. Place it so that you have a little more negative space in front of the face than behind the head. That way you don't look like you have your nose pressed against the edge of the canvas, and it makes a more-pleasing composition for your portrait. Figure 11-6 shows the initial sketch for our finished color portrait.

 Make your drawing with a light color — yellow ochre, for example. Make the oval and the lines for the features, and correct them as you work. Draw and assess until you feel that you have the position for all the features and contours of the face.

2. **Begin to prepare your palette of colors by mixing up your medium flesh color.**

 Try to match the tones on the lower cheek. This pool of paint is your main stock. From it, you mix pools of the other major tones that you need. Your pool of medium flesh color should be about the size of two tablespoons. Use all the usual painting materials and colors, but make sure that you have yellow ochre, cadmium red light or alizarin crimson, ultramarine blue, and titanium white.

3. **Separate about a nickel-sized portion from the pool of medium flesh color and add a little white to it.**

 Use this color for lighter areas of the face.

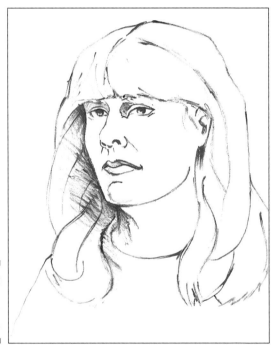

Figure 11-6:
Getting
started with
a sketch.

4. **Section off a dime-sized amount of the medium flesh color and add a tiny bit of the red that you used to make the flesh color.**

 Use this color for your lips and the areas around your eyes.

5. **Take another dime-sized amount of the stock flesh and mix in a bit of blue.**

 Use this color for the shadows.

 You now have four pools of paint to use for the major areas of the face. You can also modify small amounts from these pools when you need lighter, darker, warmer, or cooler colors for the face and neck. Because you modify your paint as you go, be sure to squeeze out small amounts of your tube colors so that they're available when you need them.

6. **Before you begin to paint, study the value patterns of the light and dark areas of the face.**

 You'll notice that their shapes generally follow the changes in the planes of the face. As you study the face, note the direction of the lighting and how it affects the values and coloring.

7. **Start laying on the medium tones for the major planes of the face, like the lower cheek, middle forehead, and nearside of the nose.**

 Ignore the features for a while as you start working general to specific. Block in the colors in the shapes of the patterns that you see without doing a lot of blending (see Figure 11-7). Don't paint in details like pink lips or blue eyes until later. Concentrate on just the medium skin tones on the major planes of the face.

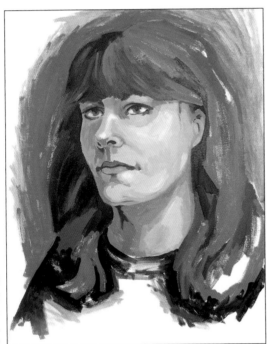

Figure 11-7: Blocking in color.

8. **Add light values on the cheekbones and on the plane down the ridge of the nose, lightening the color for highlighted areas.**

9. **Lay in your darker color for the shadows in the hollows of the eyes next to the nose, the underside of the nose, and under the chin.**

 If you see a shadowed area cast by the nose on the far cheek, add that as well.

 Throughout the painting process, make sure that you continue to observe the shapes of the values and colors of the face. At this stage, you can easily get absorbed in what you're doing and forget to look at your subject.

10. **Add the pink on the lips, cheeks, edges of the eyes, and anywhere else you see it.**

 Notice that the upper lip is darker than the lower lip. You can pick up a little more red and maybe blue with your brush and mix it to create this color. The lower lip has a highlighted area as well. Just add a little more white to the pink for this area.

11. **Paint the eyes by following the procedure that we describe in the black and white portrait.**

 Here are some tips for working in color:

 - Use a dark version of your flesh tone to define the upper lid and a lighter version for the lower lid.

 - Don't paint the color of the iris too brightly or make the whites of the eyes too white. The upper eyelid casts a shadow on the iris and whites of the eyes, so that area is darker than the lighted area. The iris and white of a shadowed eye are darker than the same areas of the eye in light.

 - Here's a mix that you can use for the white of the eye: Take a bit of your darker flesh color and add more white and blue to it. The mix should look like a slightly pinkish gray-violet. That alone may work for the darkest areas of the white that you need. If it's too dark, add a little white. Add more white for the light areas of the white of the eye.

 - The highlight on the iris isn't white. It's a lighter version of the white of the eye.

12. **Paint the rest of the nose.**

 The underside of the nose is triangular, with the sides of the nose wrapping around the nostrils. You may have already painted a darker value on the underside of the nose.

13. **Study the shapes and tilts of the nostrils; mix a dark blue-violet (almost black) and paint their shapes.**

14. **Paint the hair by following the suggestions in the black and white study.**

 Make sure that you approach hair as a pattern of dark and light versions of the color of the hair. Use your brushstrokes to emulate the texture of the hair.

15. **Continue to develop and refine the face with mixtures of all the colors.**

 If you lose the position of any of the features, take a moment to reestablish the position. Check out Figure 11-8 to see an example of a completed color self-portrait.

You're working on a small canvas, so if it gets too wet to work, spend some time on the position of the neck or the hair texture, or take a break from it for few minutes.

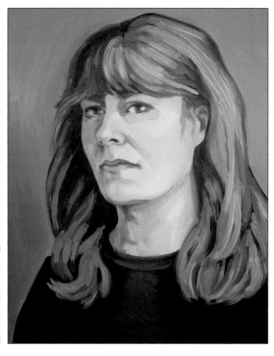

Figure 11-8:
A self-portrait study in color.

 Sometimes you may feel that the work is getting too intense, and you'll get antsy and nervous. Stop and take a break. Use the time to wash your hands and reapply barrier cream, leave the room for a few minutes, and do something else. When you return, you'll be ready to tackle the painting again.

Don't try to blend the colors too much — you're making a sketchy painting, like Van Gogh's self-portraits. If you want to refine the study into a more-complete painting, let it dry for a day or two and then return to it. The paint will be dry enough at that point that you'll be able to blend the edges of the colors, or try some glazing techniques that you can see in Chapter 8.

After you have all parts of the canvas covered (no gesso showing), wrap your palette in foil, clean your brushes, and leave the painting for a day or two.

You can leave the painting as it is, a study, or you can go back into the painting and refine it. The great thing about working general to specific is that you can stop at any point for a study or continue for a very polished work. As with everything, if your goal is to develop good portraits skills, the key is practice, practice, practice.

Chapter 12

Beyond Portraiture: More on Painting People

*I*n this chapter, we discuss painting from a model. We show you how to work on a general approach to painting people to get you started in this fascinating area. We help you build some basic skills that will enable you to paint your friends and family, and we also show you areas that can be problematic.

As you begin this work, you should realize that building skills in painting people is a lifelong endeavor. Don't be discouraged if your first efforts don't live up to your hopes. If you work regularly and with consistency, you'll continue to progress.

Working with a Model

The idea of working from a live model often conjures up all kinds of romantic notions. In reality, little is glamorous about it. The work is hard for both the artist and model.

Painting people as your subject matter is known as *figure painting*. Your model may also be called the *figure*.

Setting up your model for a painting

Setting up your model for a painting is like setting up a good still life. You have all the same considerations that you do when you set up a still life: lighting, background, color, composition, and so on. Here are some things that you should think about when you set up your model:

- ✔ The best point of view for a seated figure is a three-quarter view, especially if you're thinking about a full-figure portrait.

- ✔ Lighting is one of your most important concerns. Try several lighting situations before finalizing your setup.

 Natural light may be attractive, but remember that it's constantly changing. Light from a window on the north side of a building provides the most constant illumination.

- ✔ Consider how the colors in your model's clothing relate to the rest of the colors in the scene.

- ✔ Look at your background. It can be plain or active, but it shouldn't distract attention from your model.

- ✔ Use your viewfinder to check your scene while you put it together.

- ✔ If you plan to work for more than one session, be sure that you can rebuild your scene easily. Also, make sure that your model can maintain the pose for the duration.

Taking care of your model

Your model is a living being. Getting involved in your work and forgetting to take care of your model's comfort is easy to do. Here are some things you should do to set up a good working environment for your model:

- ✔ First and most importantly, don't torture your model by making him or her pose endlessly without a break. Get an inexpensive kitchen timer and set it for no more than 20-minute sessions. Let your model take a break of at least 10 minutes between sessions.

 When it's time to take a break, mark the positions of the model's feet, arms, and seat with strips of masking tape. Ask the model to remain seated while you outline the positions of the feet on the floor and run strips along the sides of the hips on the seat of a chair, and on the arms of the chair, if applicable. Use your drawing to help the model get back into position.

- ✔ Don't let the entire working session run too long. Working longer than two to three hours is very taxing for the model.

- ✔ Make sure that the temperature of the room and other conditions are comfortable for your model.

- ✔ When you set your lighting, keep it out of your model's eyes.

> ✔ Make sure that the model is sitting in a position that will remain comfortable for the entire work session.
>
> ✔ Some models are chatty, but others fall asleep. If chatting bothers you, arrange to have some entertainment, such as television or music, for the model.
>
> ✔ Be a good host.

Young children aren't good models for beginning figure and portrait paintings and shouldn't be expected to sit for them.

A few words about nude models

If you decide that you want to focus on painting the human form, you eventually should take some figure drawing courses where you can work from a nude model in a class environment. If you want to understand the underlying structure of the body and the way it moves, working from a nude model is necessary. Trying to learn to paint people only while they're clothed is like learning to paint hands only when they're gloved.

If you take a course, you work with an experienced instructor and model in a professional, dignified environment. This is an established part of artists' training that's many centuries old.

Most students are nervous before their first session, but within minutes they're more worried about their drawing than the fact that they're drawing from a nude model. From then on, they think nothing of it. Many students even have a sense of pride and accomplishment that goes along with it. They've walked across the bed of hot coals and survived to tell about it!

You can find figure drawing and painting courses through your local arts organizations and junior colleges or universities. Most art schools also have community outreach programs that offer courses.

Setting Up Your Work Area

After you arrange your setup and decide how you want to paint your model, let your model relax or do something else for a bit while you prepare your work area.

When you work from a model, you pull together everything you learned from doing still life painting and self-portrait into one painting. Don't think of this painting as something completely different. Use those skills to set up your scene and your work area. If you need to refresh your memory, read the sections in Chapter 4 on setting up your work area, Chapter 7 on setting up a still life, and Chapter 11 on the colors to mix.

Figure 12-1 shows how the work area and model were set up for the painting in Figures 12-2, 12-3, and 12-4. Here are some important points to remember when you set up your own model:

- Set up your work area so that you have a clear view of the model without having to peer over your canvas or across your painting arm. Set up your palette on the same side of your body as your painting arm.

- Space yourself far enough away from the model that you can see the entire scene you plan to paint without tilting your head down or turning to either side.

- Mix pools of paint that you'll use for the major areas of the painting before you seat your model. These pools include major flesh tones, as well as clothing and background colors.

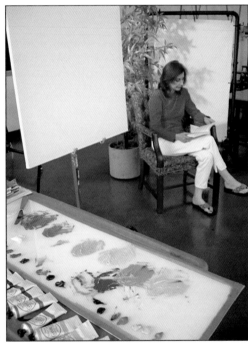

Figure 12-1:
Fully
prepare
before you
seat your
model for
the painting
session.

Project: How to Block In and Paint the Figure

One of the biggest mistakes beginners make when they first begin to paint people is to paint them too small in their compositions. You can control this easily when you first begin the drawing for your painting.

The first marks you make on the canvas establish how big your figure is going to be and where it will be on the composition. If you can arrange the figure to touch any two sides of the picture frame in your composition, you'll never paint a figure too small in the composition.

When you paint the full figure, working larger is easier than working on a small canvas. Choose a prepared stretched canvas or canvas board that's at least 18 x 24 inches. A good size may be 24 x 30 inches. When you're ready to begin, follow these steps:

1. **Choose or mix a very light color to start your drawing.**

 Because painting figures is new to you, using a light color allows you to make corrections with a darker color.

2. **Start drawing the figure like a stick figure.**

 By drawing the interior directions of the body first, rather than the outside contours, you can control the positions much more easily. Refer to Chapter 13, where we describe this process for drawing the figure.

3. **On top of those simple directional lines, make geometric shapes for the major parts of the body.**

4. **Refine the geometric shapes to look more like the organic forms of the body and clothing.**

5. **After you complete your drawing of the figure, draw its background.**

 See an example of a completed drawing in Figure 12-2.

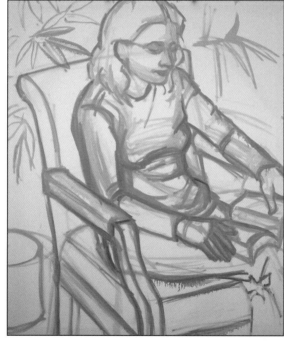

Figure 12-2: Start your painting by drawing with a light color and make corrections with a darker color.

6. **Block in the major value patterns.**

 Lay in the shapes of the darker values in the scene with dark versions of the colors of the clothing or with the darker, cooler flesh tones in the face and body. This step helps you set the value pattern for your painting and gives you an idea of what your general composition is going to look like. Be sure to lay in any dark areas of the background that will help you define the light edges of the figure. Define edges this way rather than drawing a dark line to define the area.

TIP

Don't paint the figure as if you're coloring a page out of a coloring book — your work will look flat. As you paint, think about painting the forms edge-to-edge and plane-to-plane rather than painting lines and filling in. This way, you paint patterns and planes that make your work look more three-dimensional.

7. **After you paint your dark patterns, block in your middle value colors, and finally the light areas (don't add highlights until the painting is nearly finished).**

 When you work on the face, hands, or feet, keep them very general in the beginning. Don't fuss over them and neglect the rest of your canvas. Just concentrate on capturing their basic planes and patterns. In Figure 12-3, you can see how we blocked in the major forms.

 Clothing has many different weights and textures. Concentrate only on painting the basic value patterns that you see rather than focusing on the details and minutia of the cloth.

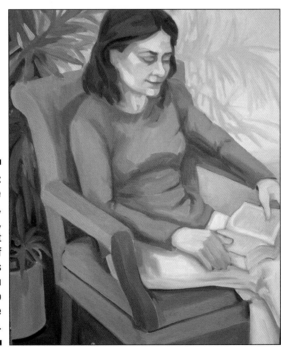

Figure 12-3: Block in the major dark, medium, and light values of your colors before you begin to refine the forms.

8. **After you block in the basic value patterns, begin to refine the forms.**

 Again, don't get tied up in knots over the face and hands. Treat them just as you do the rest of the canvas. The shapes in those areas will probably be smaller than the shapes in most of the other areas of your picture, but the way you paint them is the same. You just need smaller brushes.

 Be especially careful not to make the hands or feet look too worried and overworked. Take a breath and look closely at the patterns and shapes. Use the correct shapes, but don't paint them so that their complexity detracts attention from the face or other important parts of the composition. Keep the forms simple yet true to their shapes.

See the sections on troublesome body parts and painting fabric later in this chapter for more information about painting these areas.

9. **As you refine the forms, be selective about which areas you refine — those areas will have more detail and come into focus more than other areas.**

 Stand back and evaluate your work often.

10. **Add highlights and darkest darks last. Figure 12-4 shows our finished portrait.**

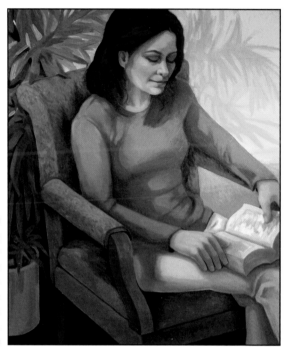

Figure 12-4:
Selectively
refine areas
of the
painting to
bring them
into focus.

Special Concerns in Figure Painting

Painting figures is a complicated process, and you're bound to have trouble in one area or another. This section presents some tips for dealing with these problems.

Proportions and realistic body positions

Everyone makes a big deal about proportions. Getting them right *is* important, but memorizing a set of standard proportions isn't really that useful. Most are idealized sets of body proportions that resemble the kennel club standards you'd use for breeding dogs.

Everyone is different from any given set of standards, and if you try to impose them on the figure in your painting, your painting will never look like the model. The only practical way that you can apply them is if you have someone modeling for you in a standing position.

Sighting the figure

The best way to establish proportions is by observation. A tool that can help you find your directional lines, as well as measurements of different parts of the body, is a sighting stick. We discuss this tool in Chapter 6, but we also give you a brief description here as it relates to painting from a model.

The best object that you can use for a sighting stick is a skewer, but you can also use a pencil or paintbrush. When you look for the angles of your directional lines, you compare the angular lines of the body against a horizontal sighting stick. When you use the sighting stick as a measuring device, you compare other parts of the body to a specific part of the body, such as the width of the shoulders. This measurement is your "given" or "known" measurement, and you compare everything else to it.

Getting the proportions right

A few simple guidelines may be helpful. Check out Figure 12-5 as you look over them.

Because many beginning artists make the legs too short, here are two guidelines that may help:

- ✔ The distance from the top of the head to the hipbones is equal to the distance from the hipbones to the heels of the feet.

- ✔ The distance from the hipbone to the middle of the knee is equal to the distance from the knee to the heel of the foot.

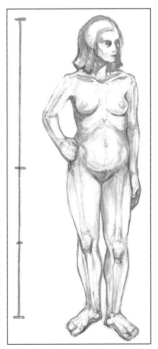

Figure 12-5: Some simple proportions that may help guide you.

Because making the hands too small is a common problem, keep these guidelines in mind:

✔ The length of the hand is equal to two-thirds the distance from the crook of the arm to the wrist.

✔ When arms are relaxed at the sides of the body, the wrists hit at the hipbones and the tips of the fingers hit at the halfway point between the hipbones and the middle of the knees.

You'd be amazed at how many people on television have big heads — physically, that is. Here's a proportion that you can use to check it:

✔ The head is one-third the width of the shoulders.

These guidelines are useful only if the model poses in a standing position. Most of the time, however, the model is posed so that you're looking at the body in any number of inconvenient angles. That's when things get interesting.

Understanding foreshortening

In *foreshortening,* an object appears to become shorter as it changes from being parallel to the viewer to pointing toward or away from the viewer.

Foreshortening is the reason that you need to learn how to sight angles and measure lengths. You have to deal with foreshortening any time any object sits on an angle toward or away from you.

Try this exercise to better understand foreshortening:

1. **Stand in front of a mirror with your arms resting at your sides.**

2. **Keep your right arm straight, and swing it out to the side until it reaches shoulder level.**

 Notice how the length of your upper arm and the length of your lower arm remain the same as they were when your arm was at your side. Their lengths don't change as long as they remain parallel to your body.

3. **Keep your arm at shoulder level and slowly swing your arm toward the mirror until you can point your finger at yourself in the mirror.**

 Notice how the lengths of your upper and lower arm appear to become shorter and shorter until your arm nearly disappears behind your pointing finger. If you continue to swing your arm until it crosses your body, you'll see the lengths start to become longer again.

You can use a two-part strategy for drawing foreshortened limbs and other parts of the body. We call it the "inside-outside" technique, and we show it in Figure 12-6. Here's what you need to know:

✔ **The inside:** Imagine that you can see the bone inside and draw a line that represents its angle and length. Use your sighting stick to help you.

✔ **The outside:** Imagine that the foreshortened limb is a jigsaw puzzle. Visually break the limb down into a few basic shapes that can be put together like a puzzle. Draw the shapes so that they fit together on top of the line you drew to represent the inside.

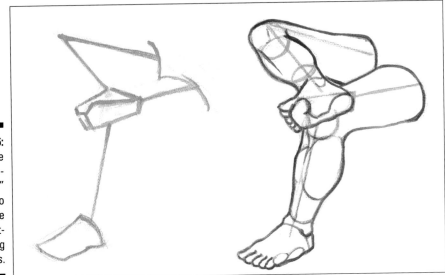

Figure 12-6:
Use the
"inside-
outside"
strategy to
tackle
foreshort-
ening
problems.

Troublesome body parts

Guess what? They're *all* troublesome!

Okay, we hear that, and we urge you to be patient. We give you a lot to do and a lot to think about in this chapter. It doesn't come right away or all at once. With every painting, you gain more skill. If you work consistently, you see a lot of progress in a short time. Keep working and you'll surprise yourself.

In the meantime, we offer some help with the parts of the body that give beginning artists the most trouble.

Putting some meat on those bones

Breaking the body down into manageable parts is easier if you have some understanding of human anatomy. Don't freak. You don't have to memorize any muscles or bones. You already know the parts that you need to know to get started. You just need to look at them more closely.

Rather than drawing and painting arms and legs that look like noodles, give them some shape. When you can see them, draw the elbow and knee bones and the major muscles, like calves and biceps. Muscle and bone also affect how clothing drapes over them, so you need to have some understanding of what's underneath the fabric.

To start, you can use some basic oval shapes for the muscles that most affect the shapes of the arms and legs. In Figure 12-7, we show you how to draw the shapes of the muscles, and how to draw the patterns of the values and paint them in.

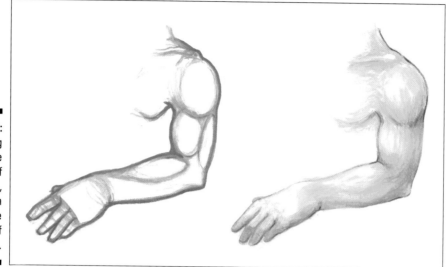

Figure 12-7: Drawing ovals for the shapes of the muscles, and then finding the patterns of value.

To help you see the anatomy of the legs better, look in a mirror, feel your own legs to check them out, or take a look at Figure 12-8. This list includes some additional tips:

✔ The ankle bone on the inside of your leg is higher than the ankle bone on the outside of your leg.

✔ The calf of your leg bulges out higher on the outside of your leg and lower on the inside of your leg.

✔ You can see an "H" shape on the backside of your leg at the knee.

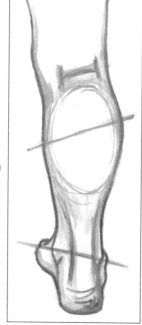

Figure 12-8: The distances between the inner and outermost points of the calves and ankles.

Depicting hands and feet

The secret to drawing hands and feet is to break them down into simple parts. Follow these steps to get an idea of how to draw hands, and refer to Figure 12-9:

1. **Draw the hand like a mitten, but rather than drawing it as a generalized mitten-like shape, draw it as though the mitten is tight and you can see the positions of the fingers.**

2. **Draw the negative spaces between the fingers.**

3. **Break down the flat of the hand and the fingers into planes.**

4. **Paint the value patterns in the hand.**

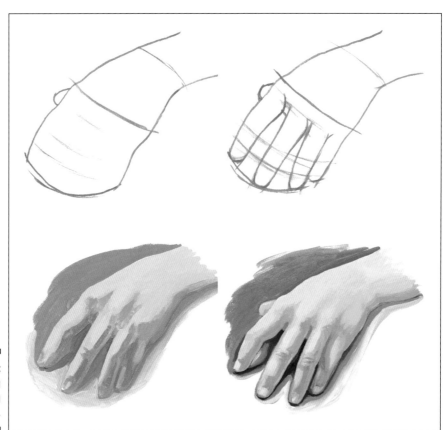

Figure 12-9:
Drawing
and painting
a hand.

Feet are a little more complicated to describe. In essence, you need to draw a large basic shape from which you can build the rest of the foot. For example, you can draw triangles for the front and outside views of the foot and modify them to make the toes or heel. For the inside view, you can use an arch shape and add the toes and heel. For the back view, you can use a triangle for the Achilles' heel and tendon and then add the ankles and visible parts of the foot on either side. It's probably easiest if you simply take a look at some pictures of shapes that you can use for back, front, and side views — that's what Figure 12-10 provides.

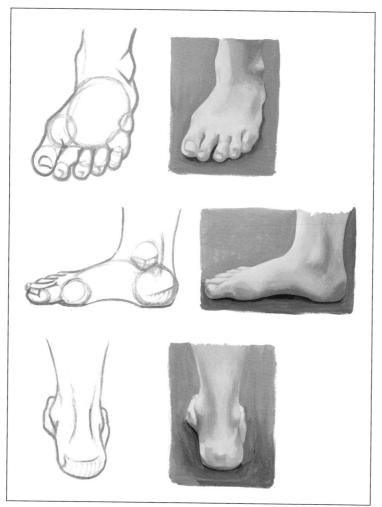

Figure 12-10:
Painting
different
views of a
foot.

Problem areas in the face

Becoming comfortable painting the features of the face takes a little practice.
The following sections provide some pointers.

Eyes

Take a look at Figure 12-11 and keep these points in mind:

- ✔ Structurally, the eyes are balls set into sockets.
- ✔ The lids wrap around the top and bottom of the eyeball and they have thickness.
- ✔ The eyelashes and upper lids cast a shadow on the iris and whites of the eyes.

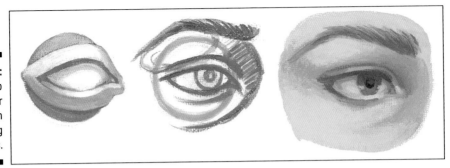

Figure 12-11:
Points to
remember
when
painting
eyes.

Ears

You can paint an ear in three steps (as shown in Figure 12-12):

1. **Use the darker values of the hair to define the outside shape of the ear.**

 It's roughly shaped like an organic looking "C." Include the ear lobe.

2. **Use the dark area of the ear canal to define the squareish shaped flap of cartilage that protects it.**

3. **Paint the rest of the ear by looking at the shapes of the dark values.**

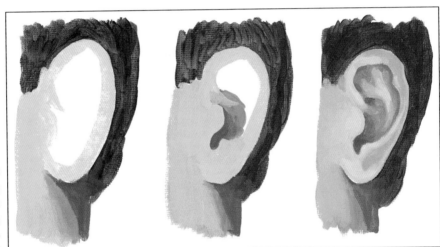

Figure 12-12:
Three steps
to painting
ears.

Noses

Noses are essentially triangular tent shapes that you can refine into the shape of a nose. Check out Figure 12-13 and follow these steps:

1. **Draw a tent shape first, and then slice off the narrow ridge of the nose (unless you need it) so that you have a flat plane running down the ridge.**

2. **Mark where this plane changes angles, if it does.**

3. **On the triangular underside of the nose, draw the shapes of the openings of the nostrils.**

 They're more or less shaped like beans.

4. **Draw the curved sides of the nostrils and refine the rest of the shapes of the nose.**

5. **Look very closely at the value patterns and then paint them.**

 Each change of plane is a different value. Often, the underside of the nose is the darkest area.

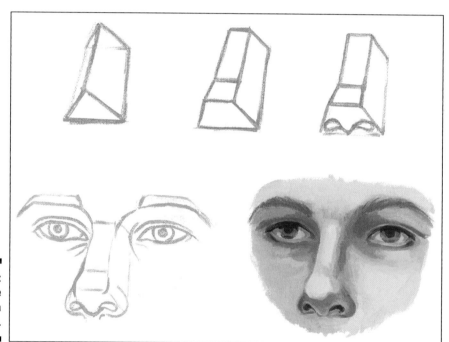

Figure 12-13:
An example of painting a nose.

Mouths

Mouths don't have to be difficult. If you keep a few things in mind and refer to Figure 12-14, you can paint a great mouth every time:

- ✔ Don't outline and fill in the lips as if you're applying lipstick. Treat the upper and lower lips differently.
- ✔ The center line that represents the opening of the lips is the darkest line.
- ✔ In most cases, the entire upper lip is darker than the lower lip.
- ✔ The center third of the bottom lip's lower edge is darker than the rest of the lip.
- ✔ The corners of the mouth are dark.

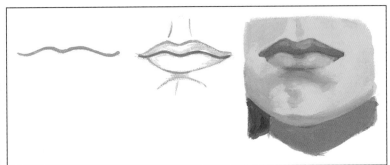

Figure 12-14:
Paint a
great mouth
every time.

How to paint clothing

Painting clothing can be an overwhelming task, but if you remember to work *general to specific,* you can break it down into manageable parts — and that makes it much less confusing.

If you study the fabric your model is wearing, you find that you have two different kinds of shapes in the fabric: smooth, rolling shapes and angular shapes. When you paint the rolling shapes, paint even transitions from one value to another. The angular shapes are easier to paint, but they look more complicated. Break down large shapes into a series of smaller triangular shapes. Paint each shape a different value from the shapes around it, as shown in Figure 12-15.

You achieve texture by matching your brushstrokes and values to the type of surface that you're emulating. Use smooth, blended strokes and a wide range of values from very light to very dark for shiny satin fabrics. On the other hand, a matte fabric with a texture may require short, choppy strokes and limited range of values.

Pay a lot of attention to the value pattern in the fabrics of the clothing your models are wearing and you can paint realistic clothing.

Figure 12-15:
Rolling (left)
and angular
(right)
shapes in
the fabric.

Part IV
Color and Design

The 5th Wave By Rich Tennant

"Here's the problem with oil painting on bathroom tiles. The portrait of your niece has soap scum in her hair and the nose needs to be re-grouted."

In this part . . .

We begin by talking about how to plan your painting and how to start making decisions about the way it will look. Painting is more than slapping paint on a canvas. A good painting is designed well. In Chapters 15 and 16, we talk about the core concepts of good design and tell you how you can avoid the mistakes that beginners make. We show you how to tie the way you compose your painting to the ideas that you want to express. We also help you recognize how your personality shows up in the way you put your painting together and how you can harness that knowledge about yourself to benefit your painting. We end this part by beefing up your knowledge of color. We show you how to use color to create depth and direct your viewer's attention around your canvas. Finally, we provide strategies for choosing color schemes that will result in mesmerizing color in your painting.

Chapter 13

Planning Your Painting

In This Chapter

▶ Planning and painting your own subject matter

▶ Discovering different approaches to planning your paintings

▶ Making preparatory sketches

*N*othing is as tantalizing — or as frightening — as a blank canvas. It's brimming with possibility for exhilarating success, miserable failure, and everything in between. If you paint a lot, you'll have many successes, but in the beginning, you'll also have some frustrating "learning experiences."

Painting is a process that begins well before you start putting a brush and paint to canvas. Although your main concern may be how realistic you can paint that vase of irises, you undermine your efforts when you don't stop to do a little planning before you start. There's a time for diving in and painting directly on the canvas, but at other times you need to slow down and do some drawing or make rough color sketches before you begin painting on the canvas.

The fate of the final work can be decided by the time you apply the first layer of paint to the canvas. You can maximize your chances for a successful painting if you think through what you need to do before you get your brushes out.

In this chapter, we talk about the things you need to think about or do before you actually start painting: setting up a good still life and making rough sketches. We give you some simple drawing lessons, show you how to transfer a thumbnail sketch to your canvas, and talk about how to keep a sketchbook. We also give you some strategies for working more creatively by developing images from collage.

Working from Observation

Working from observation can be tricky because most people have a tendency to focus more on how to draw or paint the individual objects than the appearance of the overall picture. Throughout this book, we encourage you to work *general to specific.* When you're more concerned with how to paint individual objects at the expense of the total composition, you're literally too bogged down in the specifics to see the big picture.

Designing off the canvas

The design process that happens prior to working on the canvas can involve any combination of these steps:

- ✔ Researching an artist or a technique
- ✔ Gathering interesting objects or arranging for someone to model for you
- ✔ Arranging the objects or seating the model in an interesting manner
- ✔ Making thumbnail sketches to test different compositions
- ✔ Making rough color sketches to try out different color compositions
- ✔ Transferring the drawing to the canvas

Having compelling things to paint and arranging them in an interesting way are essential preparation for all observational work. The others are optional based on the needs of the work you're doing.

Setting up a successful still life

Your painting is only as good as your setup, so the process of designing the look of your painting starts with the choices you make. What objects are you going to paint, and how are you going to arrange them? Here, we give you some basic guidelines to follow.

Do:

- ✔ Choose a collection of objects that combines similar shapes with a variety of shapes. A mix of basic shapes that resemble circles, rectangles, and lines (or cylinders, boxes, and linear forms) works well.
- ✔ Use an odd number of objects. An odd number is usually more effective than an even number, but this isn't a rigid rule.
- ✔ Use your viewfinder to find the best framing for your picture. Look at the areas near the outer edges of the composition. Are they so empty that your objects look like they have a big halo around them? If so, stop and spread them out, or, if you like their positions, frame the picture in closer so that they fill the frame better.

 Your viewfinder must be set to the same proportions as your canvas if you want your painting to resemble what you see.

- ✔ Consider your shadows important shapes. Use an inexpensive clip-on light to create shadows that have character. Lighting your still life from the side gives you better shadows than lighting it from above does. Play with the clip-on light to find the best shadows for your setup.

Avoid:

- Bunching your objects together like football players in a huddle. Spread them out. Look at how the *space* around the objects is shaped by their placement. Give them some air and look at the shape of that space while you try different placements.

- Clustering objects to the sides of the picture with empty space in the middle.

- Making pyramidal arrangements, unless you have a good reason for doing it. They work great for crucifixion scenes, but it's best to avoid using them for your everyday fruit and wine bottle still life.

- "Police lineup" arrangements, unless you have a reason for it.

- Lining up the bottoms of all the objects on a horizontal line.

- Washing the whole setup with light.

We can't give you a single, perfect way to set up your objects to paint. You'll discover many different kinds of compositions and ways to arrange your objects. Ideally, you should arrange your objects to convey a certain mood or idea that you're trying to communicate. Chapters 14 and 15 discuss these concepts more thoroughly and help you begin to think about tying your ideas to your arrangements.

Making Preparatory Drawings

Taking a few minutes to make a rough sketch of your setup before you start painting is the most valuable action you can take to prepare for your painting. It's quick and gives you the opportunity to make important decisions about the composition of the painting before you actually start working on the canvas. After you start applying paint to the canvas, making changes can be difficult and time-consuming because the paint dries so slowly. Of course, you always have the option of wiping out areas with a rag, but it's messy, inconvenient, and wasteful. A little sketching beforehand is worth every minute.

You can use several approaches to making preparatory drawings:

- You can actually sketch on the canvas with charcoal or draw with thinned paint and a brush.

- You can make small *thumbnail sketches,* which aren't quite as small as the name implies, but are still miniature in relationship to the size of the canvas. Artists often keep sketchbooks where they make their thumbnail sketches and collect ideas for paintings.

- You can make a rough sketch that's the actual size of the painting. This approach is good to use for a smaller painting, but if you're making a large painting, make this approach your second stage of preparation, after making thumbnail sketches. The Renaissance artists, like Michelangelo and Leonardo da Vinci, made actual-size drawings of the figures they planned to paint so that they could transfer the drawings to the areas they were painting. These drawings were called *cartoons.*

Deciding to draw directly on the canvas

The only real reason to draw directly on the canvas is speed. Speed is an advantage when you're making studies and single-sitting paintings. You want to get in quickly and start painting. The painting itself is like a sketch.

Speed also makes a painting look very fresh, as long as you don't work on it too long. Some artists dislike paintings that look very finished and enjoy the directness of beginning with sketching on the canvas. It takes practice and doing a lot of quick paintings to learn when to stop working on an individual painting.

Keeping a sketchbook

Sketchbooks are great tools for artists. In a lot of ways, they're at the heart of what it is to make art. You may think that sketchbooks are just for drawing, but it's better to think of them more like a journal. Regardless of whether an artist works in it every day or very sporadically, it's the place where the artist works out problems, makes notes, keeps a diary, and, yes, draws! Here's a list of the kinds of things you might find in a sketchbook:

- Thumbnail sketches
- Ideas for artwork
- Drawings of objects and people for practice and skill building
- Research about subject matter
- Color samples
- Clippings of articles, photographs, and other printed materials
- Poetry and prose written by the artist
- Collages
- Notes about the daily activities of the artist

Many artists recommend that you work in your sketchbook every day. Frankly, the more you work on your drawing, the faster your painting improves and the less you struggle with the drawing in your painting. If you consistently practice the instructions we give you for making thumbnail sketches for 20 minutes a day, you should make great progress. Much more so than if you draw only to make your paintings.

Making thumbnail sketches

As the name implies, *thumbnail sketches* are small, quickly made drawings. Artists usually make them to work out ideas for every kind of artwork, including three-dimensional art, such as ceramics and sculpture.

Don't agonize over details in thumbnail sketches. Just work quickly to capture the general shapes, sizes, and positions of the objects that you're drawing. The idea is to estimate the general proportion and scale of the objects in relation to each other and the way you'll arrange them within the space of your canvas. See the example in Figure 13-1, and follow these steps to create your own:

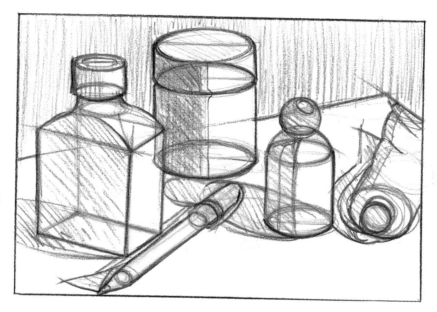

Figure 13-1:
An example
of a
thumbnail
sketch.

1. **Arrange your setup and figure the size of your thumbnails.**

 You can approach this step in two ways:

 - If you already have a canvas or other surface to paint on, make sure that you keep your thumbnails the same proportion as that surface. The forms you're drawing won't fit the same way into a space with different proportions. If the proportions don't match, you're wasting your time. Take the measurement of the canvas you have, and find a small rectangle the same proportion as the measurement of your canvas. For example, if you have a 16-x-20-inch canvas, use a 4-x-5-inch rectangle. For an 18-x-24-inch canvas, use a 3-x-4-inch or 6-x-8-inch rectangle.

 - If you want to plan your composition and then decide the size of your canvas, choose a rectangle for your thumbnails that translates into a standard size. Squares are also good, and you can choose any size square because the proportions are always the same (thanks to the fact that all four sides are equal).

2. **Draw a few rectangles so that you can try more than one composition; consider both horizontal and vertical formats.**

3. **Set your viewfinder to a rectangle that's the same proportion as your thumbnails, and test several possible compositions.**

4. **Begin to draw with a sharp pencil using very loose, free lines.**

 Draw lightly at first and then darken the lines when you're sure that you want to keep them. Don't spend more than five to ten minutes on each drawing.

Here are some additional tips for drawing thumbnails:

✔ If all that math in the preceding steps is making your eyes glaze over, a *proportion wheel* is a handy, inexpensive tool that you can pick up at your local art supply store. By simply lining up the numbers on two concentric wheels, you can easily figure the measurements for enlarging or reducing the sizes of rectangles in proper proportion. It's easy!

✔ If the enlargement isn't going to be bigger than the sheet of paper that you're making your rough sketch on, you can find the size of the enlargement very easily. Simply draw a diagonal through the bottom-left and top-right corners of the frame that you're using and then continue it outside the rectangle of the frame. Mark a new height or width and draw the new line down or out so that it meets the diagonal you drew. Where these two lines meet is your new top-right corner, so all you have to do now is draw the last line of your rectangle. Measure the size of the new rectangle to get the size of your enlargement. (See Figure 13-2.)

✔ If you draw the objects in your thumbnails as though you can see through them, you prevent objects from looking like they're intertwined with each other. In Figure 13-3, notice that the two objects on the left seem too tightly placed together. Many people will look at it and think that something is vaguely wrong, but they won't quite be able to put their fingers on it. If you draw your shapes as though you can see through them, as in the two figures on the right in Figure 13-3, you can see that the problem is that the two objects are trying to occupy the same space.

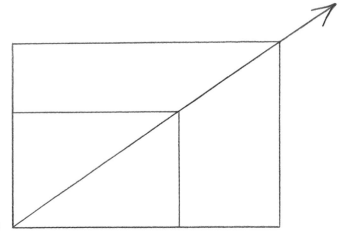

Figure 13-2:
Using a diagonal line to find rectangles in proportion.

Figure 13-3:
The objects
on the left
seem too
tightly
spaced;
use the
technique
on the right.

Drawing box shapes

Your drawings will always appear fairly structurally sound if you make sure
that all the vertical lines are parallel to each other as well as to the sides of
your frame. It's like making a building plumb so that it doesn't collapse. Also
ensure that all lines that are meant to be horizontal are parallel to the top
and bottom of your frame.

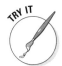

To draw a box as though you can see through it, follow these steps (see
Figure 13-4):

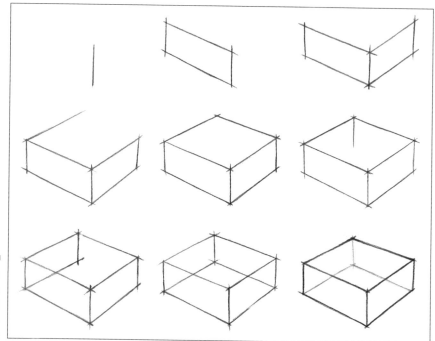

Figure 13-4:
Drawing a
transparent
box.

1. Draw the *leading edge* (the vertical edge closest to you).

2. Draw the side of the box to the left of the leading edge, making sure that your vertical lines are plumb.

3. Draw the side of the box to the right of the leading edge.

4. From the farthest-top corner of the left side, draw a line that runs slightly longer and nearly parallel to the top line of the right side of the box.

 Make sure that the space between the lines doesn't get wider as you draw it. The space should stay the same or become slightly narrower.

5. From the farthest-top corner of the right side, draw a line that runs nearly parallel to the left side of the box until it crosses the line you drew from the left corner.

 The lines cross at the back corner of the box.

6. Draw a light vertical line down from the back corner; make it very slightly shorter than the length of your leading edge.

7. Lightly draw a line from the farthest-bottom corner of the left side to the bottom of the vertical you just drew.

8. Draw a light line from the farthest-bottom corner of the right side to the bottom of the vertical.

 This step completes the box.

9. To clarify the shape of the box, darken the lines of the edges that you would be able to see.

Drawing bottles, cans, and other cylinders

Bottles, tin cans, and many other containers are cylinders. A cylinder is a set of ellipses attached with lines. Here are some tips that will make your cylinders look great every time:

✔ Many beginners do a good job with the tops of their cylinders but make the bottoms look flat. Always draw a full ellipse at the bottom to get a better-looking cylinder. (Figure 13-5 shows you how the ellipse at the bottom should look.)

✔ Make a true ellipse. Football, almond, and racetrack shapes aren't ellipses. Figure 13-6 shows you the three common mistakes beginners make when they draw ellipses.

✔ Follow Figure 13-7 and these steps for a simple way to draw any cylinder:

 1. Draw its profile as if it's a flat shape.

 2. If the lines change direction the way they do with a wine bottle, draw a horizontal line across every point where they change direction.

 3. On every horizontal line, draw an ellipse.

 Make sure that each ellipse is narrower at the top of the bottle and that the set of ellipses becomes progressively wider at the bottom.

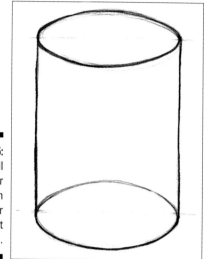

Figure 13-5:
Draw a full ellipse for the bottom of a cylinder to get it right every time.

True ellipse

Figure 13-6:
Football, almond, and racetrack shapes aren't ellipses.

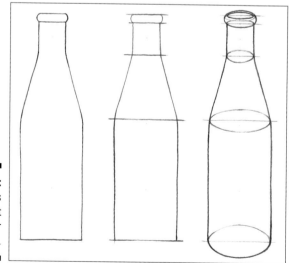

Figure 13-7:
Three steps for a perfect cylinder every time.

Drawing people

Making a good, rough drawing of a person takes practice, so don't be too hard on yourself if it doesn't look as good as you'd like right away. The best strategy is to lightly plot out the position of the person as a stick figure first and then build the flesh and clothing of the figure on top of that drawing. Don't worry about the details of the face and hands; just try to capture the general shapes.

This drawing should take no more than five minutes. Don't torture your model by drawing longer. Let the model rest and then try other poses. The more poses you draw, the better and faster you'll get. Follow these steps for practice and check out Figure 13-8:

1. **Have your model stand in a relaxed position, and take a second to look at him or her before you begin drawing.**

 Note the angles of the lines of the shoulders and hips. Also look at the directions of the lines of the arms and legs. Especially look at the position of the feet in relationship to the shoulders and hips.

2. **Don't start with the head — instead, lightly draw lines for the angle of the shoulders, spine, and hips.**

 Of course, you can't actually see the spine, so estimate it with a straight or curved line, depending on the pose.

3. **Look at where the knees and feet are in relation to the shoulders and mark their positions, lightly drawing straight lines to note the directions of the legs and feet.**

4. **Draw lines to represent the arms and hands.**

5. **Find the position of the chin in relation to the shoulders and draw an egg shape for the head.**

6. **Add a nose if you're working with a profile.**

7. **Lightly draw almond shapes for the rib cage, and a U shape for the pelvis.**

8. **Loosely draw the clothing.**

 Don't bother with details. Just draw the basic shapes.

9. **Block in the shape of the hair.**

You can use this process for sitting poses as well. Just make sure that you carefully observe the angles and lengths of the sections of the arms and legs.

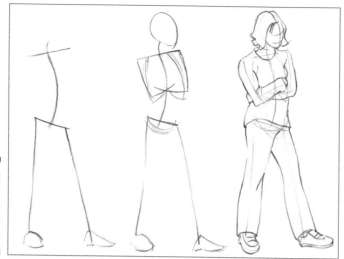

Figure 13-8:
Making a
rough
sketch of a
person.

Using collages and tracing paper for painting

Sometimes you make a set of sketches and none is exactly what you want.
One section of one sketch may look great, and another section of another
sketch may look good, but none really has it pulled together. Rather than
redrawing everything, you can use collage techniques and tracing paper to
make corrections and put together the parts of the drawings that are working.
You can use several strategies:

- ✔ Use rubber cement to fit blank paper into a drawing and rework the area.
- ✔ Trace the parts of a drawing you want to keep and continue the drawing
 on the tracing paper.
- ✔ Trace parts of several drawings onto one tracing paper, or tape tracings
 from several drawings together into one drawing.
- ✔ Compose tracings together to make a realistic still life, or collage parts
 together to make a painting that appears to be a collage.

After you collage the parts of the drawings together for any of these options,
photocopy it so that you can clearly see your resulting drawing.

Making a master sketch from thumbnails

After you rough out several possible thumbnails for your painting and choose
the drawing that you want to paint, you need to make a master sketch and
decide which method you'll use to transfer it to the canvas.

Refining the drawing into a master sketch can be as involved as you want to
make it, but keep in mind that the object is to develop and refine the shapes
and positions of the objects that you're painting so that you don't have to
make corrections on the canvas. Adding a lot of detail makes transferring the
drawing tedious, so keep it simple. You can add the details when you move to
the canvas. You also want to clarify the lines of the drawing as much as possi-
ble so that you don't have any question about the directions and positions of
the lines when you're transferring them. The rough nature of the thumbnails
serves their purpose quite well, but they can be confusing when you try to
transfer a drawing.

To make sure that you have a clear drawing to transfer, use a fine-point marker to establish the lines you want to transfer after you clean up the thumbnail sketch.

The master sketches can be three different sizes:

- ✓ **Thumbnail:** If you want to use this size, simply attach a piece of tracing paper to your thumbnail, and use a pencil to make the shapes more clear and correct. Adding a lot of detail to a small sketch is useless, so continue to keep it simple.

- ✓ **Intermediate:** Another approach is to transfer the thumbnail to a larger drawing for refinement. You don't have to make the new drawing as large as the canvas. Think of this size as a step between the thumbnail and the larger painting. In this drawing, you can develop more detail if necessary.

- ✓ **Actual size:** If you're very particular about getting everything just right, make a drawing that's the same size as the painting. This ensures that you see exactly how the relationships of the objects will work in the painting. The positions of the objects of the smaller drawings can seem different when the drawings are enlarged to the size of the paintings. Sometimes you need to make changes to correct problems that appear in enlargements.

Making enlargements for master drawings

Enlarging drawings is fairly easy, and you have some choices. The most accessible method is the grid enlargement, but photocopiers and art projectors are great tools to use when they're available to you.

Photocopy enlargements

Photocopies make simple enlargements up to 11 x 17 inches very easily. In just a few steps, you can enlarge your drawing and transfer it to another surface.

1. **Make a sample copy to see whether your drawing is dark enough to copy.**

 If your drawing is very light to begin with, you may need to darken it before you start. Otherwise, use the adjustment on the copier to darken the image as much as necessary.

2. **Determine what size you want the enlarged copy to be.**

 Most photocopiers ask you to punch in a number up to 200 percent. You also can experiment by trying different sizes and measuring them with a ruler.

3. **Check the copy with a ruler to make sure that it's the right size.**

4. **At this point, you have some choices based on the size and surfaces that you're working with:**

 - **Enlargements for intermediate sketches:** Cover the back of the copy with graphite from a pencil or 2B graphite stick, and trace the drawing onto a new sheet of drawing paper. A sharp 2H pencil is better for tracing than a #2 pencil because it gives you a more precise line.

- **Enlargements for small, smooth painting surfaces:** The procedure is similar to the one for intermediate sketches, but use a fine coating of charcoal rather than graphite. Avoid using graphite on painting surfaces, because it bleeds through to the surface of the painting for years after the painting is finished.

- **Enlargements for all other painting surfaces:** Grid off the photocopy and the canvas in proportionate squares and draw what you see in each square. (See the simple enlargement in Figure 13-9. Instructions for doing grid enlargements appear later in this chapter.)

Projection enlargements

Art projectors are indispensable tools if you're planning to paint large canvases or work regularly from photographs. You place small drawings and photographs in the projector, and it projects the image onto your canvas. You can focus and adjust the projection to fit the canvas and then simply draw the image onto the canvas with a charcoal pencil. Many projectors also reduce images for you.

These projectors are valuable tools, but they can be costly. Inexpensive versions are available, but carefully research them to make sure that they fit your needs.

Grid enlargements

Grid enlargements are a great low-tech way to make any sort of enlargement, even enlarging a thumbnail drawing to the size of a mural on the side of a building! It's simple and requires little more that a ruler and a pencil. This is how you do it:

1. **Refine your thumbnail sketch so that it has clear, simple lines.**

 Use a fine-point marker for the final lines if you like.

2. **With a ruler and pencil, draw a grid of 1-inch squares on top of your drawing.**

 It's okay if you don't end up with a grid of whole squares. Mark off the squares from left to right and top to bottom, with partial squares to the right and bottom rows. (See Figure 13-9 for an example of a grid enlargement.)

3. **On your canvas, divide the space into a grid of squares that corresponds to the number of squares in your drawing.**

 If your small drawing has six squares across and four down, your canvas should have the same. Make sure that they're all squares — not rectangles. If you can't match the number of squares to the canvas, your frames are different and you need to adjust your thumbnail drawing to match the proportions of the canvas.

4. **In each square, use your charcoal pencil to draw the lines that you see in the corresponding square on the thumbnail.**

 Pay extra attention to the points where lines cross the sides and corners of the squares.

5. **Make corrections in areas where the drawing deviates from your original, and check the total drawing to see whether you need to make any final changes before beginning to paint.**

6. **Add the details that you need for painting but were too complex to use in the preparatory drawings.**

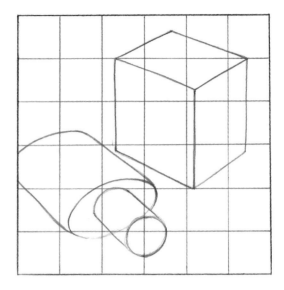

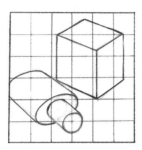

Figure 13-9:
Using grid enlargement to go from thumbnail sketch to canvas.

Project: Working Past Your First Idea, Step by Step

This project pulls together all the information we present in this chapter into one process for preparing to paint.

1. **Collect ten objects that you want to try to paint.**

 Later on, you're going to narrow it down and choose five to paint.

2. **Spend some time trying different combinations of objects in still life setups.**

3. **Choose the five objects you want to paint based on the way they look together in the still life setup.**

4. **Set the rectangle for your viewfinder.**

 If you already have a canvas, set your viewfinder to the same proportions as your canvas. If you don't, consider the shape you want. Is it going to be square or rectangular? Remember to set it so that you can use a standard-size canvas if you plan to purchase something ready made.

5. **Draw six rectangles — all the same size — to use as frames for your thumbnails.**

6. **Arrange the objects in six different setups, making a thumbnail sketch of each before going to the next.**

 Try both vertical and horizontal sketches. Fill the frame with each drawing.

7. **If you don't like the setups, make changes until you find one that you do like.**

8. **Make corrections or use collage techniques to work out any problems on a drawing you like.**

9. Tape a piece of tracing paper over the thumbnail drawing you want to use for your painting.

10. Trace the drawing onto the tracing paper, working to refine the edges of the objects in the drawing.

11. When the edges are clear, trace the lines with a fine-point marker.

 Don't forget to trace the frame. This is your master drawing.

12. Draw a grid of 1-inch squares on the master drawing.

13. Grid the canvas, dividing it into the same number of squares as the master drawing.

14. Using a charcoal pencil, draw the lines in each square of the master drawing into the corresponding square on the canvas.

15. Stand back and check the overall drawing; make corrections and add details as necessary.

 Now you're ready to paint.

Chapter 14

Shape, Space, and the Surface of Your Painting

In This Chapter

▶ Choosing the shape of your painting

▶ Looking at your subject and its background

▶ Designing an interesting composition

*I*f you plan to build a house, at some point you have to move from tinkering with blueprints to digging a foundation. When you dig the foundation, you set the footprint for the basic structure of the house. You set its size, basic design, space, and other characteristics that won't change as the house is built. If you skip this step and start building on bare earth, eventually the house will fall down.

Just as you'd design and dig a foundation for a house, you make design decisions for the foundation of your painting. Shape, size, surface, and space are four design decisions that artists make about every painting. They're the first decisions that you make, and they determine the most basic look of your finished work. This chapter helps you make these decisions deliberately instead of building your painting on bare earth.

Thinking about the Size of Your Painting

In Chapter 13, we talk about the preparations that you need to make before you begin your canvas. As you begin these preparations, one of the first decisions you have to make is the shape and size of your painting. Ideally, you should tie these decisions to the way you want your viewers to respond to your subject matter, but other factors can influence these decisions as well.

When you think about the size of your painting, think about how its scale affects your subject matter and the way your intended audience will respond to it. A large painting can have a powerful impact just because it's big, but a painting the size of a postcard can be very powerful as well.

Here are a couple of size-related terms to keep in mind:

✔ *Scale* is the size of an object, especially in relation to other objects.

✔ *Proportion* is the size of a part of an object in relation to other parts of the same object.

Here are some things to consider when you're deciding the size of your painting:

✔ **What size is appropriate for your subject matter?** Ideally, you want to size your painting so that its size is part of the way you want your viewer to respond to the work. Small paintings pull your viewer in. They invite your audience to step closer to them. Large paintings can have a powerful presence. It's not often someone says a painting is too large, but a painting can easily be too small. A small painting seduces its audience into moving closer to look at it, but at a great risk of disappointing them.

✔ **Where will this painting be displayed?** Of course, having grand aspirations that your work will be collected by museums is nice, but your work doesn't have to be large to be collected by a museum. It's more important to concentrate on quality than size. Beyond that, what you're really considering is who your audience will be. If your audience is your family and friends, size the work to hang in a home. On the other hand, if your painting is intended for a public space, like the lobby of a concert hall, it needs to be large enough to create a presence in the space. Otherwise, it will be lost.

✔ **What's your skill level?** When you first start out, working in the small to medium range is best — at least until you understand what you're doing. Very large and very small paintings take more skill. Complex subject matter, like a complicated still life, is easier for you to tackle on a larger canvas. A simpler subject, like a portrait, may be easier to paint at a size between two-thirds and life size.

✔ **How much time do you have to paint your painting?** Large paintings and very tiny paintings generally take a lot of time to do right. Being ambitious is good, but remember that in the beginning, your skills will advance more quickly if you do a lot of work instead of getting bogged down in one large painting for a long time.

✔ **What kind of budget have you set aside for painting?** Large canvases and paints to cover them are expensive. If you're on a smaller budget, you'll make more progress doing a series of small works that don't cost as much.

✔ **How much space do you have to paint and store large canvases?** Paintings take up space. If your space is limited, you have several options other than giving up large canvases. Staple canvas to the wall to paint it and roll it up after it dries. You can also work on gesso-covered paper or on pieces of paper pieced together. If you must insist on stretched canvas, you may have to downsize the work or become very generous to your friends and family.

Framing Your Painting

Most people think of picture frames as actual wood or metal that you put on a finished painting. Another kind of picture frame represents the shape of your picture. Picture frames can be the edge of your canvas or the rectangle you draw to make a rough sketch. They define the edges of your pictures.

A *picture frame* contains your subject matter into a specific area. Sometimes the picture frame is the edge of the artwork. Other times, the picture frame is a specific line drawn around the image area. A picture frame can be square, rectangular, or any other shape you can imagine. The shape of your picture frame should have a connection to your subject matter.

The edge of your canvas is always the picture frame for your painting, but you have to think about it a little differently when you're making a drawing to plan your painting. If you don't actually draw a picture frame to define your image area, the entire sheet of paper can become your image area. Making drawings without drawn picture frames is possible, and often desirable, but when you're making preparatory drawings for your painting, working with a drawn frame is best.

Your viewfinder also acts as a picture frame. When you hold it up to view your setup, it eliminates everything except the area that you plan to paint or draw. In this case, its inside edge acts as the picture frame.

Classic shapes

The shapes of some picture frames recall certain types of images before you even start making rough sketches for them. That doesn't mean that they're the only kinds of pictures that you can put in those particular frames; it just means that you've seen enough paintings of that type of image and shape that you've begun to associate them with each other. For example:

- ✔ An oval frame is associated with portraiture.
- ✔ A long, horizontal frame is associated with a panoramic landscape.
- ✔ A tall, vertical frame is associated with tall subjects, such as skyscrapers and trees.
- ✔ Circular frames don't suggest specific objects, but they do suggest that you may see a strong focus on something, as if through a telescope.

Figure 14-1 shows examples of classic frames.

Neutral shapes

Some shapes are so neutral that they're like vanilla ice cream; you can put anything in them.

Of course, you can find many variations on rectangles, but not all are neutral. The preceding section mentions two that are very suggestive. The panoramic view and the tall vertical have extreme differences between height and width. Almost all rectangles are neutral, however, and you can use them either direction. The most common neutral rectangle you can find is your 12-x-16-inch drawing pad, which is a 3 to 4 ratio.

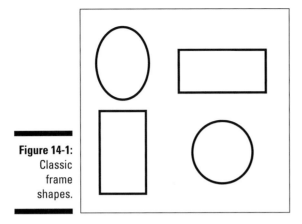

Figure 14-1:
Classic
frame
shapes.

Squares are interesting shapes that have much of the flexibility of rectangles, except that you can't turn them in different directions. (Well, you *can,* but you won't be able to tell the difference!) They're a little more difficult to work with, but the resulting compositions can be very pleasing.

Figure 14-2 shows examples of neutral frames.

Figure 14-2:
It's hip to be
square (or
rectangular).

Irregularly shaped images

Artists have always painted images within frames that aren't exactly classic shapes. The surfaces that artists want to paint on aren't always configured in convenient rectangular forms. Some paintings conform to the shapes of existing spaces in church architecture; others are circular or arch shaped. In contemporary times, some artists have made abstract art on shaped canvases. Other artists have pared away the backgrounds in their paintings so that all that's left is their subject matter.

A *shaped canvas* is any painting without a rectangular picture frame. The term has a long history of being applied to circles, ovals, diamonds, and other traditional shapes that aren't rectangular. But in the last two decades, it's been closely associated with extremely irregular shapes. All, however, are shaped canvases.

Although most traditional picture frames are like windowpanes onto a scene, the irregularly shaped canvas has had an active part in how people view the painting. The picture frame actually contributes to the message that the artist is trying to convey. Frank Stella, Alex Katz, and Elizabeth Murray are good artists to study if you're interested in doing an irregularly shaped canvas.

Project: Experimenting with your viewfinder to decide the shape of your painting

Use this exercise to help you choose the right shape and size for your painting when you don't already have a canvas on hand. For this exercise, you use another type of viewfinder.

First you're going to make a bracketed viewfinder. This viewfinder is two "L" shaped pieces of cardboard that you can position to make any rectangle you like. You can also set it up in the same proportions as the picture frames of your sketches and canvases. Make sure that you use a stiff board so that it doesn't droop over while you're using it.

1. **Use your pencil and ruler to measure and draw a line 3 inches from the outside edge of a 15-x-20-inch piece of stiff board in a neutral color; you end up with two "L" shapes, as shown in Figure 14-3.**

2. **Cut out the two "L" shapes.**

 If you're cutting them with a utility knife, protect your table by putting a cutting mat or piece of board under your cutting area. This protection also gives you a cleaner, neater cut. If your board isn't very heavy, you can use scissors to cut out the "L" shapes.

3. **Line up your ruler on each inside edge of the "L" so that the zero is on the inside corner and mark off the inches, half inches, and quarter inches.**

 Mark the measurements on both "L" shapes.

4. **Set your viewfinder so that the corners are square, and tape them together with two pieces of masking tape.**

 If you want to set up your viewfinder for a 12-x-16-inch picture frame, set your "Ls" so that they make a rectangle crossing at the 3- and 4-inch marks. Always attach them using a temporary method, like tape, so that you can reuse them in different configurations.

5. **Set up a still life with any objects you want to use and try several possible frames for paintings.**

 Set up your viewfinder as squares, long horizontal rectangles, long vertical rectangles, and other variations on rectangles. Also, try looking at the still life from different points of view.

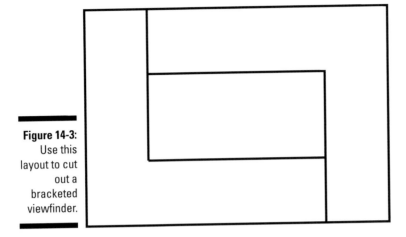

Considering Both the Background and Subject

After you make your rough sketches and you know the size and shape of your painting, you're ready to start drawing your subject matter onto the surface of your canvas. As you start drawing these shapes on your canvas, you make decisions about how you want your viewer to understand the space in your painting. Your painting is two-dimensional. It has a height and width, but no depth — only the surface. When you make marks on your canvas to create a subject and background, you start to create an illusion of depth in the image, and you divide the surface of the painting into patterns.

Illusion of depth means that viewers "read" a two-dimensional picture as having depth when it's clearly flat. *Pattern* is the relationships of the lines, shapes, values, and colors in the design of your drawings and paintings. For example, a *value pattern* is the relationship of the lights and darks in your painting.

Working with positive and negative space

When you begin to draw your subject onto the surface of your canvas, you divide the space in your painting into subject and background. If you expand this idea a bit, you can consider your subject matter to be the *foreground* and everything behind it the *background.* In the image on the left in Figure 14-2, you can see that the black silhouette of the girl is the subject, or foreground, and the white space around her is the background. In the image on the right, the black and white is reversed but the girl is still the subject and foreground, while the black area behind her is the background.

When you speak in these terms, you're talking about your image as though it has three-dimensional qualities. What if you squished the whole thing flat like a bug, though, so that it all seemed to exist on one paper-thin surface? Then you're thinking of your image as being more like a design of abstract patterns. Everything that would have been your subject matter becomes the *positive space,* and your background becomes the *negative space.* In the images

in Figure 14-4, the silhouettes are flattened, abstract forms that have no three-dimensional qualities. The black figure in the image on the left is the positive space in the composition. The black background in the image on the right is the negative space in the composition.

Positive space is the shape and pattern made by the subject in a composition. Synonyms for the positive space are *figure* and *foreground*. *Negative space* refers to the shape and pattern of the background. A synonym for the negative space is the *ground*.

The interaction of the patterns made by the shapes your positive and negative spaces is the heart of what makes your painting designed well. They are two parts of a whole and you want them to relate to each other in a complementary way, like a good marriage. When viewers enter a room and see your painting from a distance, they see the design and the way the patterns interact with each other in an abstract way long before they see your subject matter or how well you painted it.

Figure 14-4:
The foreground is positive space (left), and the background is negative space (right).

If you look at your composition as a set of white shapes against a dark field, you can easily see how your positive and negative spaces interact with each other. If these patterns are interesting, you likely have a strong composition. If they put you to sleep, you may have some work to do.

We encourage you to work *general to specific*. If you establish strong basic patterns in your positive and negative spaces early in the painting process, the composition of the painting will be strong when you're ready to refine the details in the painting.

Activating the entire composition

We advise you throughout this book to arrange your compositions so that objects touch the edge of your picture frame or seem to continue outside the painting. By giving you this advice, we're trying to encourage you to *activate* your entire composition. When we say *activate,* we merely mean that you should arrange the parts of your composition so that it looks like you considered every area of the composition, including the outer edges, as you designed it.

Plopping your subject matter in the middle of your composition and starting to paint is so easy, but it rarely makes a strong composition. Sometimes that sort of composition looks like a photograph taken from too far away. The subject looks lost or as if it's floating in a void. The background can overwhelm or compete with your subject matter so that it looks weak. For example, if you jump forward to Figure 14-6 you see how a cluster of objects can seem to float in the composition, but if you make the change shown in the image on the right in the figure, framing the image in closer, the entire composition is active.

Shaping your background

One of the most effective things that you can do to make a strong composition is pay attention to the shapes in the negative space in your setup. Focusing on the arrangements of your objects may seem more logical, but you can't rely on that method alone. Ideally, you should alternate between looking at the relationships of your objects and looking at the shapes that you're making with your background.

The simplest way to check the relationship between your positive and negative spaces is to make a rough thumbnail sketch of your setup and blacken in the background or negative space by filling it in with a soft graphite pencil. Don't be satisfied with whatever result you happen to get. The only way to improve is by challenging yourself. Be objective, examine your sketch, and answer these questions:

- ✔ **Is your sketch compelling?** Does it hold your attention? Can you point to areas that are particularly effective?

- ✔ **How much black is in the composition?** If more than half of the composition is black, look at the shapes and determine whether they're appealing. If the black shapes are large and lackluster, they can act like a black hole, sucking the energy out of your work. You may need to tweak the positions of your objects to make the shapes more varied or add some objects to break the spaces up.

- ✔ **Does the black negative space touch large sections of, or the entire, picture frame?** Long channels of negative spaces that run down the sides of the composition without breaking are called *gutters*. If your sketch has gutters, you may need to frame the composition closer to your subject matter to improve the balance of positive and negative spaces.

- ✔ **Do you have a variety of shapes in the composition?** Can you find a balance of large areas versus small, broken-up areas? Or can you find areas that have mass versus areas that are linear?

Figures 14-5, 14-6, and 14-7 show some examples of negative space problems and simple fixes.

Figure 14-5:
The large
expanse of
black in the
center
creates a
void.

Figure 14-6:
Correct the
floating
objects in
the
composition
by framing it
in closer.

Figure 14-7:
The inactive
areas on the
sides create
gutters.

Here are some general guidelines that you can use to create strong interactions between your positive and negative spaces:

- ✔ Make a conscious effort to create interesting shapes in your negative space.
- ✔ Look for ways to break up large, uninspiring areas of negative space.
- ✔ Try to create an interesting pattern that balances large shapes with smaller, broken-up shapes.
- ✔ Try to create a balance of shapes that have mass with shapes that have linear qualities.
- ✔ Pay attention to the edges of your composition, especially the sides.

Pulling It All Together: Shape, Space, and Surface at Work

In the previous section, you look at positive space as the subject and negative space as the background. You divide positive and negative space into black and white areas based on whether the area is an object or the area around an object. In the thumbnail sketches, you leave the objects white and fill in the background with black. This method is extremely helpful in organizing the placement of your subject matter, but you need to take it a step further to be able to fully apply it to your painting.

You aren't likely to make paintings of white figures on a black background, so you have to use these concepts in a slightly different way. When you look at paintings by Caravaggio and Rembrandt, you see that they painted striking contrasts between light and dark areas. The value patterns are very strong, but the dark values aren't confined only to the figures or only to the backgrounds. You find dark areas in both, and sometimes the values in areas of the figure and areas of the background are so similar that finding the edge of the figure is difficult.

Chiaroscuro is a term that refers to the way artists use values of light and dark to make an object or figure look three-dimensional. *Tenebrism* is a dramatic form of chiaroscuro, where the range of values is limited to very light lights and very dark darks, almost like a high-contrast photograph. The artist Caravaggio is known for using tenebrism in his work.

These patterns of light and dark provide another opportunity for you to look at positive and negative spaces in your painting. Making a rough thumbnail sketch of your setup and then paring down the value patterns to the extreme lights and darks gives you a chance to examine the overall pattern in your composition. (Check out Figure 14-8 a little later in this chapter.) You evaluate this new sketch by using the same questions we give you in the earlier "Shaping your background" section, but this time you have a better sense of what your final painting will look like.

Project: A high-contrast sketch

In this project, you work through the process of making a sketch that concentrates on value pattern in addition to figure and ground.

1. **Arrange a still life setup with light-colored objects.**

2. **Darken the room and put a strong, directed light on your setup from the side.**

 The lighting for this exercise is important, so arrange it carefully. (Consult Chapter 13 for help setting up a still life.)

3. **Use your viewfinder to find the area you plan to sketch.**

4. **Determine the size of your thumbnail sketch, and lay out the picture frame for your sketch on a piece of paper.**

 The information we provide earlier in this chapter will help you.

5. **With a 4B or softer 6B pencil, make a rough sketch of your setup as you look through your viewfinder.**

 See Figure 14-8 for an example and Chapter 13 for additional help.

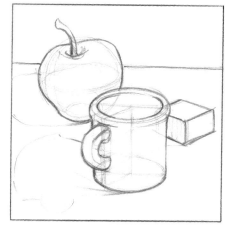

Figure 14-8:
Make a rough sketch of your setup.

6. **Observe the shapes of the shadows in the setup and lightly draw the shapes of all the shadows that are darker than middle gray and fall on the objects in your rough sketch.**

7. **Draw the shapes of all the shadows cast by the objects.**

 Figure 14-9 shows you how the shapes of the shadows were drawn into the rough sketch. In some areas the shadows change gradually without a clear edge. Use your best judgment in finding the shape, or change your lighting to get higher contrast between the light and dark areas.

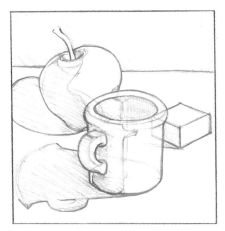

Figure 14-9:
Draw the shapes of all the shadows (including cast shadows) that are middle gray and darker.

8. Blacken in all the areas that are middle gray and darker.

If you have dark areas in your background — from cast shadows or simply a dark background — there may be some shadowed areas of your objects that blend with the dark background. That's okay. It's *tenebrism* at its best. If, however, you lose too much of the form of the object, look closely to see if you can use a bit of white edge in the form to separate the object from its background.

Figure 14-10 shows you what your finished high-contrast drawing might look like. If you like, outline these areas to more clearly define the shapes before you fill them in.

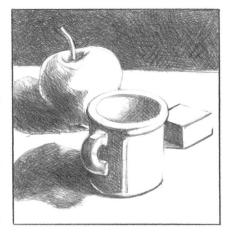

Figure 14-10:
Fill in all the areas of the drawing that are middle gray and darker.

9. Examine your value pattern drawing using the questions from "Shaping your background," earlier in this chapter, and make changes as needed.

Chapter 15

How the Parts of a Composition Work Together

What is your most beautiful possession? Maybe it's art, but it could just as easily be furniture, a dress, or a sports car. Look at it and consider what qualities most mesmerize you. Is it the curve of its line, the contrast of its colors, or the way its shapes fit together? Whatever those characteristics are, they share elements of design that are part of everything people make, whether it's an everyday object or the finest painting. Design is about creating and arranging the parts of an object.

Talented designers have abilities that may seem magical, but those abilities aren't magic. Designers have skills that can be learned. The same is true of painters. Paintings aren't just painted, they're designed. The skills that you need to design a painting can also be learned, and with practice, you can design an impressive painting as well as anyone.

This chapter lays out the basics of arranging the parts of your composition and discusses how to see those parts.

Getting the Big Picture

In art schools, sometimes you hear it said that a museum visitor spends only about eight seconds in front of any given painting. We could quibble over the number of seconds, but the major point is true. Artists have a very limited amount of time to snag their viewers' attention and entice them to linger in front of their artwork.

Think about what happens when you enter a gallery. You immediately scan the room for something enticing. You don't necessarily want to walk to the nearest painting and work your way around the room spending equal amounts of time in front of each one. How do you accept or eliminate the works that you want to view in just a split-second glance?

You make these decisions the same way that you're able to recognize your best friend walking halfway down a beach. When you look at paintings, or anything else for that matter, you see its overall patterns of shapes, values, and colors — its design — before you see the details. If you create a painting that has a strong overall design and carries well at a distance, you can engage your viewer quickly.

The whole is greater than the sum of the parts

The success of the compositions of your paintings relies on creating relationships that glue the parts together. Without these relationships, your compositions can seem chaotic and disorganized, like a roomful of people playing a game without rules.

Think of a time when you were part of a successful group effort. Maybe it was a sports team or a project for a charity. Everyone had a job to do, and everyone did those jobs well. As a result, the group's efforts rose above what each person may have contributed individually.

You can see this effect in the classroom as well. The energy of a group of students working in the same room is much greater than the energy of the same group working independently. So much so that the stronger skills of the group actually raise the skills of those who are weaker.

Of course, these examples refer to experiences, but they relate closely to the way you understand what you see. It's all about relationships. People working together rather than independently accomplish more, even if they're doing the same work. When you look at a building, you see its whole before you see its parts because those parts have a structural relationship. You see the whole of anything at first glance because the relationships of the parts are gluing them together. You have to make an effort to see most things as individual parts strung together.

The term for the study of how people process what they see and experience is *gestalt,* a German word referring to "pattern" or "form." It's generally considered to include the way you experience the whole of something before the parts. Artists have borrowed a number of ideas from Gestalt psychology to explain how viewers see the parts of a composition. The majority of this chapter is devoted to gestalt concepts and how you can use them to create better compositions for your paintings.

The devil in the details

You can easily be seduced into concentrating on painting just the objects when you're first learning to paint. You're still finding your way, and sometimes the challenge of trying to get something "right" just takes over. Moving to another area is hard when things are going well with the area you're working on. But none of this is in the best interest of your painting or your progress as a painter.

It bears repeating that you're more likely to create a strong design if you work *general to specific*. When you develop your big shapes and patterns and slowly refine them down to specific details, you're creating the relationships you need to hold the composition of your painting together. We've made it our mantra because it's one of the hardest habits to develop as a beginning painter. If you allow yourself to concentrate on the details at the expense of the total design, your painting will be weak.

You may argue that you can paint only one object at a time. That's true, but you want to bring your painting up in layers, like building a house. You visit every part several times, rather than once or twice. A construction crew doesn't finish the front of the house before putting sheathing on the other sides; the workers add layer after layer over the entire building. To make your painting strong, build your painting the way you'd build a house, layer by layer.

Project: Blurring details to see the overall composition better

Blurring paintings and photographs is a good way to learn to see the basic design rather than concentrating on details. If you're computer savvy and have access to Adobe Photoshop, you can posterize the image to pare it down to the basic shapes and patterns (Figure 15-1 shows an example). When you posterize an image, you turn it into something similar to a paint-by-number image. The computer breaks the image down into a specific number of values, which you select. To give it a try, follow these steps:

1. **Scan or open your image as a Photoshop document.**

2. **Make a copy that you can play with by choosing File ⇨ Save As.**

 Don't work on your original document.

3. **Convert your image to grayscale by choosing Image ⇨ Mode ⇨ Grayscale.**

4. **Posterize your image by choosing Image ⇨ Adjustments ⇨ Posterize.**

 When you select Posterize, you're asked to select the number of steps from white to black that you want to see. When you plug in a number, you immediately see the effect of the posterization. Plugging in "2" makes a high-contrast black and white image. Plugging in "3" gives you black, white, and middle gray. Experiment with several different numbers.

5. **If you want to save and print your posterized image, do so.**

If working with a computer isn't your deal, you can do this project a couple of alternative ways:

- ✔ If you're working with a still life setup and have a camera that you can manually focus, try looking at your setup out of focus.

- ✔ Make rough pencil sketches of pictures in a manner similar to the painted value pattern sketch of a master work described in Chapter 14. Rather than painting the image, use a soft pencil (4B or softer) to make a high-contrast black and white sketch concentrating on basic shapes. (Figure 15-2 shows you an example of this kind of sketch.)

Figure 15-1:
A posterized photograph.

Figure 15-2:
A high-contrast pencil sketch.

How You See the Parts

Fortunately, you don't have to rely solely on your intuition to be able to make a solid arrangement for your painting. Human brains are wonderful machines, and they do act in somewhat predictable patterns. Scientists and psychologists have been able to identify specific ways that the brain processes what the

viewer sees. Artists have always used these ideas when they made their artwork, but only relatively recently has a scientific basis for their work been established.

You need to know only a few gestalt concepts to help you create solid compositions for your painting. They aren't hard to understand. Chapter 14 tells you how to use picture frames in your artwork. That discussion is about the gestalt concept of containment. You need to know only a few others: similarity, proximity, and continuation. As you work through this chapter, you will see how you can use these concepts to create strong compositions.

Harmony or chaos?

Human brains are natural sorters. During the course of your day, your brain constantly sorts what you see into what's known and familiar and what's different and unfamiliar. Things that are different catch your eye, while you may simply glance over something that you're familiar with.

Most people like a little predictability. The similarity of your daily routine gives you stability in your life. Similarity creates harmony and peace. Too much similarity, however, creates monotony and boredom. Having cereal and milk for breakfast may be part of your routine every morning, but what if you had to eat cereal and milk for lunch and dinner every day, as well? Your diet needs some constants, but you also need variation to make it interesting and healthy.

On the other hand, too much difference is chaotic and upsetting. What if you lived in a war zone and had no idea what might happen next or where your next meal might come from? The only constant is that there is no constant. Too much difference is chaos.

As in life, paintings need some similarity to create harmony and hold the parts together, but they also need difference to create a little spice. One way that you can use this concept in a composition is by balancing objects and shapes that are similar to each other with some that are different. Those objects that are similar to each other help hold the composition together, while the objects that are different make it interesting.

The parts of a composition that have similar characteristics tend to group and help hold a composition together. This gestalt concept is called *similarity*. Similarity creates harmony in the composition. Too much similarity, however, creates monotony. It is best to balance similarity with difference to create interest.

In Figure 15-3, you see three compositions. On the far left is a composition made only of similar objects. In the middle is a composition made of very different objects. On the far right is a composition that attempts to create a balance between similar objects and different objects.

Keep in mind that the ideas of harmony and chaos aren't limited to objects. They apply also to color, value, line, and texture. For example, using a single hue can create a monotonous painting, but varying its values and intensities and adding a contrasting hue can make a striking painting.

Figure 15-3:
Compositions of similar objects, different objects, and a mix of similar and different objects.

Project: Composing similar objects and different objects

In this exercise, you create three compositions that are similar to those you see in Figure 15-3. After creating a setup for each composition, draw it if you like, or simply photograph it with a digital camera. For each setup, select and arrange five objects for a possible still life painting.

1. **Decide on a picture frame size and shape for all three compositions. You will use the same picture frame for all three compositions.**

 Make sure that you orient them the same direction, horizontal or vertical. Refer to Chapter 14 for more information if you need help setting up.

2. **Select five objects that are exactly the same — the same size, shape, and color — and arrange them in a setup.**

3. **Draw or photograph your first setup.**

4. **Select five objects that aren't similar in any way — not in shape, size, or color.**

 Make these objects as different as possible.

5. **Arrange the five dissimilar objects in a setup and draw or photograph it.**

6. **Choose five different objects for the final setup, but look for similarities in three of them.**

 You may want to choose different objects that have similar shapes. For example, maybe they're all cylindrical containers, but they're different sizes and have variations in the cylindrical shapes.

7. **Arrange these five objects in a setup and draw or photograph it.**

8. **Compare your drawings or photographs.**

 Does each fit the criteria well? The answer affects how you see them. Which is more interesting to you? Why?

The glue that holds the parts together

The next time you go to a park, look at the people. Some are likely walking in pairs or groups while others are sitting or walking alone. What kind of assumptions do you make about these people? You may think that the groups of people are family or friends on an outing, or you may assume that the people off by themselves have no relationship to the others and actually want to be left alone. What clues lead you to think that? Your most important clue is the proximity of the people to each other. If all the people were evenly spaced from each other, it would take you a while to determine what their relationships were. Or maybe you'd assume that they're all together, because it would be unlikely that they arranged themselves that way on their own.

This gestalt concept is called *proximity.* When you place objects in your paintings close to each other, you see them as a group. Their closeness causes them to form a bond that's very similar to two magnets attracting each other. If you space the objects too far apart, they can seem farther away from each other than they actually are. Even worse, they can form a void, or big hole, in the composition. Figure 15-4 shows you objects that form a group on the left, and objects that are so far apart that they create a void on the right.

Figure 15-4: The placement of the objects can form a group or create a void.

You don't want to overdo this concept. If you cluster your objects together like a litter of puppies, your objects may seem too much like a single mass and you won't be able to take advantage of what your negative spaces can contribute to the composition. (Figure 15-5 shows you the problem with placing your objects too close together; on the right, you see how to combat this problem and create interesting negative space.) Ideally, you should space your objects closely enough to create an interesting tension in the work, but not so closely that you're doing all the visual work for your viewer. It's okay for some of the objects to touch each other, but spread out most of the objects. Experiment to see how far away from the others you can place an object and still maintain its membership in the group.

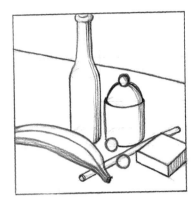 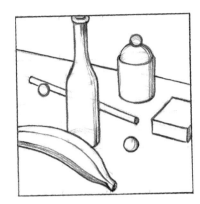

Figure 15-5: Placing objects too close together causes them to mass together.

Always consider the shapes of the negative spaces in your composition when you try various placements for your objects.

Project: Spacing objects together and apart

This exercise is an experiment in seeing what you can get away with. You cut several silhouettes of objects out of black paper and place them in various positions within a picture frame. Then you position them in the frame, trying different placements. Some placements cause the silhouettes to group. See how far apart you can place them and still maintain a relationship with the rest of the silhouettes. See the example in Figure 15-6, and follow these steps:

1. **Use a ruler and pencil to rule a 9-x-12-inch picture frame on a sheet of drawing paper, and then set it aside.**

2. **Choose five still life objects that work well together, and draw their silhouettes without interior details on black paper.**

 Any sort of black paper will do. Make sure that you don't make your objects too big. The largest should be no larger than 6 inches and the rest should be sized in relationship to the largest one.

3. **Use scissors to cut out the silhouettes.**

4. **Start positioning silhouette shapes in your picture frame by playing with that magnetic characteristic that shapes develop when they're placed near each other.**

 Not sure how to do that? Follow these guidelines:

 a. Choose your large silhouette shape and put it to the left in your frame.

 b. Choose a medium-sized shape and place it next to the large shape.

 c. Pull the medium shape a little farther to the right. Does it still look like it is grouped with the large shape? Unless you pulled it too far away, it should.

d. Pull it a little farther away. Does it still look like it is grouped?

e. Keep pulling the medium-sized shape away until you're certain that they look like two independent shapes. See how far away the two shapes can be and still look like they're grouped together. At what point does the shape change from grouping with the large shape to being an independent shape?

5. Gather the rest of your shapes and make some really bad compositions.

The goal is to just get it out of your system!

a. Group the objects together as a cluster in the center; look at the shapes of the cluster and the negative space.

b. Divide the group so that you have a smaller group of three touching the left edge and another group of two touching the right edge. More than likely you have a big space in the middle that isn't doing anything. Does it look like you scraped everything to the sides?

c. Line up your shapes in a row. The top half of your composition may have some interesting negative space, but the white space below the line of the shapes probably isn't doing anything. It's a dead area in your composition.

6. Try to make at least six interesting compositions.

We can't tell you where to place the shapes because we can't see your shapes, but try some ideas while you work. Try to be adventuresome. It's only paper and you can push it around! Try some of these tips:

• Let some of the shapes go outside your picture frame.

• Position the shapes so that none of the negative spaces between them are equal.

• Try to make the negative space in the bottom half of the composition as interesting as the top half.

• Mix narrow, linear negative spaces with wide, irregular negative spaces.

• Try not to allow more than three shapes to touch each other in one group.

Figure 15-6:
An example of a cut paper silhouette composition.

How the parts interact with each other

Compositions are living things. While you're working on them, the way you perceive the relationships of the parts is constantly changing. Every time you add a shape, color, value, line, or texture, the relationships within the composition change.

Focal points are areas of the composition that attract the eye. *Major focal points* or *primary focal points* are the areas that attract the eye first and usually are associated with the main subject matter or idea of the painting. *Secondary focal points* are areas that keep your eye moving through the composition and elaborate on the main idea of the painting.

When you look at a composition, your eye begins in one area — the major focal point — and then moves to other areas around the composition. Some of these other areas are secondary focal points. When you have more than one secondary focal point, what determines where you look after you see the major focal point?

Proximity can determine where the eye moves away from the major focal point to a secondary one, but another factor is the gestalt concept of *continuation*. It's a lot like a magic trick. Your eye makes things seem whole by closing up or making a leap across spaces when nothing is there. A very simple example is the idea of the *implied line*. In Figure 15-7, you can see that the line seems whole even though a big chunk is missing out of it.

Figure 15-7:
In an implied line, the line seems whole even though large portions are missing.

Another example refers to what you assume when two shapes overlap. (In Figure 15-8, you assume that the shape in the back continues to the other side of the shape in the front.) You assume that a shape continues behind the object and directly out the other side, but nothing there says that it didn't take a little side trip in the meantime. Human brains close up those areas, making them seem to continue uninterrupted.

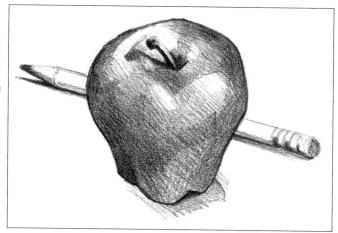

Figure 15-8:
Two overlapping shapes force your brain to make assumptions.

When you look at a composition, the combination of primary and secondary focal points and the kinds of visual lines you establish with your shapes lead your eye around. An example is Michelangelo's *God Creating Adam* on the ceiling of the Sistine Chapel. A line is established by the figures with their outstretched arms, but their hands never touch. You mentally make a leap across, closing up the two sides of the composition. In a more extreme example, try having two friends point at each other. (Make sure that you can see them both at the same time.) You'll see an implied line connecting the two of them.

You can establish lines with edges of forms, pointing fingers, the limbs of a tree, a row of street lamps — anything that establishes a direction for your eye to follow. These linear elements work subliminally to create movement in the work and lay a path for your eyes to follow while you explore the work.

Continuation is a gestalt concept that refers to the way your eyes close up areas that are visually fragmented, making them seem to be whole.

Avoiding common errors in placement

The following sections show you how to avoid some common errors when you're creating your arrangement. Of course, the minute you set up a "rule," someone finds an exception to it. These are general guidelines. Feel free to take any of them and make an interesting painting out of it.

Avoid lineups

Don't line up shapes so that their edges seem to continue from one to another. Offset them a bit to separate them and shape your negative space better (see Figure 15-9).

Figure 15-9:
Don't line up shapes so that their edges seem to continue from one to another.

Stay out of the corners

Avoid placing shapes in the corners of your picture frame — they'll look glued there. Bring them away from the corner a bit (see Figure 15-10).

Figure 15-10:
Avoid placing shapes in the corners of your picture frame.

Watch your small shapes

Avoid cropping shapes too narrowly outside the picture frame. The small shapes it creates direct your viewer's eye outside your work (see Figure 15-11). Remember that you're trying to keep your viewers engaged — not send them packing to the painting next to yours.

Along the same line, avoid bringing distracting little shapes in from the sides (see Figure 15-12). Small shapes, no matter whether they are singles or clusters, attract the eye. You don't want to inadvertently establish a focal point at an edge of your composition. It will direct the viewer's eye outside the composition.

Figure 15-11:
Avoid
cropping
shapes too
narrowly
outside the
picture
frame.

Figure 15-12:
Avoid
bringing
distracting
little shapes
in from the
sides.

Keep off the bottom

Avoid lining all your objects up on the bottom of your picture frame (see Figure 15-13). Occasionally you can break this rule if you have a good reason, like you're painting a shelf of bottles.

Also avoid placing all your shapes at the bottom of your frame and leaving a lot of empty space at the top — unless of course you're painting a landscape with a lot of sky (see Figure 15-14).

Figure 15-13:
Avoid lining up all of your objects on the bottom of your picture frame.

Figure 15-14:
Avoid placing all of your shapes at the bottom of your frame, leaving too much empty space at the top.

Strive for balance

Don't cluster all your shapes to one side without balancing the composition in some way on the other side (see Figure 15-15).

Figure 15-15:
Don't cluster all of your shapes to one side without balancing them on the other.

Watch the background behind people

If you're painting people, be aware of the positions of the things behind and around them (see Figure 15-16). You don't want anything to appear to be growing out of their heads.

Figure 15-16: When painting people, don't allow objects to appear to grow out of their heads.

Place objects with authority

Don't make wishy-washy, careless placements (see Figure 15-17). If you mean to place something in the middle of your composition, make sure it looks like it's in the middle. If you want to place it to the side, make sure that it doesn't look like you wanted it to be in the middle.

Figure 15-17: Don't make careless placements.

Creating Effective Focal Points

Most paintings have some sort of system of focal points, but not all. Jackson Pollock, who dripped paint on canvas laid out on the floor, made many paintings without obvious focal points. In fact, many contemporary artists make paintings without any focal points at all. Most of these artists make abstract work.

Almost all realistic work has focal points because it has recognizable subject matter. Viewers naturally look for the main idea of the painting, and a well-designed system of focal points steer them toward understanding what the

work is about. It also helps them find their way around the painting and enrich their viewing experience.

Making realistic work without major focal points is possible. Think of wallpaper. It's designed to provide a background for your furnishings — even the boldest wallpaper you can find probably doesn't have a major focal point. If a wallpaper design provides a major focal point for the room — and some do — you have to design the room around it. Some realistic artwork reads much like wallpaper. (And that's not a statement about the quality of the work!) An example in book illustration is the *Where's Waldo?* series. The work has some minor focal points, to be sure, but if it was composed the way you normally compose an image, there wouldn't be much of a series. You'd find Waldo quite quickly, and that would be the end of it.

Shiny objects and other devices that demand your attention

Why are your eyes attracted to sparkling diamond rings, strobe lights, yellow school buses, waving arms, and fluorescent-colored paper? In short, they're very different from their surroundings. Glittery objects reflect more light than their surroundings. Bright colors also do that, but to a lesser degree. Movement stands out in an area that's static. Human brains are constantly evaluating their surroundings for what's similar, and thus familiar, and what's different. If something is different, your eye goes to it. This characteristic keeps you out of a lot of trouble, but it also enriches your life, keeping it from being too mundane.

When you look at paintings and other artwork, this same behavior determines how you experience the work. If artists want an area of a painting to catch your eye, they make that area different from the other areas. Sometimes, they make the value different or use a brighter color. Maybe that area has more texture or detail. On the other hand, if they want an area to be quiet or to recede into the background, the artists make everything in that area similar. The range of lights or darks may be very narrow. The colors may be rather dull. There may be very little detail. The contrast in the artwork determines where you look as you experience a painting.

Contrast simply means "difference." Little contrast means that there isn't much change between two areas. A lot of contrast means that there's a big change.

The role of contrast

After you understand how to use contrast in your painting, you'll rule the way others see your work instead of allowing the painting to rule you. You can use contrast in several ways, and the choice of how you're going to use it depends on what you're painting. In the meantime, we give you some ways to create contrast.

Value

Value is the most important, overriding way that you can create contrast. Difference between light and dark values catches the eye. On the other hand, the eye skims over similar values. See Figure 15-18 for an example.

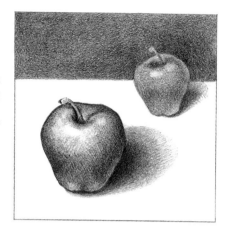

Figure 15-18: Use contrast of value to create focal points in your composition.

Color

Color is the second-most important way that you can create contrast. In two-dimensional compositions, bright, intense colors attract attention, while dull, muted colors tend to recede. Placing bright colors against duller colors creates contrast (see Figure 15-19). You can also create contrast by playing complementary colors against each other. Using colors that are similar to each other is less likely to attract attention. (See Chapter 17 for more in-depth information.)

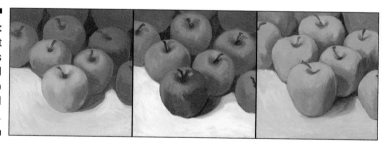

Figure 15-19: Contrast bright colors against dull colors to create focal points.

Shape

Contrasting different sizes of shapes against each other attracts the eye (see Figure 15-20). In a similar manner, you can use areas that have mass contrasted against areas of line, or large unbroken areas against areas of detailed shape.

Figure 15-20:
Groups of small shapes and linear shapes both attract attention when placed with larger shapes.

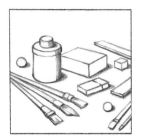

Texture

The obvious idea here is to contrast areas with and without texture (see Figure 15-21), but you can also contrast bold or rough textures against areas that have refined textures.

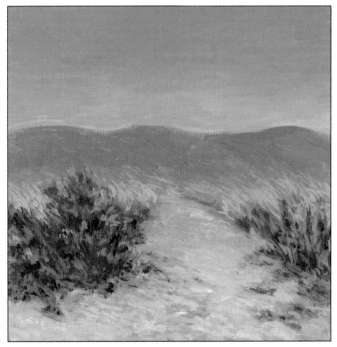

Figure 15-21:
Contrasting areas with and without texture.

Line

Contrasting different kinds of lines can be effective for both your drawing and your painting (see Figure 15-22). These contrasts can involve using lines that have different *weights,* which is art jargon for lines that can be thick and thin or sharp and wide. It can also apply to a contrast of a heavy-handed stroke against a delicate stroke.

Figure 15-22:
Contrasting
lines.

Directing the eye around the composition

You can use this information in very practical ways, but first you need to think about what you want to accomplish. Answer these questions:

- ✔ What do you want to emphasize in your painting?
- ✔ How much depth do you want to show in your painting?
- ✔ How do these choices affect what the viewer may think is happening in the painting?

If you don't have some idea of what you want your viewers to experience when they look at your painting, you may be working without a sense of direction — which means that you can get lost very easily in the process of painting. Wandering through making a painting and intuitively coming up with something very beautiful is possible, and you can even manage to simultaneously learn some things along the way. If you consider how you can use various forms of contrast to achieve your goals, however, it frees you to experiment in a more productive way and you don't make as many rookie mistakes.

Here are some problems that you can create if you don't use contrast well:

- ✔ Creating a contrast on an insignificant portion of the composition confuses your viewers. They wonder why you emphasized the area and what its significance is.
- ✔ Creating contrast on the outer edges of the composition without significant contrast in other areas leads the viewer's eye outside your painting.
- ✔ Too much contrast throughout the painting can be chaotic. If you want a busy, energetic composition, that may be a good thing. You should still consider whether you need more emphasis in some areas than others.

Consider how much contrast you need. We can think of a few Monet paintings that would be ruined if he had added more contrast of value. The contrast of cool and warm colors made them sparkle enough. Use the right amount of contrast for what you're trying to accomplish. Little contrast is okay if it serves your purpose.

Here are some specific situations where you can apply contrast to your compositions:

✔ To attract attention to specific areas, use a contrast of very light and very dark areas against each other. Don't do this in the background of your paintings if you want the appearance of depth, because it flattens the painting out. If you want the eye to move to the background, use a less extreme combination of lights and darks.

✔ To bring areas forward in the composition, use contrast of value, brighter colors than the background, and more detail (smaller shapes).

✔ To make areas seem farther away, make the values and intensities of the colors similar to each other. The duller the colors are, the farther away they seem. Be careful not to make the colors too dull for the situation that you're painting.

For more information about how you can use color in your composition, see Chapter 17.

Project: Keeping your viewer's attention: Contrast at work

For this project, you create an abstract painting that explores depth. Design a simple shape, and then repeat it in different sizes and paint it so that some seem to be closer and others seem to be farther away. See the example in Figure 15-23.

1. **Prepare a 12-x-12-inch square, preferably smooth painting surface as necessary, and then set it aside.**

 A prepared board and gesso coated heavy paper both work well.

2. **Design a simple shape that you can easily trace and paint, avoiding detailed shapes and linear shapes.**

3. **Make rough sketches to explore different shapes.**

 Make your sketches with a 4B, 6B, or Ebony pencil in your sketchbook.

4. **Pick the best shapes and roughly compose them in square picture frames to see how they look.**

 Use the three different sizes, three to six times each.

5. **Choose a shape and refine the design into a master sketch.**

6. **Photocopy your master sketch in several different sizes and pick three sizes to use in your painting.**

7. **Use scissors to cut out your shapes so that you can use them as templates.**

8. **Use a sharp charcoal pencil to trace the shapes onto your painting surface, consulting your rough sketch for positions.**

9. **Check the composition and make adjustments as desired.**

10. **Use your paints and painting equipment to paint the composition by using the following guidelines:**

 • Paint the background a cool, rather dark color. Don't paint it black.

 Choosing colors and painting is easier if you do the background first.

 • Paint the largest shapes the lightest, brightest colors that you want to use.

 • Paint the middle size shapes slightly darker, duller colors than the colors of the large shapes.

 • Paint the smallest shapes colors that are slightly lighter and brighter than the background color.

 For further information on how to choose and mix colors, see Chapter 17.

Try to evaluate the colors as you go, but if you want to make any big changes, allow the paint to dry for a couple of days, and then paint a different color over the old color.

When you finish, look at the composition and evaluate whether you can see depth in your composition. If it needs improvement, read over the section on contrast and see whether you can adjust any areas.

Figure 15-23:
Contrasting
size and
spacing.

Chapter 16

Communicating Ideas Visually

As you become more comfortable in the painting process, you naturally want to look for ways to add more difficulty and to be more creative. You also start wanting to speak to your viewers with your painting. If you've ever said that you just want to make people happy with your painting, you've expressed a desire to speak to your viewers about beauty. Everyone has something that he or she wants to say. It may be a personal story, a political statement, a view of life, or simply a statement about the act of painting, but when you paint, you're communicating your ideas.

In this chapter, we talk about developing an awareness of the way your composition speaks to your viewers, and we tell you how you can consciously compose your painting to express your ideas creatively.

The Right Composition for the Job

The way you arrange the parts of a painting communicates ideas. If, for example, you line up the objects in your painting like a bunch of little soldiers, your composition may be seen as rigid or formal. On the other hand, if you scatter the objects in a random manner, your composition may be seen as casual or possibly chaotic.

Every society has a certain clothing "language" that its people understand. You make decisions about what to wear based on that shared language. Painting also has a certain "language" that people understand, regardless of how much they know about art. You bring to painting all kinds of things that you've experienced and know about the world. Some of these things include the way that you respond to color, your physical awareness of gravity and balance, and what you share with other people within your culture. When you "read," or look at, a painting, you respond not only with your senses and perception, but also with your knowledge and life experiences.

Visual language refers to the common ways that people see and understand an image. These common ways include what you see and understand in the world around you, as well as the way you relate to shared experiences.

Because people have this shared visual language, they tend to understand paintings in relatively similar ways, regardless of what the artist's intent is. For example, if you don't paint a building perfectly vertical and plumb, everyone will agree that the building looks like it's falling down. Color is another part of this language. People associate certain colors with particular moods or ideas. You may think of yellow as cheery, while blue is calm or melancholy. All the ways that you perceive what you see become a part of your visual language. (For further information about visual perception, read Chapter 15.)

Developing Awareness of Your Composition Decisions

As you arrange your compositions for your paintings, think about your ideas and what you're trying to accomplish. Avoid designing your composition with eyes blind to what each decision is doing to your composition.

Most people tend to be either analytical thinkers or intuitive thinkers, but everyone has the capacity for both. The way you solve problems influences the way that you naturally make compositions, so knowing whether you're more analytical or more intuitive is helpful. You may think that being intuitive is necessary for being an artist, but you can be a very fine painter no matter what. If you understand your natural tendencies and can work objectively, you can use both to support your efforts.

You probably already have some idea of whether you lean toward being analytical or intuitive, but here are some characteristics of each:

- ✔ **Analytical problem-solvers** are rules-oriented and like structure. They like to have everything clearly outlined, and will do research to collect as much information about what interests them as they can. They like to have definite, correct answers to questions. Their solutions to problems converge toward one clear, well-considered solution.

- ✔ **Intuitive problem-solvers** work by trial and error. They like to feel their way through a problem. They think that rules are more like guidelines, and will research by following their noses in whatever direction their interests take them. Their solutions to problems are divergent, having multiple possible solutions.

Try to find your place on a continuum instead of trying to decide whether you fit into one style or another. Figure 16-1 shows a simple continuum with analytical problem-solvers on one end and intuitive problem-solvers on the other end.

Figure 16-1:
The continuum of analytical and intuitive problem-solvers.

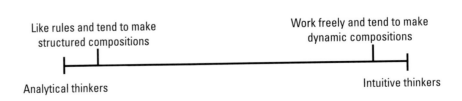

Like rules and tend to make structured compositions

Work freely and tend to make dynamic compositions

Analytical thinkers

Intuitive thinkers

Structured compositions

Structured compositions are easy to identify because they have distinct characteristics. They look formal and planned because they were put together according to a devised set of rules.

If you think of your composition as a grid, everything in your composition is placed on the grid according to a math-like plan. All linear shapes line up parallel to or on a diagonal with the picture frame. Other shapes are organized in a geometric pattern. In Figure 16-2, you see two structured compositions. The objects in the composition on the left are plotted on the grid. Notice that the objects in the composition on the right relate to a grid but also line up parallel to the picture frame.

Structured compositions that conform to geometric forms or formulas based on grids are also called *architectonic* compositions.

Figure 16-2: Objects in structured compositions are plotted on a grid or lined up parallel to the picture frame.

Traditional Christian crucifixion scenes are examples of structured compositions. Jesus becomes the major focal point at the top of a triangle formed with mourners and Roman soldiers at the base. In another example, Andy Warhol composed many of his paintings in a structured manner, including the soup can paintings and many of his portraits of celebrities. Figure 16-3 shows additional examples of structured compositions.

Figure 16-3: Examples of structured compositions.

Dynamic compositions

As its name implies, dynamic compositions are active compositions that have a lot of movement. Because no rules are in place to lock the parts into static relationships, they're flexible and casual in feeling.

Once again, if you think of your composition as a grid, the rule is that there are no rules — except that nothing can line up with the grid or picture frame. You feel your way through a dynamic composition. You start with an object and, through trial and error, add objects and take objects out, moving things around until it works. In Figure 16-4, you see the same objects from Figure 16-2 repositioned in a dynamic manner.

Make *dynamic compositions* by composing objects so that they have no relationship to a grid. Instead, put objects together and evaluate how they look with the rest of the composition.

Figure 16-4:
The objects in a dynamic composition have no relationship to the grid.

Most traditional still life and landscape paintings are dynamic compositions. Many of the paintings that you make in the beginning will probably be dynamic compositions. See Figure 16-5 for examples.

Figure 16-5:
Examples of dynamic compositions.

Symmetrical and Asymmetrical Compositions

You can approach making compositions in a number of ways. Structured and intuitive compositions are examples based on mental approaches that you can map on a grid. Other approaches are based on different strategies, but they all provide a platform for making strong compositions. You use the strategy that works best for the way you're most comfortable working and for your idea and composition.

Balance is one of the most common approaches to composing artwork. It's based on the idea of gravity. That probably seems completely crazy — after all, no special gravitational forces apply only to artwork! It does make sense if you consider the way that people understand what they see, though. You bring what you know about the world to the way that you understand artwork, and that includes the idea that something can fall.

Look at Figure 16-6. The object seems completely stable when it sits near the bottom of the picture frame in the example on the far left. When the object sits higher in the frame, in the next two frames, it seems heavier, as if it's in the act of falling. The higher an object is in the frame, the heavier it seems.

Figure 16-6:
Weight and gravity affect the way a viewer sees objects in compositions.

The interesting thing is that if you change the object into something that you expect to see higher in the frame, the feeling of weight disappears. Seeing objects that you expect to float or fly up high seems perfectly natural. Figure 16-7 illustrates this change.

Figure 16-7:
The sense of weight disappears when you see an object that you expect to fly.

When you use the principle of balance, you take the concept of weight further. You divide your image area into two side-by-side halves that are "weighed" against each other as if they're on a teeter-totter. The parts of your composition on the left are weighed against the parts of your composition on the right. Examples appear later in Figures 16-8 and 16-10.

Bilateral symmetry is a term for all the kinds of balance that weigh the parts of the left half of a composition against the parts of the right half. This is an umbrella term for both symmetric and asymmetric compositions.

Symmetric compositions

An easy way to describe symmetric compositions is to say that about the same amount of stuff is on either side of the composition. If you think of it as a bunch of kids on a teeter-totter, you have different kids on both sides, but each side weighs about the same. In a composition, the parts of the left side appear to have a similar weight to the parts on the right side. (See Figure 16-8 for an example of a symmetric composition.)

Figure 16-8:
Both sides of the composition have about the same weight.

There are two types of symmetric compositions. Most symmetric compositions fall under the general description we just gave you. The second type is called *mirror image*.

In *mirror image* compositions, the parts on the left side are mirrored on the right side. That means that the parts on the left are duplicated and flipped over to complete the whole composition. (Figure 16-9 shows you an example.) Think of it as one side of your body being mirrored on the other side. If someone gives you only one side of a mirrored composition, you know exactly what the other side looks like. Because mirror image compositions have one overriding rule — what's on the left is mirrored on the right — *all* mirror image compositions are structured compositions.

Figure 16-9:
In this
image, one
side of the
composition
is mirrored
on the other.

Asymmetric compositions

In asymmetric compositions, you have one side that's a lot heavier than the other side, but the entire composition still needs to be balanced. As you can see in Figure 16-10, it's like having a big kid and a little kid on the teeter-totter. If they both sit on the ends, the big kid can sit all day with his end on the ground while the little kid is stuck stranded in the air. Of course, you probably learned on the playground that if you move the kids around, the board evens out. You can move the big kid in toward the middle and the little kid stays out toward the end. Everybody's happy.

Figure 16-10:
A balanced
asymmetric
composition
is like
balancing
different
sized kids
on a teeter-
totter.

You have one overriding rule in asymmetric compositions. A major focal point must be located to one side of the composition. It's never in the middle of the composition. Beyond that, you have to move things around to get the composition to balance (just like the big kid and little kid on the teeter-totter). It's an intuitive process of starting with your major subject matter and then composing everything in relationship to each other. Figure 16-11 shows you how to balance an asymmetric composition by positioning a major focal point on one side of the composition.

Flat and Illusionary Compositions

When you look at paintings from the Renaissance like da Vinci's *The Last Supper,* the space seems so realistic that you could reach right into the composition. Other paintings, like Robert Indiana's *Love,* are so flat that they hardly seem to have any depth at all.

Paintings like *The Last Supper* are *illusions of reality.* The surface they're painted on is flat, yet they appear to have depth. The artist uses special *spatial devices* to make the space seem real. Devices such as *overlapping* and *linear perspective* are easy-to-learn tools that create any sort of depth you want.

A *spatial device* is a specific way of placing or drawing the objects in your composition to show different kinds of space or depth.

Paintings that appear to have little realistic depth and are relatively flat are generally *abstractions.* They tend to hug the picture plane. Some abstract paintings are about the *act* of painting, and are made purely of color, line, or shape. Other types of abstract paintings are about simplifying realistic subject matter. To *abstract* something means to simplify it. For example, a cartoon or manga character is an abstraction of a human form. Even very realistic portrait drawings are slight abstractions of the actual person.

Think of illusionary and abstract images as being on a continuum, with illusion on one end and abstraction on the other. (Figure 16-12 illustrates this continuum.) The most "real"-looking work falls on the extreme end. This end may include *trompe l'oeil* painting, a term for a super-realistic kind of art that means "fool the eye," and Photorealism. At the other end are forms of abstraction that have no relationship to actual objects. Everything else falls on the line in between, depending on how simplified the image is compared to the actual object. Monet's *Waterlilies* lies on the abstract half of the line, while Andy Warhol's soup cans are probably positioned toward the middle.

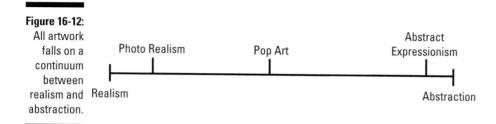

Figure 16-12:
All artwork falls on a continuum between realism and abstraction.

You can use several devices besides linear perspective to show space in a composition. Artists across time have used them in different combinations, which accounts for differences in the way you see space in them. These various combinations of devices cause the different kinds of space that you see in ancient Egyptian art and Renaissance art, for example, or traditional art from Asia and the Middle East.

Unlike the past, you live in a time when you have many choices in the way you can make art. You can make art as flat or as illusionary as you like. The question is what works best to communicate your message, and then what devices you should use to make the work.

Working on flat compositions

Ancient Egyptian art and the cover of your favorite magazine have a lot in common. Both have celebrities, intriguing storylines, and flat design. In flat design, you treat the picture plane like a table upon which you move the parts of your composition around as you compose it. You can think of it as composing a painting the same way you would lay out the front page of a newspaper. Beyond that, the following sections give you a few devices that you can use. These devices still give you flat space, but they make it a little more interesting.

Flat pattern

Flat pattern is fairly self-explanatory, but you can think of it as decorative parts of the composition that really do lie flat to the picture plane — like words to a page. In ancient Egyptian art, that's exactly what the hieroglyphics are, but the lotus flowers, reeds, and other repeated elements you often find in the art are flat pattern as well.

You can find many examples of flat pattern in print design. The text and headlines form blocks that act as flat pattern. The front cover of this book and most of the interior is flat pattern.

Transparency

Transparency is an interesting device that allows you to show more than the viewer would normally be able to see. It has a shallowness to it, but you can build up layers of imagery and make it very interesting. Picasso used this device extensively. A still life on a table with transparent areas may expose the grain of the wood in the tabletop and even the pattern of the wallpaper behind it. (Check out Figure 16-13 to see an example of transparency in a composition.)

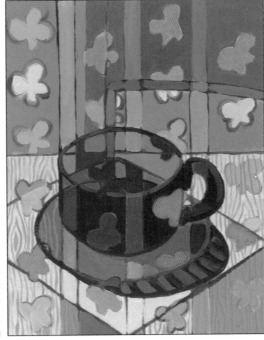

Figure 16-13:
Transparency shows your viewers something they may not normally be able to see.

Ambiguity

Ambiguity is a device that's often associated with *transparency,* but you can attain it by using other strategies. The basic idea is that you execute the area in such a way that you can't tell what's in front and what's in back. That's easy to do with transparency, but you can also achieve it by balancing light and dark areas so evenly that the positive and negative spaces switch dominance depending on how you look at them. In Figure 16-14, the subject and its background are interchangeable, creating ambiguous space.

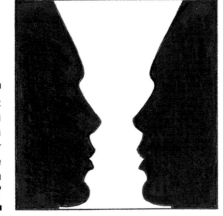

Figure 16-14:
Are you looking at a chalice or two people facing each other?

Creating depth in your composition

Throughout time, artists have used combinations of devices to show depth. They commonly combined *overlapping, diminishing size,* and *vertical location* to create depth. *Linear perspective* has been used in art only since the beginning of the Renaissance, less than 600 years ago. Even so, it was primarily used in Western cultures until relatively recent times. Today, artists everywhere use the spatial devices in various combinations according to their needs.

The following sections outline the devices that you can use to help show depth in your artwork.

Overlapping

Overlapping is the simplest device that you can use to show depth. If you want one object to appear to be behind another, overlap them. Draw the object in front so that it covers up part of the object in back. Figure 16-15 shows you an example of overlapping in the drawing on the left.

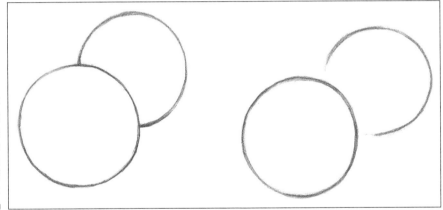

Figure 16-15: Overlapping puts one object in front of another.

 If you want one object to look like it's behind another, make sure that you paint its edges right up to the edges of the object in front. If you don't, the front object looks like it has a halo around it and the space looks flat, as you can see in the drawing of the objects on the right in Figure 16-15.

Diminishing size

Diminishing size is a device in which you make the objects in your composition larger if they're close to you and smaller if they're farther away. (See Figure 16-16 for an example.)

Vertical location

In *vertical location,* you show objects that are closer to you toward the bottom of the composition, and you place objects that are farther away higher in the composition. (Figure 16-17 shows the vertical location device in action.)

Linear perspective

Linear perspective is a structural method of drawing that gives you the most lifelike sense of space. It assumes that you're viewing your subject from a single point of view, standing in one spot with one eye shut.

When you use this method, you establish a line on your paper that represents the level of your eyes if you look straight ahead. Everything else you draw has a relationship to that line. For example, boxes are made of sets of flat planes. If you extend the lines of the sides of a box indefinitely, the lines eventually converge at points on the eye level line. These are called *vanishing points.*

Atmospheric perspective

Have you ever noticed how a hazy summer day, city smog, or even fog affects what you can see in the distance? Water and dust in the atmosphere cloud how clearly you can see distant objects. Even on a clear day, you can see everything near you much more clearly than anything farther away.

You can use atmospheric perspective to create depth in your composition in the following ways (see Figure 16-18 for an example):

- For objects close to you, use brighter colors with a full range of value, from very dark to very light. Give these objects more detail than objects that are farther away.

- For objects farther away from you, use duller colors. Limit the use of darks and lights so that you use only the middle range of values.

See Chapter 17 for more information about how you can choose colors for atmospheric perspective.

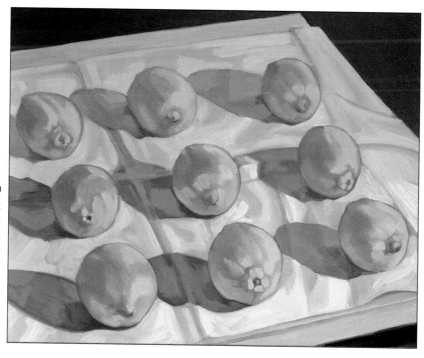

Figure 16-18: Make objects look like they're farther away by making them less detailed.

Isometric projection

Isometric projection can seem to be similar to linear perspective, but they're very different. In isometric projection, the lines you'd use to draw the sides of your boxes remain parallel to each other. They never converge at a point on an eye level line — there is no eye level line. You also draw the lines on the same degree angle throughout the drawing. The box in Figure 16-19 is drawn using isometric projection.

Figure 16-19:
A box
drawn using
isometric
projection.

This type of drawing is used for industrial design and has a long history of use in traditional Asian art. It can be useful to you in drawing close-up still life objects. They're so close that you don't see as much of the effect of linear perspective. If you're having trouble making lines that *diverge* rather than *converge,* this device can help you solve it.

Multiple perspective

While linear perspective assumes that you're looking at a scene from one position with one eye shut, multiple perspective allows you to combine more than one point of view into one painting.

A simple example of multiple perspective is the ancient Egyptian figure whose face and lower half of the body turn to the side, while the eye and shoulders face the viewer. The Cubists — Picasso and Braque, for example — took this device to another level. They rejected the stationary view of reality that came out of the Renaissance with linear perspective. They said that it was more *real* to show what you see when you look at an object from different sides or even through it. So, they worked out a way to combine different points of view in one painting. (Try the upcoming project on multiple perspective painting.)

You can use multiple perspective in your painting in other ways. Here are some possibilities:

- ✔ If you want to do a panoramic landscape, use different points of view that have a common horizon. Take photographs each time you turn a little until you make a full circle. Your eye level stays the same, but each view is different. Then patch all the photographs together, matching the horizon lines.

- ✔ Make a painting that repeats the same subject from different points of view in one composition.

- ✔ Photograph a subject in fragments, collage the photographs together, and then paint the resulting image.

Project: A multiple perspective painting

A simple way to do this version of multiple perspective is to create a different layer of drawing for each point of view, combine the layers, and then choose to paint parts to emphasize different layers and create focal points. It's always a good idea to look at the work of other artists before you begin a painting. It can help you focus on your goals for your painting. For this painting, take a look at Picasso's or Braque's still life paintings from the early 20th century. When you're ready to tackle this project, check out Figure 16-20 for an example and then follow these steps:

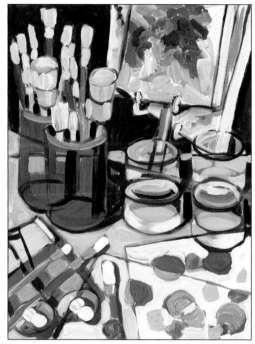

Figure 16-20:
An example
of a multiple
perspective
painting.

1. **Prepare to paint by setting up your work area, paints, and palette; you need a painting surface that's about 16 x 20 inches.**

2. **Set up your still life, and be sure to consider your lighting.**

3. **Choose two analogous colors to use for the preliminary drawing for this painting.**

 Examples of analogous colors are blue and violet, or blue and green. One should be noticeably lighter than the other.

4. **Make a wash of the lighter analogous color and draw the entire still life on your canvas with that color.**

 Be sure to use your viewfinder to help you see the composition.

5. **Move a few steps to the side so that you have a different point of view of the still life, and use the darker color to draw the new view of the still life on top of the first drawing.**

Note that when you move a few steps to the side, you may want to move the table with the still life to make painting easier. Ignore the former drawing as you work. Allow the forms to fully overlap each other.

6. **Look at your drawing and decide what you want to emphasize in the painting, and consider where your patterns of dark and light might be.**

Maybe you want to emphasize an interesting overlap of two cups, or a pattern overlapping a shape.

7. **Begin your underpainting by painting every shape made by the overlapping drawings a different color.**

Don't do this arbitrarily. Look at your still life as you work. If the shape of a cup is divided in two by the drawing from the other point of view, try painting it two similar values or hues. If you want to paint it two very different values, but you want to keep the shape of the cup, paint the lines of the drawing of the cup a light or dark color. (See Figure 16-21 for two ways to treat a multiple perspective cup.) This painting process is intuitive; paint an area and constantly assess how it works with the rest of the composition.

8. **After you cover your surface with paint, continue to develop the painting in layers.**

Feel free to try adding texture to your work by using your painting knife or different kinds of brushstrokes. Experiment!

9. **As you paint, step back every now and then and ask yourself these questions:**

 • Where are my focal points? Do they direct the eye to appropriate parts of the composition, or do they direct the eye to the outer edge or off the canvas?

 • What does my overall value pattern look like? Is the total value pattern interesting?

 • Where are my areas of contrast? Does the composition look spotty or well designed?

 • Is the color vibrant or dead? Are all the colors dull, bright, or a nice mix of both?

 • Does the total composition look well resolved or does your eye go to parts that that seem off?

Figure 16-21:
Two ways to treat a multiple perspective cup.

Working in your sketchbook

Working in your sketchbook is an essential part of learning to paint. Your sketchbook is a place to try out new ideas, experiment, and study. In these exercises, you put what you read in this chapter to work. You may not be interested in making a painting about every spatial device we discuss — neither are we — but these exercises help you recognize the devices and dissect how an artist has put together his composition.

Did you ever collect leaf specimens for science class when you were a child? It was a good project. It helped you learn to identify various kinds of trees. You can do a little of that for this sketchbook work so that you can learn to recognize different kinds of compositions. Start by going through some art books and photocopying "specimens" of paintings that represent various types of compositions. Glue them into your sketchbook and label them.

Thinking about point of view

Every time you paint from life or make other realistic images, you make a choice about the point of view. Ideally, you're always looking for something interesting, but if you really want to give your work impact, unusual points of view can deliver it. You do want to consider what angle is best for getting your point across, however. Impact for the sake of impact may not be appropriate. For example, if you're making a movie and you use the points of view in a romantic comedy that you typically find in a horror movie, you may have some very confused viewers!

Mouse eye views are a lot of fun and make very dramatic compositions. The idea is merely that you capture a point of view that's as low to the floor as possible. If you have a tabletop setup, you may capture your point of view as low to the top of the table as possible. The objects in these compositions often seem larger than life, or at least life as you normally experience it. This point of view is common for young children and babies, but it's outside most people's day-to-day way of looking at things.

Bird's eye views, as the name implies, are aerial views. The viewer hovers over the scene at a height you determine. The point of view can be as low as if the viewer is standing over a setup or any reasonable height above.

You can easily stand over a setup that you place on the floor and then draw it. If you want it to appear that you're working from a greater height, think about how much you need to reduce the size of the drawn setup to get the desired appearance of height that you want. The smaller the setup is, the farther away it appears to be. (Figure 16-22 shows an example of each view.)

Figure 16-22:
A bird's eye
view
composition
(left) and a
mouse eye
view (right).

Chapter 17

Using Color with Confidence

Have you ever been disappointed with the color you painted a room? Most people have at one time or another. Maybe you did all the right things: You picked up a set of paint chips from the hardware store. You held them up to the wall and chose the one that you liked the best. You bought the paint that matched the chip. It wasn't like you picked up the first gallon of paint you could put our hands on. What went wrong?

Well, the truth is that color is very tricky and deceitful, more so even than that old boyfriend or girlfriend you had in high school. Color is strongly affected by the colors around it. You think you have the right color, and, whoops! It slips right by you. If you want to get a handle on color while you learn to paint, the best thing you can do is commit to understanding it really well.

In this chapter we tell you all the secrets of color and how to apply them to your own painting.

Describing Color Clearly: Hue, Value, Intensity

What color is "peach?" Well, if you look at a real peach, its color is a range of hues like red, orange, and yellow-orange, and some of the colors are dark while others are very light. So, what do people mean when they call a color "peach?"

Most color names like "peach," "cornflower," or "forest green" are subjective names that tell you very little about what a color really looks like. What if you had never seen a peach, a cornflower, or a forest? These names tell you more about an experience than what a color looks like.

Being able to see and describe color accurately is important. If you can describe a color, you can mix it.

Every color has three characteristics that can help you describe it. The word *color* actually means more than whether a color is red or blue. It also includes how light or dark a color is, as well as how bright or dull a color is. Read on for more on these three characteristics:

✔ **Hue:** You can begin describing a color by looking at its *hue,* which merely refers to its position on the color wheel. Hue names are simple: red, blue, green, red-orange, and so forth. Look closely, though. A red may be a warm red that looks a little red-orange, or it may be a cool red that looks a little red-violet. Look at the color wheel on the Cheat Sheet in the front of this book. You see many possible hues that could lie between the hues we provided.

✔ **Value:** The second characteristic of a color is *value,* which refers to how light or dark a color is. Light colors are closer to white in value, while dark colors are closer to black. A pure red or green is similar in value to middle gray. Look at Figure 17-1 to see where some colors on the color wheel lie on a grayscale.

To see the value pattern of the objects that you're painting, squint while you look at them. Squinting allows you to see their values but not their intensities. If you're worried that squinting will land you in the plastic surgeon's office sooner than you want to be there, just drop your eyelids and look through your eyelashes.

✔ **Intensity:** The third characteristic of a color is *intensity.* This refers to how vibrant or bright a color is on the high end, or how dull or gray or neutral a color is on the low end. Some colors are naturally more intense than others. This is their *temperature.* For example, *warm colors* like reds and oranges — the colors you associate with fire — are naturally more intense than *cool colors* like blues and violets — the colors you associate with ice.

Another factor that affects intensity is how *saturated,* or pure, a color is, which means how free the color is of white, black, or other hues. A pure orange has no white, black, or blue in it. On the other hand, the color of an oak floor is a less-saturated, less-intense version of orange and would be mixed by adding white and other hues or black to an orange pure hue. See Figure 17-2 for two colors that have the same value of orange despite one being much duller than the other.

Figure 17-1:
All colors have a value that falls somewhere on a scale of white to black.

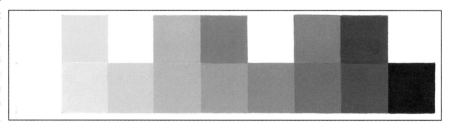

Beginners often confuse brightness with lightness. Use this simple activity to help you develop your ability to detect intensity.

Figure 17-2:
Intensity
refers to
how bright
or dull a
color is.

Collect a stack of magazines or advertising supplements from your Sunday paper and then follow these steps:

1. **With a utility knife, cut out swatches of as many variations of yellow as you can find and spread them out on white paper.**

 Collect swatches that are at least ¼ inch wide.

2. **Sort the swatches that seem to "glow" into a group on a separate sheet of paper.**

 Look at your pool of yellow swatches. Which yellows seem to "glow" more than the others? These swatches appear to be more vibrant and clear; they're free of white, black, or other hues.

3. **Sort the swatches that seem hazy or dull onto another sheet of paper.**

4. **Study the remaining swatches; if any seem to belong in the other two groups, place them in those groups; the remaining swatches make up their own group.**

5. **Study each of the three groups, sorting each group into pools of brighter and duller swatches.**

6. **In your sketchbook or on a piece of white bond paper, glue each group of swatches down as a long, rectangular strip making a scale or transition from bright to dull.**

 Use rubber cement because it doesn't warp the paper like white glue does.

7. **Slice off the sides and ends of your scale using a ruler and the utility knife to make it look neat.**

8. **Glue the strip down to another sheet of paper.**

9. **Compare your strip to the example in Figure 17-3.**

 How did you do? A good exercise will remind you of a ray of light from a flashlight, bright on one end and defused at the other.

Figure 17-3:
A transition
from bright
to dull using
printed
papers.

The Four Basic Kinds of Colors: Pure Hues, Shades, Tones, and Tints

As discussed in Chapter 7, you learn to mix paints by making a chart of colors. You make pure versions of basic *hues* and then add white to them to make *tints*. You make *shades* by adding black or complementary hues to the pure hues. To those shade mixtures, you add white to make *tones*. As you add white, black, and complementary colors to your pure hues, you change their values and their intensities in very specific ways.

Complementary hues are the hues directly across from each other on the color wheel. For example, the complement of blue is orange.

The color wheel in Figure 17-4 includes pure hues, shades, tones, and tints. Notice how the values and intensities change from one ring to another.

✔ **The pure hues,** the outer ring on this wheel, are the brightest, most intense forms of a hue. The brightest warm hues, like yellow, yellow-green, and yellow-orange actually seem to vibrate. The cool colors, like blue and blue-violet, have a quiet glow about them. Their values can run from very light, like the yellow, to very dark, like the blue and blue-violet.

✔ **The shades,** the second ring, are always darker and duller than the pure hues, but they often seem bright compared to other colors. Shades are very much like the colors of fall leaves.

✔ **Tones,** the third ring, are the most versatile of colors, with a wide range of values and intensities. Their values can range from dark to light, and their intensities can range from bright to dull. Nearly all the colors that you use in your palette are likely to be tones.

✔ **Tints,** the inner ring, are always lighter in value than pure hues. The recipe for them is pure hue plus white. They look like spring colors and tend to be a little bright. If you compare a tint and a tone of the same hue and value, you notice that the tint is brighter than the tone.

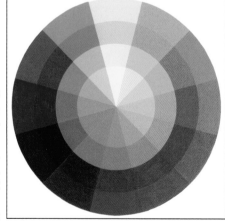

Figure 17-4: A color wheel with pure hue, shade, tone, and tint rings.

Paint store samples can help you learn to see color. Ask the employees at your local paint or hardware store for old or discontinued sample books that they're planning to throw away.

One way you can use samples is to simply place them on the objects that you're planning to paint to help you identify the local color. Sometimes, however, the local color is so strongly affected by the colors surrounding it that it can fool you into thinking that it's a totally different color than it really is. Use a white index card with a hole punched in it to isolate the local color so that you can compare it to your color samples.

Of course, none of this makes any difference if you can't mix a color similar to the color sample that you matched the local color to. Choose a color sample from a book or collection of color samples, and try to match your paint to it. Here's how to approach it:

1. **Hold a color sample against the color wheel in Figure 17-4 and find the closest hue to your sample.**

 If your target hue is between two hues on the wheel, decide whether your hue lies exactly halfway between the two or leans toward one hue or the other. If you aren't sure, view your color through a white index card with a hole punched in it.

2. **Make a pool of paint as close to your hue as you can.**

 If you're mixing one of the oranges, ask yourself if it needs to be more red or more yellow. If you're mixing a green, ask if it should be more blue or more yellow. And if you're working with violet, ask if it needs to go more red or more blue.

 Theoretically, every color on the color wheel is made of only one or two primary hues: red, blue, or yellow. You learn in grade school that you can mix the primary colors to get the secondary colors — orange, green, and violet. It worked pretty well as long as you were mixing to get orange and green, but it fell apart when you mixed red and blue and got a dull, grayed-down violet. The theory didn't fail you; your pigments did. You *did* mix violet; it just wasn't a *pure hue* of violet. Pigments have limitations and sometimes you need to buy a pigment similar to the hue you need in order to get the brightest version of a hue.

3. **Determine the *value* of your target color and use your complementary mixture, black, or white to darken or lighten it.**

 Decide whether your target color is lighter or darker than the pure hue you have. Use the complementary mixture or black to darken it; add white to lighten it. When the hue and value are similar to your target color, move on to the next step.

4. **Check the *intensity* of the color and make it duller or brighter to match the target.**

 Is your color brighter or duller than your target color? If your color is brighter than your sample, you need to add the complement or black to dull it. That will probably make it too dark for the value you want, so you'll also need to lighten it back to the earlier value by adding white.

 If your color is too dull or appears washed out, add some of your pure hue back into it to brighten it up.

All this color creation can make you a little crazy, but just remember that getting the right color is merely a balance of three things: the pure hue, white, and the complement or black.

Cutting the Light: How Complementary Colors Work

So why bother talking about complementary colors when grabbing that tube of black paint is so easy when you want to darken or gray-down a color? Black is fast and it does the job, but if you really want to improve your use of color, you need to get to know your complementary colors and how they work.

First, take a quick trip back in time to your fifth-grade science class. The color you see around you is *subtractive color*. White light from the sun strikes an object that you're looking at, and all the colors of the spectrum — that rainbow that shows up after an afternoon thunderstorm — are absorbed by the object *except* the color we see, which is the *local color*. So, if you're looking at a blue bowl, all the colors in a ray of light are being absorbed except blue, which is reflected to your eyes. That's why wearing a black t-shirt on a summer day is so much hotter than wearing a white t-shirt. Black absorbs all the light, and thus much of the energy, while white reflects all the light and absorbs less of the energy.

So black pigment particles absorb light, and when you mix black into a pool of pure hue, you dilute the amount of the hue's light that can be reflected for you to see. It's like pulling a window shade partially down.

You can mix a very nice black by mixing the primary colors together in the right proportions. The three primaries cancel each other out by absorbing the light rays of the others, so very little light is reflected. These proportions aren't equal; they're approximately two parts blue, one part red, and one part yellow, depending on the pigments you use. (You wouldn't want to use one of the lighter blue pigments like cerulean blue, for example. A dark blue like phthalocyanine blue works better.) So, try mixing a black as an interesting alternative to tube black. Rather than the dull, dead black that comes out of a tube, you'll have a black that shimmers with the colors you mixed to make it.

Using black is an effective way to adjust colors for value and intensity, but beware of these two problems with it:

✔ If you use black too much, your paintings have an all-over grayness about them that makes them seem dull and lifeless.

✔ There is no perfect black, so when it's added to many colors, it changes their basic hue. For example, orange is notorious for turning greenish when you add black to it.

Look at the examples in Figure 17-5. On the left, you see a pure orange hue and its shade, which we made by adding black to it. Compare that set with the set on the right — a pure orange hue and its shade, which we made by

adding the true complement of orange. The orange shade on the left looks a little greenish, while the orange shade on the right looks more reddish in comparison. How do you know which is correct?

Figure 17-5:
We made a shade of orange by adding black (left), and by adding the complement (right).

An easy technique for checking to see whether you maintained the hue of the original color is to cast a shadow across the original hue and compare it to the new mixture. It doesn't matter how light or dark your shadow appears; you're checking to see whether the hues appear to be the same.

So, hold your finger over each pure hue in the example and compare the shadows you're casting over them with each of their shades. The shade made with the complement is much more like the shadow than the shade made with black.

Complements work by *completing* the set of three primaries you need to make black: red, blue, and yellow. For example, if you're working with green and you want to make a green shade, here's what you do:

1. **Think of the primaries that you use to make green — yellow and blue.**

2. **Ask yourself what the missing primary hue is — red.**

3. **Red is the complement of green.**

4. **Mix red into the green mixture.**

5. **The red combines with some of the yellow and blue in the green mixture, in effect making black, and resulting in a darker green shade.**

Here's an interesting combination: Suppose you want to make a violet shade. Violet is made of red and blue primaries; therefore, its complement is yellow. Yellow is a very light color, but if you add a small amount of yellow to violet, the resulting violet shade is *darker* than the original violet, despite the addition of the lighter color. Cool, huh?

This is a fun project that plays with the idea of using shades:

1. **Hang a 12-x-16-inch (or similar) prepared painting surface on the wall and shine a strong light on it.**

2. **Ask someone to form a shadow puppet with his or her hands in the light, casting the shadow onto your painting surface.**

 You may have to experiment with the position of the lights and your model to make the shadow the right size and sharpness on your surface.

3. **Trace the shape of the shadow with a charcoal pencil.**

4. **Mix a bright pure hue for the background color and paint it in the background areas.**

 The example in Figure 17-6 is yellow-green. (Use the recipes for colors in Chapter 7 if you need help with the pure hue and shade.)

Figure 17-6:
Use a pure
hue and its
shade to
create a
shadow
puppet
painting.

5. **Find the complement of your pure hue and mix its shade.**

 The complement of yellow-green is red-violet, making a yellow-green shade.

6. **Paint the shade flatly into the outline of the puppet shadow.**

7. **Use a brush to blur the edges of the shadow and background.**

How Color Interactions Can Mess with Your Mind

We talk a lot about how colors change when you mix them together, but the appearance of a color is in constant change because colors strongly influence each other. We discuss five rules in this section that describe how colors influence each other's value, hue, and intensity.

Look at the color squares in Figure 17-7. They appear to be very different colors, but they're actually the color you see to the far right. Check it by isolating the colors with a punched index card.

Figure 17-7:
The three small squares appear to be different, but they're all the same color.

Rule 1: Value and size

The smaller an area of color is, the darker and brighter it appears to be.

This color rule helps you to predict how colors can change. For example, remember the example of the paint chip you brought home from the store and how disappointed you were in the color of the room after you painted it? It's because the color you painted your room appears to be significantly lighter and duller than the color chip you used to pick your paint. That's the effect of this color rule.

Rule 2: Value

A color surrounded by a lighter color appears to be darker, but if it's surrounded by a darker color, it appears to be lighter.

Look at Figure 17-8. Both small squares are the same color, but the square on the dark background on the left appears to be lighter, and the square on the light background on the right appears to be darker.

Rule 3: Hue

If a color is surrounded by one of its primary hues, it appears to be more like its other primary pure hue.

This concept is a lot like a subtraction problem. Violet is made of the primaries red and blue, so violet "take away" (or surrounded by) red equals blue, and violet "take away" (or surrounded by) blue equals red.

Look at Figure 17-9. On the left, you can see a square of the original hue of violet. Compare it to the small squares in the figure. In the left large square, the small violet square is surrounded by a blue tone, but the surrounded violet appears more red than the original violet. In the right large square, the violet square is surrounded by a red tone, but the violet appears to be more blue than the original violet.

Rule 4: Intensity — Complement Sets

Complementary colors placed next to each other make each other look brighter, but similar hues make each other look duller.

Look at Figure 17-10. On the left, you can see a small orange square surrounded by its complement, blue, and on the right, you see the same orange square surrounded by an orange tone. The orange surrounded by blue is significantly brighter than the orange surrounded by orange.

Figure 17-10:
Colors
surrounded
by their
complement
appear to be
brighter.

Rule 5: Intensity — Relative Intensity Sets

Any brighter color makes another color look duller, and any duller color makes another color look brighter.

This rule is important to consider as you choose colors for your subjects and backgrounds. A bright background can kill the color in your subject and make the depth in the painting look flat. On the other hand, a duller background can add to the depth in your painting, making the space seem very real. It can also make the colors in your subject appear much more vibrant.

Color and Focal Points: Using Contrast for Emphasis

Color can help you emphasize the areas of your paintings that you want your audience to see first. Most of the time, these areas are the main subject matter in your painting, but sometimes you may want to emphasize other areas as well. Treating all the areas of your painting the same isn't a good idea because it can confuse your viewers.

Contrast is one of the most important tools you can add to your toolbox. *Contrast* merely means difference. People tend to notice things that are different. If you walk into a room and the décor is blue, you're likely to notice a couple of big, red pillows. If you're wearing a light t-shirt, you're likely to notice the black paint smeared across the front.

Contrast of value

You can use different kinds of color contrasts, or differences, to draw attention to important parts of your painting. The strongest contrast you can use is contrast of value. A light subject on a dark background can be striking, but if the values of the subject and background are similar, the subject blends into the background. Think about the way animals are protected by camouflage. Their hides and furs are so similar to their environment that you could look right at them and never see them. So, if you want your subject to stand out from the rest of your painting, make it a different value.

Contrast of hue

Another kind of contrast that you can use is contrast of hue. Complementary colors are contrasting hues that make each other brighter, and they're natural choices for creating emphasis. Near complements are good choices as well. As a matter of fact, many artists use warm and cool hues, a variation of a complementary palette, in their paintings. Warm colors naturally dominate cool colors. If you paint your subjects in warm colors, people will notice them before they see their cool colored counterparts.

Who wants to paint all their subjects in reds, oranges, and yellows, though? That could get old really fast! Here's a guideline that allows you to take advantage of changes in intensities while using any hues you like: Bright colors are always noticed before dull colors, no matter what their hues are. Therefore, a bright blue can make a great color choice for a subject if the background is a duller, warm color.

Are you noticing a theme here? Once again, the three characteristics of color — hue, value, and intensity — are your guiding concepts, this time in creating emphasis in your paintings.

Choosing the Right Colors for Your Painting

You can play with colors to give your paintings depth and drama, and that's what the next two sections cover. But you don't want to go overboard, so we conclude this section with a discussion of how to provide some order to your color choices with the use of chords.

We talk a lot about how contrast, or difference, makes your painting more interesting, but using color is like making music. Too much difference is like banging on a piano. You end up with no organization, no musicality.

Color chords are like playing chords on a piano or a guitar. They're systematic organizations of hues, creating harmonies that add beauty to a work. You choose these hues because they have a particular relationship to each other on the color wheel. After you choose these hues, mix various values and intensities of those hues to make the painting. Often these color chords are merely a starting point for making a painting, and most artists feel free to deviate from their choices according to the needs of their painting.

We mention a few color chords in this and other chapters of the book: complementary colors, warm and cool colors, and analogous colors. Here are some other color chords.

Triadic chord

Choose three colors by placing an equilateral triangle on the color wheel as seen in Figure 17-11. Use the colors located at the three points of the triangle. The primary colors — red, blue, and yellow — are a triadic chord. So are the

secondary colors — green, orange, and violet. The other two possible sets are red-orange, yellow-green, and blue-violet and red-violet, yellow-orange, and blue-green.

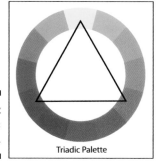

Figure 17-11:
A triadic palette.

Triadic Palette

Split complement

In this chord, you choose a set of complementary hues. You use one complement, but instead of using the other complement, you choose the two hues next to it. See Figure 17-12.

Figure 17-12:
A split complementary palette.

Split Complementary Palette

Double split complement

This one is fun! In this chord, you choose a set of complements, but you don't use either one. You use the colors next to each of the complements. See Figure 17-13.

Figure 17-13:
A double split complementary palette.

Double Split Complementary Palette

Project: Pulling It Together in a Dramatic Still Life Painting

For this project, you set up a simple still life and apply some of the ideas about color that we talk about earlier in this chapter. The goals for the project are to use color to create strong focal points and a feeling of depth in the painting.

Choose three or four objects for your still life. Look for objects whose basic geometric shapes are different from each other and can make interesting shapes in your background. Try to find objects that have analogous or complementary color relationships. For example, maybe your objects are red and green complementary colors.

Set your still life up on colored fabric or paper and put a strong light on it. Pay particular attention to the direction and shape of the shadows. Look for shadows with distinct shapes rather than fuzzy shapes for this project.

Before you start, look at the example we provide in Figure 17-14. The objects in the still life are a small rubber plant in a clay pot, an umbrella, and an apple. If you analyze the colors of the objects and map their relationships on the color wheel, you see that the painting has a double split-complementary palette. The umbrella is red-violet and the apple is yellow-green; the two colors are complements. The red-orange clay pot is a complement to the blue-green fabric. The colors are neighbors to the complementary colors red and green, making a double split.

You'll notice that the composition includes other hues as well, and that's fine. Color chords are just starting points for a painting. The handle of the umbrella is wood, which is mixed from yellow-orange. The rubber plant is a mix of greens and yellow-greens. A lot of blue-violet is in the shadows cast on the fabric. If you look closely, you see that each of the objects has a major local color, but we painted them all with colors analogous to the main color as well.

Now, look at the value pattern in the painting. Squint at it so that you can see the values better. Notice the strong difference between the values of the apple and its background. You can also see strong value differences in the center area of the painting, although not as strong as that around the apple. Toward the top of the painting, the umbrella and the fabric have very little value difference.

When you use value to show depth, you create more contrast in areas closest to the viewer and less contrast in areas meant to be farther away.

Finally, look at where the brightest colors are. The yellow-green apple is quite bright in the foreground and the next brightest colors lay in the red-orange pot and the greens of the rubber plant. The dullest colors are located in the background and far end of the umbrella. In fact, if you look along the umbrella, you see that it's brighter and has more detail in the areas closest to the viewer, while on the opposite end, the shadows aren't as dark and the colors are duller.

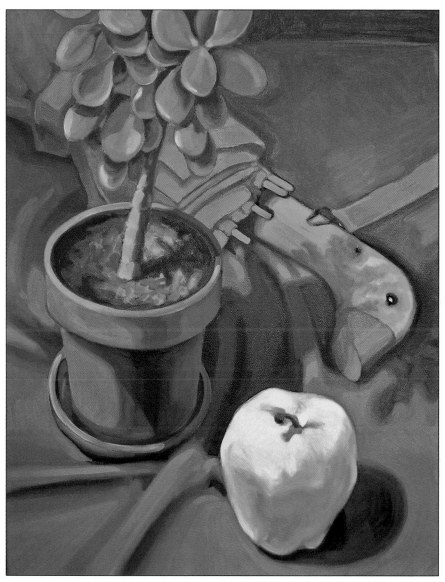

Figure 17-14:
We used a double split complementary palette in this painting.

Now you're ready to paint. Set up your still life and follow these steps:

1. **Use your viewfinder to find an image that fills your canvas well.**

 We recommend a canvas between 14 x 17 inches and 16 x 20 inches.

2. **Draw your objects with thinned paint and then draw the shapes of the shadows that you see.**

3. **Mix pools of the local colors of each of your objects and the background.**

 These colors are the stock colors for your painting. Make them a little brighter than you think you need.

4. **Squeeze out some of each of your other tube colors, except black.**

 For this one, you're going to mix your dark colors. Consult the recipes for shades, tones, and tints in Chapter 7 as you work.

5. **Begin your underpainting by laying in the local colors in thinned paint on the lit areas of your objects; in the shadowed areas, paint darker tones and shades of the local colors.**

 • As you work, you're establishing the basic value pattern for the work, so be aware of the value contrasts in the foreground of the painting and limit them in the background.

 • Don't worry about painting the perfect value and color at this point. The variety of colors is going to expand as you develop the painting.

The cast shadows are darker versions of the color the shadow is cast on. If the shadow crosses two objects that are different colors, the shadow changes color. It holds together as a single shadow if you make the values similar. Don't make all your shadows the same color.

6. **After you cover all of your canvas with paint, stop and look at your setup.**

 Note that all the shadows have variations of value within them and that the light areas have variations as well.

7. **When you begin to paint again, try to follow these outlines:**

 • In the light areas, paint lighter, warmer colors that are analogous to the major color of the body of the object. For example, we painted the light areas of the pot in our example colors that are more orange than the red-orange of the pot. Use tints and tones in these areas.

 Try not to lighten red objects with white because they turn pink and dull. Use warmer orange colors and as little white as possible.

 • In the shadowed areas, paint darker, cooler colors that are analogous to the major body color of the object. Very dark, deep shadows can go dark blue-violet. You can see it in the dark shadows cast by the clay pot in our example. The shadows on the fabric are shades and tones of blue-green and blue-violet. We painted the shadowed area of the pot in shades and tones of red-orange, red, red-violet, and a little blue-violet.

8. **Continue to develop your painting by observing and refining the value patterns of the painting.**

 When the paint starts to get harder to manage, work on another area.

9. **As the painting starts to come together, start evaluating and developing it by asking these questions:**

 • Does the painting have very light and very dark areas in the near areas of the scene? Are the areas in the background painted with middle range values?

 • Are the brightest colors in the areas near the foreground of the painting?

 • Is the background noticeably duller than the foreground?

- Do the foreground objects have clear edges and the background objects soft edges?

- Do the background objects have less noticeable details than the foreground objects?

10. **In the final stages of the painting, lay in your brightest colors and highlights.**

 Use them only in areas that are meant to draw the eye and to be closer to the viewer. Make sure that you use them very sparingly so that they can do the jobs they were meant to do — create strong focal points and bring objects forward in the composition.

Part V
The Part of Tens

The 5th Wave — By Rich Tennant

"Oh, those? I thought painting might help relieve the tension around here a little. I did these while you were napping. I'm particularly fond of the Red Cross ship. What do you think?"

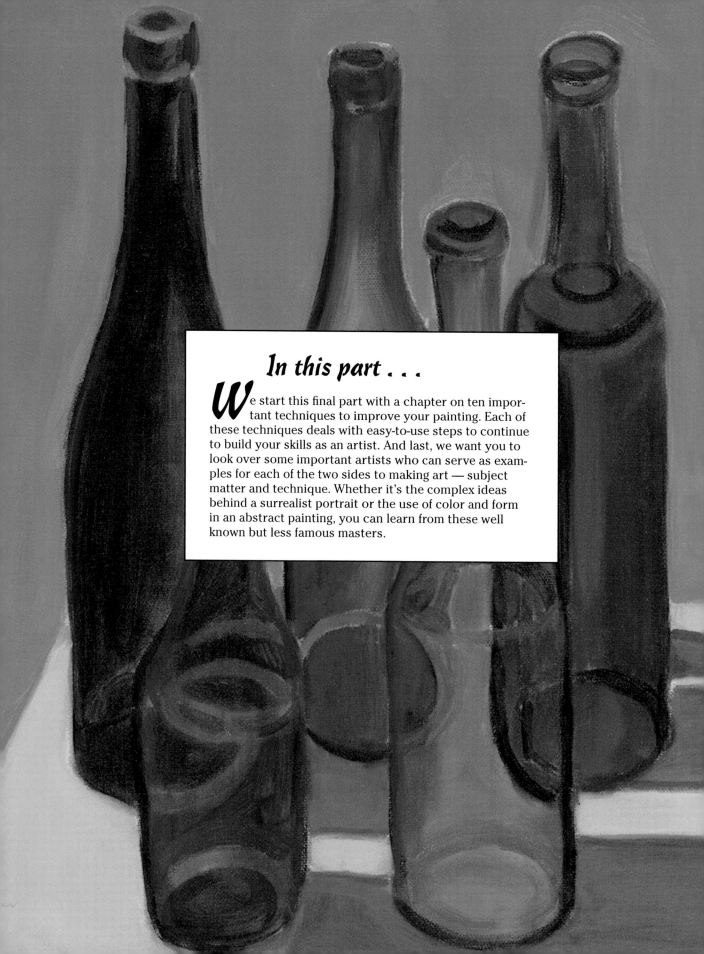

In this part . . .

*W*e start this final part with a chapter on ten impor-
tant techniques to improve your painting. Each of
these techniques deals with easy-to-use steps to continue
to build your skills as an artist. And last, we want you to
look over some important artists who can serve as exam-
ples for each of the two sides to making art — subject
matter and technique. Whether it's the complex ideas
behind a surrealist portrait or the use of color and form
in an abstract painting, you can learn from these well
known but less famous masters.

Chapter 18

Ten Strategies to Immediately Improve Your Painting

In This Chapter

▶ Making preparations

▶ Studying art and technical information

▶ Practicing in and out of class

Artists don't paint in a vacuum. They do a number of things to improve their painting skills, and many don't involve brushing paint on a canvas. They also have strategies for improving, such as making numerous paintings in a short period, which can show results very quickly. Making quick paintings, looking at both old and new artwork, studying techniques and technical information, and drawing on a daily basis all become part of an artist's lifestyle. Painting is a process of lifelong learning, but utilizing even a few of the strategies artists use can provide immediate improvement. In this chapter, we talk about how you can employ these strategies yourself.

Crank Out a Lot of Work

In the beginning, one of the best things you can do to improve your painting is to crank out a lot of short-duration paintings. By painting often, you give yourself a wide variety of experiences with handling paint and experimenting with color and composition.

Cranking out a lot of work can be difficult for some people because beginners have a tendency to conserve materials — they *are* expensive! This inclination to conserve can undermine your progress, though. If your budget for painting is slim, move to one of the fine student-grade lines available and paint on prepared paper until you develop some skill.

Working with speed and giving yourself permission to make mistakes helps you learn to handle a brush efficiently and expressively, and the color in your paintings looks fresher, too. Your painting will look like it has some life to it instead of looking overworked. Better yet, you start thinking more in terms of what your total painting is going to look like rather than getting bogged down in details.

Some of your paintings will be very good, while others may be so bad that even your grandmother wouldn't like them. The secret is to be objective and look for each painting's strengths and weaknesses. The time spent on the weaker work is worth it if you learn from it.

Take a Drawing or Painting Class

Taking a drawing or painting class offers a lot of advantages. It's the most effective action you can take to speed your improvement. A good instructor giving you feedback can shave years off the time it takes trying to learn to paint by yourself.

Studio classes are like group learning communities where you learn from the instructors, but you also learn from your fellow students, and they learn from you.

Taking a class ensures that you paint regularly. Painting is scheduled into your week, and the discipline to do it is as simple as showing up.

Another advantage to taking a class is the exposure to a variety of techniques and approaches for painting and drawing. Beware the instructors who teach only their own specialized painting style. As compelling as they may be, you won't learn as much as you would with an instructor who nurtures everyone's natural ability.

The reasons for taking drawing and painting are fairly similar, but drawing is the basis for all painting. Learning the basics of drawing makes your painting skills so much better.

If you take a class and decide that you want to continue, try to take a variety of classes from a variety of instructors. What you get out of each class is a little bit like eating at a buffet. You pick up a little bit of this and a little bit of that, and the flavors blend to make your own distinct style.

Know Your Craft

This idea may seem fairly obvious, but in the rush to paint, it's probably the most ignored. Learning the nuts and bolts of art just isn't as glamorous as throwing paint at a canvas! Taking time to learn the basics is much more rewarding, however. It not only naturally reinforces your own way of working, but also helps you analyze what other artists are doing much more easily. It makes you a smarter artist!

Know your materials

Oil painting is based on a chemical process, and if you don't understand it, your paintings will break down. For example, if you use oils and solvents that aren't made for painting on canvas, your painting won't dry properly. If you don't work "fat over lean," the surface of your painting will crack. And if you put too much linseed oil in your paint, it will dry very slowly and interfere with the painting process. We cover a lot of this information in Chapter 2, but much of what you learn about oil painting comes from experience.

You also need to learn how your pigments interact with each other and what their limitations are. Try out different materials and brushes so that you find what gives you the best results. Knowing your materials enhances your enjoyment of painting and helps you create beautiful, sound paintings that last.

In Chapter 2, you can read more about the technique of working "fat over lean" and other characteristics of your pigments.

Pay attention to good studio habits

There is no romance in keeping an unkempt studio. Besides being unhealthy and a fire hazard, all that visual clutter keeps you from seeing what's really happening in your painting. A clear area around your painting — free of objects and anything that competes for your attention — makes it easier to study your painting and make good decisions.

So clean up as you work, and when you're finished for the day, put things away properly, as we discuss in Chapter 5. Try to keep things organized so that you don't have to waste time looking for them or buy new supplies because you lost them.

Take Time to Prepare

Any time you begin any sort of project, you have to prepare, and this rule is true of painting as well. Even the most intuitive abstract painting takes preparation.

Don't ignore the surface

The stability of any painting project is dependent on proper preparation — even if you're painting your house! Preparation helps the paint adhere to the surface you want to paint on. It primes a porous surface, sets up a toothy surface for the paint to stick to, and makes sure that the paint won't flake off. Preparation also saves money because you don't lose paint if it isn't absorbed into the canvas or paper that you're working on. A prepped surface is much more pleasant to paint on, too. The brush glides across the surface instead of dragging sluggishly across. You'll be able to see the difference in your final work.

Another reason for properly preparing the surface is to make sure that your work lasts over time. You may not like a particular painting, but a loved one or a collector may value it very much. A properly prepared surface sets up a barrier between the paint and your canvas or paper that prevents acidic paints from breaking down the material that you're painting on.

Get the drawing right

The drawing is the basis for your painting, so you want to try to get it as right as you can. Standing back from your painting and checking it for problems is critical. Imagine putting a lot of work into a painting, standing back to admire it, and finding that you put two left feet on your model. So discouraging!

Because most drawing problems in a painting start with the first marks you place on the canvas, stand back from the canvas early in the process and often thereafter to check your work. It also helps to enlist a trusted friend or a

member of the family to look over your work with a fresh pair of eyes. They may not be artists, but you'd be surprised at how sharp they can be at pointing out the solution to a problem you've been struggling with.

Drawing is an integral part of painting, so practicing your drawing outside of your painting activities is one of the best things that you can do to support your painting progress. Spending as little as 15 to 20 minutes per day with your sketchbook drawing objects or people from observation will pay off with amazing results.

Take care to design the composition well

It's so tempting to just start painting in your eagerness to get started, but the design of your painting can make or break the final work. Take time to do a few rough sketches before you start. They can help you work out problems before you get so far into the painting that you're too invested in it to change anything.

Painting is about much more than painting individual objects and people. It's also about the background, how you arrange the parts, your value pattern, and a multitude of other things. Anyone walking up to your painting is going to see the effect of the whole piece long before they notice how finely you painted your mom's crystal goblet.

Be Willing to Sacrifice Any Part for the Good of the Whole

Nothing is precious! This guideline is the hardest of all to follow. You aren't alone. Painters everywhere spend *way* too much time on that one little area of the painting at the expense of everything else. They love that one little area because it's perfect, but it doesn't go with the rest of the painting *at all*. What's a painter to do?

Well, first, chalk it up to a learning experience. Working on the entire composition at once gives you a more cohesive painting. You want to bring it up in layers instead of painting in concentrated areas that seem to grow like a fungus on your canvas.

In the meantime, photograph that one perfect area for posterity and paint over it, or just crop it down and start another canvas — this time thinking in layers.

Even if you do everything right, you may have to paint over an area you really like for the sake of the whole. It's all part of the process, painful though it may seem at times.

Paint from Real Life: It's the Best Way to Learn

Photographs are great tools for an artist, but they go only so far in providing useful information for you as you draw or paint. They don't capture reflected

light or shadows well. Most importantly, they flatten out the depth and the three-dimensional qualities of your objects. The information they provide is limited enough that it's easy to spot work made by an artist who has painted only from photographs.

If you work from life as much as you can, you learn how to make objects look more three-dimensional than you do if you work only from photographs. After you work from life for a while, you're able to bring your knowledge to the work you do from photos, and your paintings become much more dimensional.

Look at Art — Real Art

Throughout this book we encourage you to go to museums and galleries to look at real paintings. Looking at art history texts and magazines is important for you to do as a painter as well, because you benefit from being exposed to a lot of different kinds of artwork. Nothing compares to looking at the real thing, though.

What you can't see in reproductions

The first thing you notice when you see a famous work is its size. It's like running into celebrities; they're always taller or shorter than you imagined. In a book or magazine, all the paintings look like they're in the same size range, but they're often vastly different in scale.

Another characteristic you can't see in photographic reproductions is the texture of the surfaces of the paintings. Photographs of art have problems capturing the appearance of the layers of paint and the brushstrokes of the artists. Some painters use a combination of matte and glossy surfaces, which doesn't appear in photos. In addition, photos rarely pick up evidence of drawing in the painting. Some artwork is difficult to photograph altogether, so you won't have an accurate picture of the painting at all.

Finally, capturing the true color of a painting is difficult in photography. Even if the photographer does capture it well, it's even more difficult to capture the color when it's printed. Because of the cost, few publications are able to go to the trouble to accurately reproduce the true color of a painting.

Let the masters teach you

What you're looking at when you stand in front of a painting is the hand of the artist and what he or she was thinking when making the work. Master artists weren't gods; they were human beings just like you. When you look at their works, look for their hand in it. Look for evidence of drawing and the under painting. Look at the brushstrokes. What size and shape brush did they use? How did they use color? If you look at paintings with the eye of a fellow artist, they'll give up their secrets.

Join an Art Group or Start Your Own Group

Artists have a long history of getting together to talk about painting and share ideas, and it continues today. That's how art movements get started. A few artists get together to talk about approaches to working, do some painting, and critique each other's work. Making art can be a very lonely endeavor without objective feedback from a few trusted friends. You don't have to be a master to take advantage of this idea. Famous artists were as unknown as anyone else when they first started working.

Attend Art Events

Earlier in this chapter, we mention going to museums and galleries to look at art, but the nice thing about getting involved in the art community is the social aspect. Join a museum or get on the mailing list of a gallery and you'll be invited to the openings of new exhibitions, lectures by artists, and all sorts of events that get you connected to other people with your interests and provide opportunities to learn about painting.

Subscribe to Art Publications

Many good publications about art are available to help you learn about painting. On a national scale, you can find magazines that focus on topics of interest to several different kinds of art audiences. The most helpful for you at this point are magazines devoted to techniques for artists, but other magazines that focus on work by contemporary artists, art theory, or specific media are good sources of information. Some areas of the country have magazines that focus on a particular kind of art made in that region; those magazines may be of interest to you.

You can also go online to browse Web sites devoted to painting. You can begin with the Web sites of the major museums and then check out the new online museums and galleries. While you're at it, look at the Web sites of major art schools to view their online student galleries, which can give you insight into what young painters are doing. The National Portfolio Day Web site, at `www.portfolioday.org`, provides links to art schools in any geographic area on the North American continent. Many major art schools belong to this organization and meet at school sites around the country to review portfolios of potential students.

A number of Web sites provide a wealth of technical information for new painters and can be very helpful to you. You can find these Web sites by typing a subject such as Oil Painting Techniques into the search engine. One fine Web site for beginners is the Art Studio Chalkboard (`http://studiochalkboard.evansville.edu`) associated with the University of Evansville. You can also find a wealth of technical information at the Web sites of Gamblin Oils, Winsor & Newton, and other paint manufacturers.

Chapter 19

Ten Artists You Should Know: The Painter's Painters

In This Chapter

▶ Examining influential artists of past generations

▶ Discovering the works of some contemporary artists

▶ Studying art with a focus on technical and conceptual approaches

*Y*ou already know painters such as da Vinci, Georgia O'Keefe, and Monet, but this chapter presents some well-known artists that you may not be so familiar with. Each of these painters has something special to contribute to your learning to paint. Some have ideas about subject matter and painting, while others have unique approaches to technique. Look them all up and don't pass over any just because you don't like to paint the same subject matter. Be like a sponge and soak up what they can teach you.

Rene Magritte (1898 – 1967)

Belgian artist Rene Magritte (ma-GREET) was a Surrealist like Salvador Dali, but we like him better. Both artists were talented realistic painters. Dali painted eerie landscapes with melting clocks. On the other hand, Magritte combined unrelated objects and ideas in creative, unusual ways. Locomotives emerge from living room fireplaces. Cloned men in bowler hats seem to rain from the sky. He created mysterious paintings that seem like dream images.

Surrealists loved to shock people with their paintings. Combining unrelated images and ideas often changed the original meanings in clever ways. More often, they created the sort of absurd images you might dream up after eating something that didn't sit well with you.

We think Magritte's paintings are imaginative and innovative. He used color masterfully to make solid, realistic forms and establish moods that range from fun and lighthearted to dark and sinister. Looking at how he combined images in creative ways can help you boost your own creative abilities.

Wayne Thiebaud (b. 1920)

We think that you'll enjoy looking at Wayne Thiebaud's paintings. They're full of cakes, pies, cupcakes, hot dogs, and ice cream cones. He lays the paint on thick; he paints these images as though they're on display, ready for you to buy and eat. He's also painted landscapes and people.

Wayne Thiebaud (TEE-bo) is a California artist identified with the Bay Area Figurative painters. Although he's often associated with Pop artists, his ideas are more about ways to paint everyday objects than they are about Pop Art. His work is interesting because he lays down paint very simply, yet he's able to make the objects look very realistic. The surface of his paintings has a different texture than you see in paintings by other artists. It may remind you of the icing on the smooth body of a cake. Unfortunately, you can't see this texture unless you see one of his paintings in person.

He can teach you a lot about color as well. When you look at his paintings, examine the colors he uses, especially the colors he uses in the shadows.

Mary Cassatt (1844 – 1926)

Mary Cassatt (ca-SAHT) was an American painter associated with the French Impressionists. Although she was a part of the Impressionist group, she was female and didn't have the same freedoms to move about as her male colleagues did. She painted scenes of home life because she was determined to paint in spite of the barriers she faced as a woman. Her paintings are peopled with members of her family going about their daily routines. She's especially known for the tender manner in which she painted children.

Cassatt's work shows how you can bring something of your life to your own painting. We want you to look at Cassatt's work for the sheer beauty of her color and brushwork. She had a sensitive, descriptive stroke that captured a lot of information about her subject with seemingly little effort.

When you look at her work, pay particular attention to her colors. Look at the overall color composition. Also look at the colors she used in light and shadowed areas of flesh tones or in the folds of fabrics. Beautiful!

Jan Vermeer (1632 – 1675)

If you saw the movie *Girl with a Pearl Earring,* you know Vermeer's work. The movie may be a totally fictionalized story about a maid in Vermeer's household, but the tone and look of the movie is completely Vermeer.

Jan Vermeer (ver-MEER) lived and worked in the same era as his more-famous colleague, Rembrandt. Dutch painters of that time specialized in painting specific kinds of images, called *genres.* These were landscapes, domestic scenes, portraits, still lifes, and so forth, which they sold to the

Dutch middle class for their homes. Vermeer specialized in domestic scenes, but he painted a couple of beautiful landscapes as well. His paintings are heavily symbolic and often seem to tell a story.

We like Vermeer because of the patterns of light and dark in his paintings and his use of color to create mood. The patterns in his paintings are so strong that you could reduce many of his paintings down to just pattern and you would have beautiful abstract paintings.

It would be a good exercise to look at Vermeer paintings and then see how the basic look of the paintings — the values, colors, forms, and so forth — was re-created in the movie to achieve the same look.

David Hockney (b. 1937)

An artist of great versatility, David Hockney is an English artist who has lived and painted in Southern California for many years. His work is playful, but not childlike. It reflects his knowledge of art history and his love to experiment.

To say that he's known for any one attribute would be difficult. Here are some groups of work that we think would be important for you to look at:

- ✔ A master of portraiture, he's able to capture the nuances of his model's personality in his paintings. He also has the unusual ability to show how the people in his paintings relate to each other. When you look at his work, you want to look at how he draws and paints people, as well as how he composes his portrait paintings.

- ✔ His somewhat abstracted paintings of landscapes and interiors are interesting experiments in adding time to a painting. The interiors may represent a walk through a friend's home. Many landscapes represent a drive down a road. When you view the paintings, look at how he patches together the views that you may see on that drive.

Hockney is also generous in sharing how he works. Besides books, a number of videos are available that you can borrow from a library with a good art video collection. These aren't how-to videos; generally, they're videos about Hockney as an artist. You're lucky to be able to see him work and hear him describe his working process.

Richard Diebenkorn (1922 – 1993)

Like Wayne Thiebaud, Richard Diebenkorn (DEE-ben-korn) was a Bay Area Figurative Painter. They shared some of the same ideas about making art, but we want you to look at them for different reasons.

Diebenkorn's simple still life paintings are perfect examples of how you can take a simple subject, such as a tomato cut in half, and make a precious gem out of it. The still life paintings are small, expressive, and elegantly designed. They show that you don't need complex subject matter to make a fine painting.

We have ulterior motives for asking you to look at these still lifes, however. We're using them to lure you into looking at his abstract paintings. Many abstract paintings are derived from sources in the artist's environment. This is the case with Diebenkorn's abstracts. You can see a clear connection between his abstract paintings and his paintings of interiors and views outside his window. These inside-outside scenes from his studio were simplified and pared down to their basic forms and colors. You can see the lines of his drawing through the paint. The shapes are so simplified, however, that you may not get it right away unless you know the connection.

Besides our very logical reasons for wanting you to look at them, we want you to look at Diebenkorn's appealing use of color and the painterly manner in which he applied the paint.

Euan Uglow (1932 – 2000)

Euan Uglow (U-won U-glow) was a British painter who painted still lifes and nude figures. The still life paintings are very realistic with solid-looking forms and beautiful color. They're simple, elegant compositions.

Interestingly, he treated his models as still life subjects as well. He posed them in simple positions that they wouldn't necessarily have taken themselves. Design is a strong element of this work. You can see that he was thinking about all the elements of good design when he posed his models.

You can learn a lot about still life and figure painting when you look at his paintings. His process was very analytical. He worked from observation and used a network of measurements to plot out his figures. You can see the marks of the charcoal on his paintings and how he used them to find the planes of the body. As you examine them, you'll also be able to see what colors he chose to show changes in light and shade.

You may not want to paint exactly as he did or work with nude models, but his methods will help you paint stronger still life images, portraits, and parts of the human form, such as hands and feet. You can use his methods as a jumping-off point for developing your own.

Paul Cezanne (1839 – 1906)

Paul Cezanne (say-ZAHN) is an influential French painter who worked during the same period as Vincent Van Gogh. At one time, he painted in the Impressionist manner. He decided, however, that Impressionism was too limiting. He saw that objects had no solid form and that it was difficult to depict depth. He had studied the paintings in museums and said that he wanted his paintings to have the same staying power as the works he had seen there.

Cezanne's landscape paintings are well known, but he also painted many still life paintings of fruit. The fruit in these paintings are casually arranged and lush with color.

He continued to paint with a *broken stroke,* as the Impressionists did. He also tried to develop more structure in the objects he was painting. His emphasis on planes in the structure of his subjects influenced many later artists. He also continued to use the brighter palettes that the Impressionists introduced.

When you study his paintings, look at the attention he paid to the various planes of the objects he painted. They look structural, but they're also expressive. Especially pay attention to how he used color, both in his objects and in the overall compositions.

Look for his incomplete still life paintings that show the general to specific painting method. The still life paintings are the best. The colors glow and he used the method of outlining the forms in the complementary color to make the colors more intense. Seeing the still life paintings in person will teach you a lot about how to paint.

Wolf Kahn (b. 1927)

Wolf Kahn is a German-born American who paints landscapes that straddle the line between realism and abstraction. They look like landscapes, but they emphasize fields of color rather than details. He makes paintings in oil and pastel about the same size as the paintings you are probably making.

His colors are rich and saturated. He studied under Hans Hoffman, whose ideas about color have guided many contemporary artists. The colors in Kahn's paintings relate to the natural colors in the environment, but they're much stronger than the colors you see when you actually look at the environment. For example, subtle violet shadows become strikingly electric under his hand. Patterns of dark and light are more than values. They sizzle with the interaction of vibrant warm and cool colors.

When you look at Kahn's work, examine the kinds of shapes and color choices he made. His shapes are similar to those you might make if you're working general to specific, but stopped before you developed the specifics. He keeps his colors fresh and immediate, without overworking or muting them too much.

Frida Kahlo (1907 – 1954)

If you're looking for unusual ways to do portraiture, you'll like Frida Kahlo. She was a Mexican Surrealist who painted self-portraits loaded with symbolism.

Her paintings are autobiographical portraits. She used her painting to work out the frustrations and challenges in her life. Due to a terrible accident when she was a young woman, she struggled with back problems and other physical ailments for the rest of her life. She wore an iron back brace and painted

while she was confined to bed. Most of her paintings refer to the constant presence of her physical problems. She also had a stormy marriage with famous muralist Diego Rivera, who was another source of consternation — and subject matter.

She was a political person as well. To show support for the Mexican working class, she wore traditional costumes and painted portraits of herself dressed in them.

Kahlo's work is good for you to study because you can see how you can incorporate symbolism and aspects of your own life into your painting. It's a good way to learn to develop your subject matter and reflect on your life and goals as you work.

Index

• *N* •

• *O* •

Notes